A Brief History of Curating

JRP|RINGIER & LES PRESSES DU RÉEL

Table of Contents

Christophe Cherix

When Hans Ulrich Obrist asked the former director of the Philadelphia Museum of Art, Anne d'Harnoncourt, what advice she would give to a young curator entering the world of today's more popular but less experimental museums, in her response she recalled with admiration Gilbert & George's famous ode to art: "I think my advice would probably not change very much; it is to look and look and look, and then to look again, because nothing replaces looking … I am not being in Duchamp's words 'only retinal,' I don't mean that. I mean to *be* with art—I always thought that was a wonderful phrase of Gilbert & George's, 'to be with art is all we ask.'"

How can one *be* fully with art? In other words, can art be experienced directly in a society that has produced so much discourse and built so many structures to guide the spectator?

Gilbert & George's answer is to consider art as a deity: "Oh Art where did you come from, who mothered such a strange being. For what kind of people are you: are you for the feeble-of-mind, are you for the poor-at-heart, art for those with no soul. Are you a branch of nature's fantastic network or are you an invention of some ambitious man? Do you come from a long line of arts? For every artist is born in the usual way and we have never seen a young artist. Is to become an artist to be reborn, or is it a condition of life?"[1] With a good dose of humor, "the human sculptors" suggest that art needs no mediation. Because artists refer to a higher authority, no curator or museum is to stand in the way.

If the modern figure of the art critic has been well recognized since Diderot and Baudelaire, the curator's true raison d'être remains largely undefined. No real methodology or clear legacy stands out in spite of today's proliferation of courses in curatorial studies. The curator's role, as shown in the following interviews, appears already built into preexisting art professions, such as museum or art center director (Johannes Cladders, Jean Leering, or Franz Meyer), dealer (Seth Siegelaub, for example), or art critic (Lucy Lippard). "The boundaries are fluid," Werner Hofmann observes, who goes on to note that this is especially true in his birth place of Vienna, where "you measure yourself against the curatorships of [Julius von] Schlosser and [Alois] Riegl."

The art of the late 19th and 20th centuries is deeply intertwined with the history of its exhibitions. The predominant accomplishments of the avant-gardes of the 1910s and the 1920s can be seen—from today's point of view—as a series of collective gatherings and exhibitions. These groups followed the road traced by their predecessors, enabling ever-increasing numbers of emerging artists to act as their own mediators. "One forgets," Ian Dunlop observed in 1972, "how difficult it was a hundred years ago to show new work. The official and semi-official exhibitions held annually in most capital cities of the West came to be dominated by self-perpetuating cliques of artists only too content to benefit from the burst of collecting that followed the Industrial Revolution. In almost every country these exhibitions failed to meet the needs of a new generation of artists. Either the annual shows created their own splinter groups, as was the case in America, for example, or artists formed their own

counter-exhibitions, as the Impressionists did in France, the New English Art Club did in Britain, and Viennese artists did in Austria."[2]

As we move through the 20th century, the history of exhibitions appears inseparable from modernity's greatest collections. Artists played a defining role in the creation of these collections. Wladyslaw Strzeminski, Katarzyna Kobro, and Henryk Stazewski started the Muzeum Sztuki in Lodz, Poland, with the presentation to the public in 1931 of one of the earliest collections of avant-garde art. And as Walter Hopps recalls, "Katherine Dreier was crucial. She, with Duchamp and Man Ray, had the first modern museum in America." However, a progressive professionalization of the curator's position was already becoming evident. Many founding directors of modern art museums, for instance, rank among the curatorial pioneers—from Alfred Barr, first director in 1929 of The Museum of Modern Art of New York, to Hofmann who created Vienna's Museum des 20. Jahrhunderts in 1962. A few years later it came as no surprise that, with the advent of curators such as Harald Szeemann at the Kunsthalle in Bern and Kynaston McShine at the Jewish Museum and at The Museum of Modern Art in New York, the majority of the most influential shows were organized by art professionals rather than artists.

During the course of the 20th century, "exhibitions have become *the* medium through which most art becomes known. Not only have the number and range of exhibitions increased dramatically in recent years, but museums and art galleries such as Tate in London and the Whitney in New York now display their permanent collections as a series of temporary exhibitions. Exhibitions are the primary site of exchange in the political economy of art, where signification is constructed, maintained, and occasionally deconstructed. Part spectacle, part socio-historical event, part structuring device, exhibitions—especially exhibitions of contemporary art—establish and administer the cultural meanings of art."[3]

While the history of exhibitions has started, in this last decade, to be examined more in depth, what remains largely unexplored are the ties that interconnected manifestations have created among curators, institutions, and artists. For this reason, Obrist's conversations go beyond stressing the remarkable achievements of a few individuals—for instance

Pontus Hultén's exhibition trilogy *Paris–New York, Paris–
Berlin,* and *Paris–Moscow,* Leering's *De straat: Vorm van
samenleven (The Street: Ways of Living Together)*, and Szeemann's
When Attitudes Become Form: Live in Your Head. Obrist's col-
lected volume pieces together "a patchwork of fragments,"
underlining a network of relationships within the art
community at the heart of emerging curatorial practices.
Shared influences among curators can be traced. The names
of Alexander Dorner, director of Hannover's Provinciaal
Museum; Arnold Rüdlinger, head of the Basel Kunstmuseum;
and Willem Sandberg, director of Amsterdam's Stedelijk
Museum, will become familiar to the reader of these inter-
views. It is however the mention of lesser-known curators—
still not present in the profession's collective consciousness—
that will most catch the historian's attention. Cladders and
Leering remember Paul Wember, director of the Museum
Haus Lange in Krefeld; Hopps points to Jermayne MacAgy,
a "pioneering curator of modern art" in San Francisco;
and d'Harnoncourt recalls a student of Mies van der Rohe
who became curator of 20th century art at the Art Institute
of Chicago, A. James Speyer.

 Meyer observes that if history fails to remember
curators, it is "mainly because their achievements were
intended for their own time. While they were influential, they
have nonetheless been forgotten." However, in the late
1960s, "the rise of the curator as creator,"[4] as Bruce Altshuler
called it, not only changed our perception of exhibitions,
but also created the need to document them more fully. If
the context of an artwork's presentation has always mattered,
the second part of the 20th century has shown that artworks
are so systematically associated with their first exhibition
that a lack of documentation of the latter puts the artists'
original intentions at risk of being misunderstood. It is one
of the many reasons why the following 11 interviews repre-
sent a key contribution to the broader approach necessary
for the study of the art of our time.

[1] Gilbert & George, *To Be With Art is All We Ask*, Art for All,
 London 1970, p. 3–4.
[2] Ian Dunlop, *The Shock of the New: Seven Historic Exhibitions
 of Modern Art*, American Heritage Press, New York,
 St Louis, and San Francisco 1972, p. 8.
[3] Reesa Greenberg, Bruce W. Ferguson, Sandy Nairne,
 "Introduction," *Thinking about Exhibitions*, Routledge,
 London and New York 1996, p. 2.
[4] Bruce Altshuler, *The Avant-Garde in Exhibition: New Art in
 the 20ᵗʰ Century*, Harry N. Abrams, New York 1994, p. 236.

Walter Hopps

Born in 1932 in California. Died in 2005 in Los Angeles.

This interview was conducted in 1996 in Houston, Texas. It was first published in *Artforum*, New York, in February 1996, under the title "Walter Hopps, Hopps, Hopps."

It was originally introduced by the following text:

In Calvin Tomkins' 1991 *New Yorker* profile "A Touch for the Now," curator Walter Hopps comes across as an eccentric maverick. We learn of his preferred schedule (his workday begins not long before sundown and stretches into the morning hours) and near-mythic disappearing acts (his elusiveness prompted employees at the Corcoran Gallery in Washington, DC, where he served as director in the 1970s, to make buttons reading "Walter Hopps Will Be Here in 20 Minutes"). It was his relentless perfectionism, however—preparators will recall the habitual groan of "Wrong, wrong, wrong" that greeted their best efforts—that cemented the impression of the curator as a mercurial iconoclast. Indeed, while Hopps' legendary non-conformity may overshadow his curatorial accomplishment, his independence is not unrelated to his achievement. In a 40-year career spent in and out of the museum world, during which he has organized well over 100 exhibitions, he has never succumbed to administrative logic or routine (he once said working for bureaucrats while a senior curator at the National Collection of Fine Arts—now the National Museum of American Art—was "like moving through an atmosphere of Seconal"). Hopps, in retrospect, manages to come across as both consummate insider and quintessential outsider.

Hopps opened his first gallery, Syndell Studio, while still a student at UCLA in the early 1950s, and soon achieved acclaim for his *Action 1* and *Action 2* overviews of a new generation of California artists. Later, his Ferus Gallery in Los Angeles would bring attention to such artists as Ed Kienholz, George Herms, and Wallace Berman. As director of the Pasadena Museum of Art (1963–1967), Hopps mounted an impressive roster of exhibitions, including the first US retrospectives of Kurt Schwitters and Joseph Cornell and the first museum overview of American Pop art (*New Paintings of Common Objects*)—not to mention Marcel Duchamp's first one-man museum show.

Yet Hopps has enjoyed as much success outside institutional settings as within them. Shows such as *Thirty-Six Hours*, in which he hung the work of any and all comers over a two-and-a-half-day period, are case studies in curating art outside museum settings. Even today Hopps works in multiple contexts: while serving as consulting curator for the Menil Collection in Houston, he also puts in time as art editor of *Grand Street*, a literary journal that he has helped turn into an artists' showcase.

Hopps' flair as an impresario is matched only by his knack for hanging stunning shows. As Anne d'Harnoncourt, director of the Philadelphia Museum of Art, put it, his success comes from "his sense of the character of works of art, and of how to bring that character out without getting in the way." But Hopps also sees the curator as something like a conductor striving to establish harmony between individual musicians. As he told me when I sat down to interview him in Houston in December, in anticipation of his Kienholz retrospective that goes up this month at the Whitney, it was Duchamp who taught him the cardinal curatorial rule: in the organization of exhibitions, the works must not stand in the way.

HUO *You worked in the early 1950s
as a music impresario and organizer.
How did the transition to organizing
exhibitions take place?*

WH They both happened at the same
time. When I was in high school,
I formed a kind of photographic
society, and we did projects and
exhibits at the high school. It was
also at that time that I first met
Walter and Louise Arensberg.
But some of my closest friends were
actually musicians, and the 1940s
were a great time of innovation in
jazz. It was a thrill to be able to see
classic performers like Billie
Holliday around the clubs in Los
Angeles, or the new people like
Charlie Parker, Miles Davis, and
Dizzy Gillespie. The younger musi-
cians I knew began to try to get
engagements and bookings, but it
was very hard in those days. Black
jazz frightened parents; it fright-
ened the officials. It was worse in
this way than rock 'n' roll. It had a
subversive quality.

I had the good luck to discover the great baritone-saxophone player Gerry Mulligan. Later, I had the chance to go on a double date with his wonderful trumpet player, Chet Baker. You know, those guys had a different sort of social life than would normally be the case. Somehow I managed a jazz business and the small gallery near UCLA, Syndell Studio, at the same time I was in school.

For contemporary artists there was an incredible lack of visibility.

Right. In Southern California there were only two occasions during my youth when any of the New York School people were shown. And the critics damned them. One was an incredible show of New York School artists, *The Intrasubjectivists*, that Sam Kootz and others were involved with putting together. And there was a show by Joseph Fulton, a predecessor of mine at the Pasadena Art Museum. He brought in a beautiful show with Pollock and Enrico Donati—a mix of the new Americans and sort of more Surrealist-oriented things. De Kooning was in it, Rothko, and so on.

The only critical writing we normally had access to was Clement Greenberg's—he was so contentious and arrogant—and the beautiful writing of Harold Rosenberg and Thomas Hess. Hess constantly looked for every reason he could to champion de Kooning, as you know. We had virtually no critics like that in Southern California at the time. There was also Jules Langsner, who championed the abstract minimal kind of hard-edged painting—John McLaughlin, etc. He just couldn't accept Pollock.

How were these shows received?

What impressed me was that the audience was there—younger artists and people who were not officially part of the art world then were really intrigued. It had a real human audience.

It seems like a paradox—there had been little to see, then suddenly around 1951, there was a climax in art on the West Coast. You've talked about a project of organizing a show of works all created in 1951.

I would see the crest of great Abstract Expressionist work as

extending from 1946 through 1951. This is true for New York and also, on a smaller scale, for San Francisco. During this period, most of the important Abstract Expressionist painters in America were working in top form. I really wanted to do a show about 1951, with 100 artists represented by a single major work apiece. It would have been fabulous. Lawrence Alloway, in London, understood what was going on in a way that many people in America did not. He had great insights about the new American art, I'll give him that.

Previously you've mentioned Stieglitz's 291 Gallery as a source of inspiration for your exhibitions.

Yes. I knew a little bit about what had gone on at 291. Stieglitz was the first person to show both Picasso and Matisse in America. Even before the Armory Show, you know.

So before Arensberg.

Yes. Arensberg's collection really began in 1913, at the time of the Armory Show. Several collections start then: Duncan and Marjorie Phillips' collection in Washington begins then; and Arensberg's began. Katherine Dreier was crucial. She, with Duchamp and Man Ray, had the first modern museum in America. And it was actually called the Modern Museum, although it was mostly known as the Société Anonyme.

The year 1913 leads us somehow back to the discussion we had during lunch, when you gave 1924 as a second very important date.

Oh, yes. Nothing really happened in museums until around 1924. It took that long. Then in New York and San Francisco, a little bit in Los Angeles, a little bit in Chicago—among certain collectors within those museums—things began to happen. Soon after Arensberg moved to Southern California, he had the idea of founding a modern art museum with his collection out there—combining some other collections with his. But it was fated not to happen. There were not enough collectors of modern art to support such a project in Southern California.

So 1924 is also the year he left New York?

Yes. To me, the Arensbergs coming to Southern California gave it the cachet, the license, to do anything, even though the public and the officials were so contrary about contemporary art. Even during my time, right after World War II—in the late 1940s and early 1950s—the politics of the McCarthy era were very hard on art in the institutions in Southern California. Picasso and even Magritte—Magritte, who had no politics, who was, if anything, a kind of patron of the royalists—had their work taken down as being subversive and communistic in the one museum we had in Los Angeles. There was plenty of weak contemporary art in Southern California. The whole school of Rico Lebrun. There were all these Picasso-like people and lots of insipid variations on Matisse; it just made you sick. There was more authenticity and soul in some of the landscape painters.

But things slowly began to creep in. In Southern California, the hard-edge painters, like John McLaughlin, began to be accepted in exhibitions. The public didn't like it, but they would be hung by the museums, for example by James B. Byrnes, the first curator of Modern art at the Los Angeles County Museum of Art. San Francisco was the other place in the United States where great Abstract Expressionist art was beginning to be shown seriously, like Clyfford Still and Mark Rothko, as presented by a brilliant and pioneering curator of Modern art, Jermayne MacAgy.

Was Richard Diebenkorn shown?

Diebenkorn was their student. He also began to be shown, as well as David Park and others.

Could you talk about the emergence of the assemblage artists of your generation? What were their sources?

Wallace Berman was fascinating—he had a great touch, and great insights about Surrealist art, but he never became some thin carbon copy of Surrealist form, which many artists did. He was crucial to the Beat sensibility. He was one of the serious people. He introduced me to the writings of William Burroughs. And he published his own little journal, *Semina*. One of the slightly older intellectuals that affected Beat culture so much on the West Coast was Kenneth Rexroth.

He was a very intelligent man, and he was a great translator of some fascinating Chinese poetry. At the same time, he was something of a mentor to people like Ginsberg and Kerouac. So was Philip Whalen.

But the cultures of San Francisco and Los Angeles were quite distant: the patronage, the infrastructure. The patrons who would spend money were mostly living in Southern California, and most, though not all, of the really interesting art was being created in the north. It was a difficult dialogue, and I felt it was crucial to unite the art from the north and the south.

In Los Angeles and the West Coast in general the artistic and intellectual circles seem to have been relatively open at the time, not dogmatic but inclusive.

Absolutely. You didn't have to make allegiances the way you would if you were in New York. Ed Kienholz could love Clyfford Still's work and that of his circle—Diebenkorn was fine; he liked Frank Lobdell even better, because he was dark and brooding. But he also liked de Kooning. He had no problem with that. In the world of the New York School, it was very difficult—Greenberg became the champion of all the color-field people; Rosenberg became the champion of de Kooning and Franz Kline. The artists took up their allegiances, also. But on the West Coast, someone like Kienholz could love both de Kooning and Still.

And Kienholz was linked to Wallace Berman and then to the Beat generation as well?

Kienholz and Berman knew each other, but there was a schism between them. Kienholz was a private, tough realist. Berman was very spiritual, with a kind of cabalistic Judaism and regard for Christianity. Kienholz would not berate him, but he didn't want to have anything to do with him either. They were very different. Both are represented near one another in the massive *Beat Culture* show curated by Lisa Phillips at the Whitney Museum in New York. Currently I'm working on a full-scale retrospective of the work of both Ed Kienholz and Nancy Reddin Kienholz, to be presented later this year at the Whitney. Ed's work was considered very controversial,

even into the 1960s when he had his first retrospective.
Today I suspect much less controversy, but you never know.
With this exhibition I hope to reveal the continuity as well
as the power of his art and both its origins in an American
sense of West Coast culture and its wide range of vital sub-
ject matter.

*To come back to the issue of curating: in an earlier interview you
mentioned a small list of American curators and conductors you consider
to be important predecessors.*

Willem Mengelberg was a conductor of the New York
Philharmonic, who imported the grand Germanic tradition
of running an orchestra and conducting. So I mention
Mengelberg not so much for his style, but for his unrelenting
rigor. No matter what, he'd make the orchestra perform.
Fine curating of an artist's work—that is, presenting it in an
exhibition—requires as broad and sensitive an understand-
ing of an artist's work as a curator can possibly muster. This
knowledge needs to go well beyond what is actually put in
the exhibition. Likewise, as far as conducting goes, a thorough
knowledge of the full body of Mozart's music underlies a
fine conductor's approach to, say, the Jupiter Symphony.
Mengelberg was the sort of conductor who had a broad know-
ledge of any composer he addressed.

Of the curators, I admired Katherine Dreier enor-
mously, with her exhibitions and activities, because she, more
than any other collector or impresario I knew, felt she should
facilitate what they actually wanted to do, to the greatest
extent possible.

So you could say she was the artist's accomplice.

Exactly. She didn't have other rich people on her board. She
had Man Ray and Duchamp—having artists in this capacity
is nothing but trouble, conventionally.

You also mentioned Alfred Barr and James Johnson Sweeney.

Yes. Barr, who came from a Protestant Yankee family, might
have become a Lutheran minister. Instead he became a
great director and curator with an institution that had all

the resources the Rockefellers, and others, could provide at
the time. There was a kind of moral imperative behind Barr.
He preached that Modern art was good for people, that the
populace could somehow become inculcated with the new
Modernism and it would improve their lives. It's very close
to a Bauhaus idea.

Sweeney was more complicated and romantic. I don't
think he would have argued that art per se was necessarily
morally good for you, but I don't think he made a big case
that it was not. But Sweeney was a genuine romantic who felt
that the aesthetic experience was a whole other territory to
explore. He was like an explorer. For him, Picasso was one of
the great adventurers, you know. Sweeney was one of the first
in his generation to admire Picasso. He worked briefly at The
Museum of Modern Art, and then later at the Guggenheim.

And then in Houston?

Yes, he was at the Museum of Fine Arts, Houston, for a
while, at the very end of his career. He responded instinctively
to the Abstract Expressionists. And because of his work in
France during his youth—in literary journals and so on—he
was responsive to the Tachistes as well, and was just begin-
ning to have a certain empathy, a certain response, to the
Nouveaux Réalistes, right before he died. I think if he had
been younger—and alive, for example—he would have been
the greatest champion of Yves Klein. Sweeney was also one
of the most rigorous people in working out an installation.
When I was young, I had the chance to actually see him in
the old Guggenheim townhouse before the Frank Lloyd
Wright building was constructed. He was never happy with
the Wright building. It was a clash of two giant egos. Sweeney
wanted something more neutral for his own stagecraft where
the art could happen. However, one gorgeous show he did
do in the Wright building was the [Alexander] Calder show.

In curating there is a need for flexible strategies. Every show is a
unique situation, and ideally it gets as close as possible to the artist.

Yes. To me, a body of work by a given artist has an inherent
kind of score that you try to relate to or understand. It puts
you in a certain psychological state. I always tried to get as

peaceful and calm as possible. If there was a simple way of doing something, I would do it that way. When I did the Duchamp retrospective in 1963, he and I walked through the old Pasadena Art Museum—the colors were white and off-white and brown; there was some wood paneling; some dark brown. Duchamp said: "It's just fine. Don't do anything that is too hard to do." In other words, he was always very practical. But he had a very subtle way of trying to orchestrate or bring out what was already there, to work with what was already given. Duchamp knew exactly how to work with what was there.

But with other artists installations were very different. Barnett Newman was a very bright man, but he would get a preconceived notion of how the space should be. Wherever I showed him, we always had to do a lot of construction.

You mean the São Paulo Biennale in 1965?

There, and then when I showed him in Washington. There was a huge wall that had distracting stuff way above, where the paintings were shown. It bothered Newman so much—but nobody else—that we had to build a false wall about ten meters high, at great expense and difficulty.

In terms of flexibility, in the 1960s and, above all, the 1970s, the European Kunsthalle was defined as something of a laboratory, where things could be tested, without the pressures of public success and thousands of square meters to be filled.

Yes. This is similar to the tradition behind Dominique de Menil, through her father's family, the Schlumbergers, in engineering. You could remove "Menil Collection" from the building's facade and call it "de Menil Research," and it would look like an engineering building.

Was this the intention behind selecting Renzo Piano as the architect?

Absolutely. It's one reason we chose Piano, whose great love is engineering. I think his ancestors were shipbuilders, and there's nothing more beautiful than a ship. But its form is absolutely rational.

Before Jean de Menil died in 1974, he wanted Louis

Kahn to build the new museum. Philip Johnson's chapel already existed, so a kind of peaceful sanctuary had already been achieved. And Jean de Menil wanted the new museum, with these pavilions, on the same land in the park. Kahn died about a year later, so it was never possible to continue it. But I think Piano's engineered public space works well against the more contained sanctuary space of the Rothko Chapel.

You've also mentioned René d'Harnoncourt as an influence.

Yes, he was special. Nelson Rockefeller was fortunate to have met him. He was yet another person whose background was in the sciences, in chemistry. He could have become an engineer-businessman in one of the great dye works of the chemical industries. But through his love of art—and ancient art, too—d'Harnoncourt became one of those who felt, instinctively, that there were archetypes of form in ancient art, relating any number of things that existed in the so-called tribal or primitive arts to what went on with the modern. When he came to The Museum of Modern Art, he saw something deeper and broader going on with Pollock, deeper than Pollock simply being influenced by the French Surrealists —that Pollock, in his way, was going back to some of the ancient sources that the Surrealists themselves went to.

D'Harnoncourt had a kind of stature as a diplomat who could keep all the departments, all the egos, more or less in balance. He was brought in to MoMA after Alfred Barr had had a nervous breakdown, and his main job, as far as Nelson Rockefeller was concerned, was to help support Barr—which he did do; they got along well.

I think the other one on this list is Jermayne MacAgy. She was the mistress, or the master, of beautiful theme shows. Her greatest work was in San Francisco. She once did a show there around the theme of time. There's a work by Chagall titled *Time Is a River without Banks* [1930–1939]. I think the phrase intrigued MacAgy—more so even than the work. Her exhibit was ahistorical, coming from any period, and cross-cultural. She included clocks and timepieces. She had a Dali with little clocks and so on, as well as all kinds of references and allusions to time—in old and new work. In another exhibition, the California Palace of the Legion of Honor in San Francisco wanted a show of arms and armor.

She did a fantastic piece of drama as a set piece for it. She made a huge chessboard in the great atrium—and lined up the figures as two competing sides.

How did MacAgy's theme shows avoid subordinating the work to the overall concept?

She had a very sure and spare touch, for the most part.

You also mentioned her shows in terms of an almost-empty design.

Yes. She managed to ignore design systems—or tried to work outside systems of taste for these shows. Early on, here in Houston, when she did a Rothko show, she went out of her way to have beautiful flowers in the entryway—living flowers, planting beds. It was just a general reminder that you don't start trying to ask why flowers are some color— you relax and enjoy their beauty. It was a very interesting reminder that viewers should not be upset with the Rothkos if there's no image there, no subject. What is the image of a flower? It's just a color, it's a flower.

If one looks at the encyclopedic range of exhibitions you've organized, it's striking that, besides the exhibitions that take place in and redefine museum spaces, you've also done shows in other spaces and contexts where you tend to change the rules of what an exhibition actually is. I'm interested in these dialectics—the exhibitions that take place outside the museum create a friction with what takes place inside the museum, and vice versa. By questioning these expectations the museum becomes a more active space. When you were a museum curator in Washington you organized the show called Thirty-Six Hours *at an alternative space.*

Yes. *Thirty-Six Hours* was literally organized from the street. There was practically no budget, no money.

So you actually had just a small alternative space, the Museum of Temporary Art, at your disposal.

Right. It had a basement and four floors. It normally just showed on two of those floors. So I said, "Let's clean up the basement and these other floors so we can have it everywhere

in the building." And the people who ran the space said: "Why? We normally only show on two floors." And I said: "You'll see. More people will come than fit two floors." They said: "How do you know?" I said: "If you say you're having a show where anyone who brings anything can be shown, people are going to come."

How did you make it public?

We worked at letting people know for a couple of weeks. We put some posters up and got certain people to mention it on the radio. We had some musicians performing the opening night; one reason we had the musicians was that they knew the disc jockeys. I knew perfectly well that lots of working artists, you know—they're in their studios at night, and so forth, they listen to rock 'n' roll, whatever's on the radio, and they're going to hear this. They'll call up and find out. And they will come.

So not just artists—everybody.

Anybody—we made no distinction. But it's interesting how few people who were not really artists showed up. One drunk guy came in who had ripped out a lurid *Hustler* photo with this nude woman exposing herself. He crumpled up the paper and then flattened it out. He'd signed it, and he came in insisting it was his work. My role in this was to be there all 36 hours, meeting and greeting every single person who brought in a work. We'd walk to a space and they would help install it, right then and there. So here was this crisis. But I found a place that was reasonably dark—it wasn't spotlit— and I walked him over there and said: "This is the perfect place for it."

So you actually did the hanging when people brought things.

Yeah. So we stapled this thing up, in a sort of shadowy corner. This guy was so out of it, and so surprised—this was just a dirty joke on his part, but I didn't treat it that way. We put it up there, and he went away, and that was fine.

So the show was inclusive.

My only requirement was that it had to fit through the door.

*In the exhibitions you organized, there's something like a thread—
from Duchamp or Joseph Cornell to Robert Rauschenberg—of artists
whose work is encyclopedic.*

Yes, that's true. They're all artists who would have a difficult
time explaining to you what they would not put in their art.
They're naturally inclusive.

Many of your exhibition projects, like the Thirty-Six Hours, *or
the unrealized project of the* 1951 *show and, of course, the* 100,000
images project, have this same impetus.

Yes. Well, it's a very innocent response to natural phenom-
ena. It's a perception of all the sorts of things one studies in
the natural sciences, where you immediately get a vast realm
of phenomena thrown out in front of you. I remember when
I studied bacteriology, I had a good professor who went out
of his way to talk about both bacteriophages and viruses
so we might get a better sense of the whole category. Some-
how, early on I got used to the idea that these people who
were exploring any given subject were constantly pushing
out beyond the boundaries, in order to understand what the
boundaries were in the first place.
 You can tell from the museum here that I believe very
much in sometimes isolating a single work, with a very dis-
crete situation—not having it be cluttered or complicated.
At the same time, I have a great feeling for really large num-
bers of works.

*This 100,000 images project was conceived as filling a single entire
building?*

That's right. I conceived of it as a really exciting project for
P.S.1 in New York. I calculated that the whole building could
hold 100,000 items, if you had some kind of discretion as
to what the size would be. That may seem unimaginably large
for an art show, but, on the other hand, if you counted
the number of phases of music, or measures, in an opera or
a symphony, you'd get an unimaginably large number, too.

Or a computer program.

That's right. I believe people could take in presentations of art that are almost as vast as nature. If a lot of things looked very repetitive, well, that's the way it is. If you're walking through the desert and looking at creosote bushes and some tamarack and some sage—they're all different and discrete. But, on the other hand, they can appear very repetitive.

And everyone can put together his or her own sequence.

Exactly. I think in the future some of the experience of finding one's way through vastly larger realms of information on the Web and in cyberspace will allow for what I'm talking about. But I've also tried to think of exhibits featuring only two or three works, or even one work, and some unusual comparisons. I've often thought that Vermeer's work would fit in this kind of show. The same is true of Rogier van der Weyden.

The explosion of images and sources leads also to Rauschenberg.

Yes, in recent years I've had a lot of involvement with Rauschenberg, and to use your term, he's probably the most encyclopedic artist of our time.

And you're working on a retrospective.

Yes, having done one at the National in 1976, the Guggenheim wants me to do one for what I guess will be 1997 or 1998—a little more than 20 years later.

So it'll be the retrospective of retrospectives.

Yes. The difficulty will come in the work after 1976, where Rauschenberg began to become prolific in larger-scale works— all the international touring he did.

The global venues.

The overseas venues seemed, to most people, not very discriminating. There wasn't any sense of discrimination as to

why this or that piece was chosen. I don't know whether, doing this show, I'll be beyond such a notion of discrimination. I'm concerned with whether one can get into that vast body of work—and truly represent the vastness of Rauschenberg's oeuvre, and yet still seem discerning.

So it's a paradoxical enterprise, to frame abundance without annihilating or reducing it.

Yes. We're talking about using both spaces—both the uptown and the SoHo Guggenheim. That appeals to me.

The last Rauschenberg retrospective you curated, in 1976—it must have been one of the first times a contemporary artist made the cover of The New York Times Magazine.

Yes.

This leads to what I call the double-leg theory: an exhibition that is highly regarded by specialists but also makes the cover of Time—*in other words, having one leg in a popular field and one in a specialized field.*

Yes, I realized early on I couldn't live without both fields. It isn't made quite clear in Calvin Tomkins' article [in *The New Yorker*], but early on, when I was at UCLA, I kept this small gallery—Syndell Studio—which was like a very discreet laboratory. I didn't care if four or five people came, as long as there were two or three that were really engaged. I met any number of interesting people that way.

We had only one or two reviews written in all the years it was there. It didn't matter. But, at the same time, I felt compelled to do this show of the new California expressionists in a very public place—in an amusement park on the Santa Monica pier …

Was this the Action *exhibition?*

Action 1—in a merry-go-round building. It was near Muscle Beach. It attracted the most totally inclusive mix of people— Mom, Dad, and the kids, and Neal Cassady, and other strange characters, and the patrons of a transvestite bar nearby. I got Ginsberg, Kerouac, and those people to attend. It's

amazing they came. Critics I'd never met before showed up. It had a big attendance. So I wanted to work, as it turns out, both ways.

You can see this clearly in the most extreme show I've done in recent years, *The Automobile and Culture*—at MoCA, in downtown LA, in the early 1980s. It later went to Detroit. Paul Schimmel and I came up with the absurd premise. I owe the title to Pontus Hultén. What I was talking about doing was looking at the history of the automobile, from the late 19th century to the present—beautiful and interesting and important cars, no trucks, no motorcycles, just cars—as a kind of quotidian device and fetishistic emblem of cultural life in the 20th century. The automobile had its own aesthetic and its own engineering imperatives. I wanted to see that in a fresh survey of 20th-century art—in cases where the automobile becomes part of the subject matter and in other cases where I think the kind of mobility the car provides influences the art.

So, as you can imagine, it was a crazy show. When you start looking for these references—arcane and goofy but perfectly wonderful things—other things turn up. There's an early Matisse in the show, a portrait of Madame Matisse sitting in the front seat of the car, looking through the windshield.

He composed the whole painting as a horizontal structure, based on the kind of horizontal windshields cars had in the 1920s. I had a wonderful picture by Alfred Stieglitz—a cityscape of old New York—where two things suggest the coming of Modernism. One is the steel frame of a skyscraper going up, and here, coming down the street, is a very early automobile—the first picture Stieglitz ever took that has an automobile in it.

I was very serious and intrigued with that 1984 show. But the local critics didn't care for it much—the local critic here in Los Angeles.

Did it bring a non-specialized audience to the museum?

It was very, very popular. People who would never come down to look at modern art were there.

Your first gallery, the Syndell Studio, was an almost-private venue.

Action 1 and Action 2, on the other hand, were very public venues. What about the Ferus Gallery? Was it a more in-between place for artists?

It was relatively more private, but less so than Syndell. Ferus was a complicated thing, in that when Kienholz and I ran it as partners from 1957 to 1958 we did it in our own clean, but bohemian, way. We did it just the way we wanted. We didn't care whether we sold work or not. I had enough money to pay the rent. But a number of the artists we represented started getting impatient—they wanted more material success. So the later history of Ferus, after 1958—when I hired Irving Blum to be director—well, I didn't compromise the kind of art, but it was meant to be more conventionally economic. I had no idea what the gross sales would have been at the old Ferus Gallery for a year—maybe $5,000, if that? In about eight months of the first year of the new Ferus, we'd sold $120,000 worth of art. But it was a thoroughly commercial enterprise at that point.

So at first the idea was to create a platform?

That's right. I mean, we could show this wonderful woman, Jay DeFeo, when there wasn't anyone to buy her work. Now she's in the Beat show at the Whitney. She's a heroine, and deservedly so. The style of the first Ferus was to resemble what an artist's working studio was like—or a salon that artists would run themselves, although they didn't. Kienholz could be ruthless with other artists; he was a taskmaster. I was never as blunt as he was. Sometimes he would cancel a show if he didn't think the work looked good enough. He would just say: "C'mon, get to work—let's see something better. We're not going to show junk. It's not good for you, it's not good for us." The first Ferus looked as though it didn't care whether it was successful or not. Somehow clients could tell that. People came to it like it was a little Kunsthalle.

The second one, with Blum, took exactly the opposite tack—it was to look very well-to-do, as if it were doing successful business—whether we were or not. And, I tell you, that approach works. It does work.

So at the beginning it was almost like an artists' collective?

Right. The solidarity between the artists was very strong. That's the positive side. The negative side, by the way, is that the artists felt they had a ruthless say over who else would be part of the enterprise.

Robert Irwin, for example, was an artist who wasn't with Ferus in the beginning, and his work was kind of weak—very lyric, easygoing, a not very powerful version of Diebenkorn. He was a conventional abstract lyric painter; his paintings weren't bad, but they were of no particular distinction. He desperately wanted to be shown by Ferus, but there wasn't a single artist in the Ferus Gallery—around Los Angeles, anyway—who wanted him in there.

I was president of the corporation. Being with him and looking at what he was up to—hearing what he was thinking about—I knew something was going to come of him. But a tyranny of the majority would have prevented it. So there are times when you just have to risk losing everyone's good opinion and sort of ram it down their throats—that was one. So I just, by sheer will, forced an Irwin show in there. And he turned out to be quite an important artist, obviously. He knocked himself out with his first show trying to do the work. It owed a lot to Clyfford Still—it was a transition. And by his second show, things got different very quickly.

At Ferus there was the idea that you did everything yourself. Harald Szeemann once defined the functions of the Ausstellungsmacher—*the one who puts on an exhibition—as an administrator, amateur, author of introductions, librarian, manager and accountant, animator, conservator, financier, and diplomat. This list can be expanded by adding the functions of the guard, the transporter, the communicator, and the researcher.*

That's absolutely true. I'll tell you the worst thing I ever had to do. From time to time—maybe once a year—we would do a historical show. Nobody was showing Josef Albers in California, so we showed Albers. Prior to that we did a joint show of Kurt Schwitters' collages and Jasper Johns' sculpture. Anyway, one of the painters I loved—and I realized that a number of the artists, including Irwin, also really loved him— was Giorgio Morandi. No one was showing Morandi in the Western United States. I had been traveling, and I came back and discovered that Blum had not put an image of Morandi

on the invitation. I was really furious. I said, "One in the thousand people who get our invitation will even know who Giorgio Morandi is. We've got to have one of his drawings on this invitation."

Well, he hadn't had a photographer come in to take a picture. I said: "Clear this desk off. I'm going in the back and choosing a drawing." I picked out a Morandi drawing that was strong enough—it had glass over it—and I laid it down on the table. I took a piece of paper and laid it over the glass, took a soft pencil—and I'm not an artist; Blum would have been better, because he can draw—and I traced out that Morandi drawing, to life size, in my own crude version. Traced the son of a bitch out on a blank piece of paper, and I said: "There's the artwork."

Blum said: "You can't do that. You've just made a fake Morandi."

I said: "You watch me do it. You just watch me do it." And that went to the printer, so it's printed in red with its line cut very elegantly on a paper. We waited to see who would identify it as a fake. Never—no one, no one. Szeemann is right—there's no telling what you'll have to do.

Certainly, in a small place like Ferus, you got used to doing everything yourself. Soon afterward, in 1962, you began curating and directing the museum in Pasadena. With only a few employees, you succeeded in doing an amazing number of exhibitions, 12 or 14 a year. You must have worked with enormous efficiency in such a small operation. You did big shows on Cornell, Duchamp, Jasper Johns, and so on—in a very short time.

Yeah. You have to be energetic and have good people. Sometimes the measures are extreme.

And the museum was also a very small structure, wasn't it?

The building was small enough to manage. It was like a square, symmetrical doughnut. There were larger rooms, and a garden in the center. A curious building. The design was fake-Chinese, like Grauman's Chinese Theatre. But there were these rooms strung together. There were walkways through the gardens. All on one floor. The second floor didn't have galleries. But somehow these separate rooms, with the garden

in the middle, were very pleasing to people—it worked very nicely.

What about the staff?

We almost never had more than three or four people physically installing a show. The hours were terrible. Somehow we were able to get some very grand shows—with Kandinsky and Paul Klee and so on. And that would mean extra people working pretty long hours to get it all straight. You couldn't do it today. Nobody would allow artists to come in and help you handle Kandinskys. I've never had better workers. You know, with a little training, they care very much for the work.

At this time there was also your pre-Pop exhibition?

Oh, yes—*New Paintings of Common Objects.*

How did this show come about?

Just seeing the work—I had been seeing the work and was determined to do it. The word "Pop" was already in use in England, and was just beginning to be used in America. But I associated the word with the English movement, so I wanted something very bland and dry. I didn't want to use the word. There were three East Coast artists—Andy Warhol, Roy Lichtenstein, and Jim Dine—and three West Coast artists—Ed Ruscha, Joe Goode, and Wayne Thiebaud. I asked Ruscha, who did design work, what to do for a poster. He said: "Well, let's do it right now. Here, let me sit down and use your phone. What are all our names? Write 'em out in alphabetical order. Here are the dates, and that's your title— fine. That's all I need to know."

　　And he called up a poster place. I said: "What are you calling?" He said: "This place does prize-fighting posters." He went to a Pop, mass-produced poster place. He got on the phone and said: "I need a poster"—and he knew the size— and he just read it off on the phone. The guy saw no layout or anything—he just read it off. And then I heard Ruscha say, "Make it loud. And we want this many." I gave him a number, they quoted a price. And he said: "Yeah, these folks are good for it," and he hung up.

And I said: "Why the hell did you say, 'Make it loud'?"
He said: "Well, after you give the guy the size, the copy, and
how many you want, he wants to know the style." And I said:
"That's all you said for style?" He said: "Those guys, that's all
they want to hear—make it loud." It was perfect. The poster
was done in yellow, red, and black, and very loud. It was the
most important poster that museum had ever done, with one
exception—the poster Duchamp designed for his show.

In 1919, Duchamp was one of the first artists to use instructions. He
sent his sister in Paris a telegram for his Ready-made malheureux,
to realize the piece on the balcony. Moholy-Nagy was the first artist
to do a piece by transmitting instructions over the phone.

Absolutely—just called it in. Sometimes the best solution is
the easiest one—if you know what to do.

If one looks at the museum situation now, creating small structures
with flexible spaces seems to be of most importance.

Somewhere in the 1970s in America—and in Europe, too—
the idea of the smaller, more independent Kunsthalle arose.
In America, it was the so-called artist's space—that whole
phenomenon.

Which leads us back to the laboratory idea.

That's right. I hope the concept doesn't disappear. I hope
a breed of entrepreneurs will come along who aren't worried
about being chic or fashionable and will keep some of that
alive. One damn way or another, some version of that idea has
always been around. We don't have the salon now; we don't
have the big competitive shows in smaller cities, you know?
They don't mean much anymore. Most serious artists don't
submit to those. In a sad way, the old salon is dead.
 I've been waiting for some breed of artist—some
terrible little ancestor of Andy Warhol or whatever—to put
out a mail-order catalogue of his or her work independently
of the galleries. Whether it's printed matter or it ends up
on the Web, people, without even using galleries, can find
interested patrons. This was the thrust of what the East
Village was all about. They had artist-entrepreneurs there.

Never in SoHo. This market appeared, then died down again, but I think it could happen again.

I really believe—and, obviously, hope for—radical, or arbitrary, presentations, where cross-cultural and cross-temporal considerations are extreme, out of all the artifacts we have. If you look at the Menil, with its range of interests—everything is quite manicured and segregated out. But there are some larger areas of juxtaposition as well. We have our African section, right up against a very small section of Egyptian art. But Egypt interposes—you can't get into the Central and Western European section, or to Greco-Roman culture, from Africa without going through Egypt. It makes a kind of sense. So just in terms of people's priorities, conventional hierarchies begin to shift some. But I mean beyond that—where special presentations can jump around in time and space, in ways we just don't do now. I really believe in these kinds of shows.

Pontus Hultén

Born in 1924 in Stockholm, where he died in 2006.

The interview was conducted in 1996 in Paris. It was first published in *Artforum*, New York, April, 1997, under the title "The Hang of It–Museum Director Pontus Hultén."

It was originally introduced by the following text:

Of Pontus Hultén, Niki de St Phalle once said "[he has] the soul of an artist, not of a museum director." Indeed Hultén always maintained a very special dialogue with artists, though he was not one himself, establishing lifelong friendships with Sam Francis, Jean Tinguely, and Niki de St Phalle, whose careers he not only followed but shaped from the start. The interactive, improvisational spirit that infused exhibitions like de St Phalle's *She*, 1966—a giant sculpture of a woman whose interior was fashioned by Tinguely and Per Olof Ultveldt—characterized the whole of Hultén's career. Director of the Moderna Museet for 15 years (1958–1973), Hultén defined the museum as an elastic and open space, hosting a plethora of activities within its walls: lectures, film series, concerts, and debates.

 Thanks to Hultén, Stockholm became in the 1960s a capital for the arts, the Moderna Museet one of the most dynamic institutions for contemporary art. During his tenure, the museum played a seminal role in bridging the gap between Europe and America. In 1962, Hultén organized a show of four young American painters (Jasper Johns, Alfred Leslie, Robert Rauschenberg, Richard Stankiewicz), followed two years later by one of the first European surveys of American Pop art. In return, Hultén was invited to organize a show at New York's Museum of Modern Art in 1968: his first historical and interdisciplinary show, it explored the machine in art, photography, and industrial design.

 In 1973 Hultén was to leave Stockholm and enter one of the most significant periods of his career. As founding director of the new museum of modern art at the Centre Georges Pompidou, which opened in 1977, Hultén organized large-scale shows that examined the making of art's history in this century's cultural capitals: *Paris–Berlin, Paris–Moscow, Paris–New York*, and *Paris–Paris* included not only art objects that ranged from Constructivist to Pop, but films, posters, documentation, and reconstructions of exhibitions spaces such as Gertrude Stein's salon. Multivalent and interdisciplinary, these shows marked a paradigm shift in exhibition making, entering the collective memory of generations of artists, curators, and critics as few others have.

 Hultén's career after Beaubourg reflected the same commitment to working with artists that have caused so many to remember him fondly. Invited by Robert Irwin and Sam Francis to establish a museum in Los Angeles (LA MoCA) in 1980, Hultén went, and, after four years of infrequent exhibitions and much fundraising, returned to Europe. From 1984–1990, he was in charge of Venice's Palazzo Grassi, and in 1985, he founded, along with Daniel Buren, Serge Fauchereau, and Sarkis, the Institut des Hautes Etudes en Arts Plastiques in Paris, which Hultén described as a cross between the Bauhaus and Black Mountain College.

 Artistic director of the Kunst- und Ausstellungshalle, Bonn, from 1991–1995, he now heads the Jean Tinguely museum in Basel, Switzerland, where he curated the inaugural exhibition. Currently writing his memoirs and a book on his years at Beaubourg, Hultén met with me in his Paris apartment to talk about his lifework at the center of the art world.

HUO *Jean Tinguely always said you should have been an artist. How did you end up running a museum?*

PH In Paris, where I was writing my dissertation, I met Tinguely, Robert Breer, and some other artists who urged me to take up art making. I resisted this idea, but did make some films with Breer, who worked as an animator, and also some objects with Tinguely. To tell the truth, if I had had a chance to become a film director, I wouldn't have hesitated. Though I managed to make some short films, I realized that the mid-1950s wasn't a very good time to try and make features. I made a 25-minute film with a friend, but it was a great failure because the producer released it with the wrong feature film. It got some prizes, though, in Brussels and New York. I wrote a second screenplay, which I wasn't even able to finance. It was at that point that I was offered the job of creating a national museum of modern art in Sweden.

Before you were put in charge of this museum, the Moderna Museet in Stockholm, you'd been organizing exhibitions for several years on your own.

Yes. In fact, in the early 1950s, I started curating shows at a tiny gallery that consisted of two small spaces, about 100-square meters each. Curiously enough, it was called The Collector [Samlaren, Stockholm]. The owner, Agnes Widlund, who was Hungarian, had invited me to do shows there, and she basically gave me *carte blanche*. I put together exhibitions with friends around themes that interested us. We did a big exhibition on Neo-Plasticism in 1951. Things were infinitely easier then. Paintings didn't have the value they do today. You could bring a Mondrian to the gallery in a taxicab.

One of your shows, held in a bookstore in 1960, was of Marcel Duchamp's work.

I had done another one with pieces of his in 1956, but it wasn't a solo show. I'd been fascinated with Duchamp since I was a teenager. He marked me very deeply. At the bookstore, we did a small show—we didn't even have a *Box-in-a-Valise* (1941–1968), but managed to come up with replicas. Duchamp later signed everything. He loved the idea that an artwork could be repeated. He hated "original" artworks with prices to match. I had met Duchamp in Paris in 1954, I think. At that time, he gave an interview in an art journal in which he discussed his notion of "retinal art," of art made only for the eye and not for the mind. It had tremendous impact; people were really hurt. The painter Richard Mortensen, who was a friend of mine, was really shattered. He had misgivings about his own work that he couldn't express or wouldn't accept. Then Duchamp put this idea out on the table, just like that, and it was as if someone had lifted the veil. I still have Mortensen's letter.

Walter Hopps told me that in the United States in the 1950s, Duchamp was known mainly to artists, not to the general public. What about in Europe?

Duchamp was much appreciated by artists because they could steal from him without risk of discovery, since he was

almost unknown. At that time, Duchamp's work had been forgotten, despite [André] Breton's praise of him in the heyday of Surrealism and again after the war. It was in many people's interest for Duchamp's work to remain unknown. For obvious reasons, this was especially the case for important gallerists. But he made a comeback—it was inevitable.

It was at Denise René's Paris gallery that you organized an exhibition of Swedish art in 1953?

Yes. I used to go to the gallery a lot. It was one of the few places in Paris that was lively. We would gather there and talk about art every day.

It sounds rather like the kind of forum created by the Surrealist magazine Littérature.

Unlike the Surrealists, we didn't expel anyone, but all the same, our discussions were infected by politics. There were great debates about how to deal with Stalinism and with capitalism. Some people seemed to think Trotskyism represented a viable alternative. There were people like Jean Dewasne (considered at the time to be a young Vasarely) who tended to take the communists' side. He was practically excluded from our circle. Eventually he left the gallery. We also engaged in numerous debates about abstraction, which were central to our discussions. Sometimes the great Modernist figures would come by, like Alexander Calder when he was in Paris, or Auguste Herbin, Jean Arp, and Sonia Delaunay. It was very exciting to meet them.

Were there other significant galleries?

There were two galleries then. Denise René was by then the most important one. She was wise enough to show not just the abstract "avant-garde," but also Picasso and Max Ernst. Then there was Galerie Arnaud, on the Rue du Four, which basically showed lyrical abstraction. Jean-Robert Arnaud had a journal called *Cimaise*, it was where I first encountered Tinguely's work. His art was shown in the gallery's bookshop. Gallery bookshops were a way of exhibiting the work of young artists without making a financial commitment. You

have to understand how differently galleries operated then.
Prestigious spaces usually showed artists with whom they
had contracts.

Didn't Alexandre Jolas also run a gallery?

Yes, a few years later. In his own way, he was much wilder.
I couldn't say whether or not he provided artists with stipends
—Denise René's artists got serious money. With Alexandre,
things changed a lot. There was a kind of looseness that mir-
rored life in the 1960s.

*During your early years as a museum director in Stockholm you
combined various art forms—dance, theater, film, painting, and so on.
Later this approach became central to your large-scale exhibitions,
first in New York and then in Paris, Los Angeles, and Venice. How
did you settle on this working method?*

I discovered that artists like Duchamp and Max Ernst had
made films, written a lot, and done theater, and it seemed
completely natural to me to mirror this interdisciplinary
aspect of their work in museum shows of any number of
artists, as I did several times, but particularly in *Art in Motion*
in 1961 (Moderna Museet, Stockholm). One person who in-
fluenced me greatly was Peter Weiss, who was a close friend
of mine and was known primarily for his plays such as *Marat/
Sade* (1963) and his three-volume treatise *Aesthetic of Resistance*
[*Die Asthetik des Widerstands*, I–1975, II–1978, III–1981]. Peter
was a filmmaker in addition to being a writer; he also painted
and made collages. All of that was perfectly natural; for him
it was all the same thing. So when Robert Bordaz—the first
president of the Centre Pompidou in Paris—asked me to
create shows that combined theater, dance, film, painting,
and so on, I had no trouble doing so.

*Looking at your program in Stockholm in the 1950s and 1960s, you
put on an impressive number of exhibitions despite very modest budgets.
It reminds me of what Alexander Dorner, director of the Landesmusem,
Hannover, from 1923 to 1936, said—that museums should be
Kraftwerke, dynamic powerhouses, capable of spontaneous change.*

That level of activity was quite natural, and corresponded to

a need. People were capable of coming to the museum every evening; they were ready to absorb everything we could show them. There were times when there was something on every night. We had many friends who were working in music, dance, and theater, for whom the museum represented the only available space, since opera houses and theaters were out of the question—their work was viewed as too "experimental." So interdisciplinarity came about all by itself. The museum became a meeting ground for an entire generation.

The museum was a place to spend time in, a place that actually encouraged the public to participate?

A museum director's first task is to create a public—not just to do great shows, but to create an audience that trusts the institution. People don't come just because it's Robert Rauschenberg, but because what's in the museum is usually interesting. That's where the French *Maisons de la Culture* went wrong. They were really run like galleries, whereas an institution must create its public.

When a museum lives through a great moment, it often becomes linked to a particular person. When people went to Stockholm, they talked of going to Hultén's; when they went to Amsterdam, of going to Sandberg's.

That's certainly true and it leads me to another issue. The institution shouldn't be completely identified with its director; it's not good for the museum. Willem Sandberg knew this quite well. He asked me, as well as others, to do things at the Stedelijk [Stedelijk Museum, Amsterdam], and he would remain on the sidelines. For an institution to be identified with only one person isn't a good thing. When it breaks down, it breaks down completely. What counts is *trust*. You need trust if you want to present the work of artists who are not well known, as was the case when we first showed Rauschenberg's work (part of an exhibition of four young American artists) at the Moderna Museet. Though people didn't yet know who he was, they came anyway. But you can't fool around with quality. If you do things for the sake of convenience, or because you're forced to do something you don't agree with, you've got to make the public believe in you all over again. You can show something weak once in a

while, but not often.

What were the points of departure for the shows on artistic exchanges that you organized at the Pompidou: Paris–New York, Paris–Berlin, Paris–Moscow, *and* Paris–Paris? *Why do you think they were so successful?*

I had proposed the *Paris–New York* show to the Guggenheim in the 1960s, but I hadn't received a response. When I started at the Centre Georges Pompidou, I had to establish a program for the next several years. *Paris–New York* brought together the people from the Musée national d'art moderne and those from various other departments—it was multidisciplinary. I should have taken out a patent on the formula that allowed me to unify so many different teams at the Pompidou; this approach later became very popular. The library also participated: in the *Paris–New York* show, their section was separate; in *Paris–Berlin* everything was part of one space. With these four shows, I was also attempting to make a complex, thematic exhibition easy to follow—to be straightforward yet to raise many issues. *Paris–Moscow*, for instance, reflected the beginnings of Glasnost before the West knew any such thing existed.

Why did you choose to stress the relationship between east and west, rather than north and south?

Strangely enough, the east-west axis seemed less familiar at the time. I came up with the exhibition trilogy *Paris–New York*, *Paris–Berlin*, and *Paris–Moscow* to address the exchange between various cultural capitals in the west and those in the east. *Paris–New York* began with reconstructions of Gertrude Stein's famous salon, Mondrian's New York studio, and Peggy Guggenheim's gallery, Art of this Century, and ended with Art Informel, Fluxus, and Pop art. *Paris–Berlin, 1900–1933* was confined to the period before National Socialism, and provided a panoramic view of cultural life in the Weimar Republic —art, theater, literature, film, architecture, design, and music. For *Paris–Moscow, 1900–1930*, thanks to a period of détente in French-Soviet relations, I was able to assemble works produced by numerous French artists showing in Moscow before the October Revolution, as well as Constructivist, Suprematist, and even some Social Realist artworks.

The groundwork for the *Paris–New York* show and the
shows that followed had been done before the Pompidou
even opened. In the late 1970s, it was considered odd to buy
American art. Thanks to Dominique de Menil and her dona-
tions of works by Pollock and other American artists, American
paintings became part of Beaubourg's collection. Before I
mounted the first show in this series, I felt it was necessary to
give the museum audience some historical background. In
addition to major retrospectives of Max Ernst, André Masson,
and Francis Picabia at the Grand Palais, I organized a big
Vladimir Mayakovsky show at CNAC [Centre National d'Art
Contemporain], the space on Rue Berryer near Place de
l'Etoile. We redid Mayakovsky's show from 1930, which he
had organized in hopes of providing a multifaceted portrait of
himself; shortly after, he committed suicide. For that show,
Roman Cieslewicz did the graphic design and he also did
the covers for the catalogues for *Paris–Berlin*, *Paris–Moscow*,
and *Paris–Paris*. But for *Paris–New York*, Larry Rivers did the
cover. Those four big catalogues, which were sold out for a
long time, were recently reissued in a smaller format. With
that series we succeeded in establishing a good relationship
with the public, because we also made conscious attempts
to prepare our audience. The Centre Pompidou was embraced
by the public because they felt it was for them, and not for
the conservators. Conservator—what a terrible word!

*I agree. Who were the curators, for lack of a better term, with whom
you spoke most frequently in the 1950s and 1960s?*

Sandberg at the Stedelijk in Amsterdam, Knud Jensen at the
Louisiana in Denmark, and Robert Giron in Brussels; once I
even did a show with Jean Cassou on the paintings of August
Strindberg at the Musée national d'art moderne. Sandberg
and Alfred Barr—at MoMA—created the blueprint; they ran
the best museums in the 1950s. I got close to Sandberg. He
came to see me in Sweden, and we got on very well. He kind
of adopted me, but our friendship ended on a rather sour
note. He wanted me to take over from him in Amsterdam, but
my wife didn't want to move, so I decided not to.

*A few years later you got an offer to do an exhibition at MoMA in
New York.*

The Stedelijk adventure was over in 1962; the offer to work for MoMA came in 1967. MoMA and the Stedelijk were quite different. In New York, the structure was less open, more academic. It was more compartmentalized than at the Stedelijk, where Sandberg had succeeded in creating a fluid, lively structure. MoMA was relatively conservative because of the source of its financial support—wealthy donors. The Stedelijk had a different kind of freedom, because Sandberg was, essentially, a city employee; he could make policy as he saw fit. All he had to do was convince the mayor of Amsterdam. Catalogues, for instance, were absolutely his domain.

*You also put a lot of energy into your catalogues. Last year the university library in Bonn organized an impressive retrospective of about 50 of your publications [*Das gedruckte Museum: Kunstausstellungen und ihre Bücher, 1953–1996, *Universitäts und Landesbibliothek Bonn, 1996* (The Printed Museum of Pontus Hultén)]. *Many of them seemed like extensions of your exhibitions. And some of them were really art objects in themselves: the Blandaren box from 1954–1955 had lots of artists' multiples, or that fabulous catalogue in the form of a suitcase for the Tinguely show in Stockholm in 1972 (Jean Tinguely, Moderna Museet, Stockholm, 1972). You also invented the encyclopedic catalogue: 500-1000-page volumes for the* Paris–New York, Paris–Berlin, Paris–Moscow, *and* Paris–Paris *shows that have since become so common. So catalogues and books would seem to play a preeminent role for you as well.*

Yes, but not as much as for Sandberg. It was from his idea of being part of the exhibition. He had his own style that he used for all his exhibitions. I am more in favor of diversification.

Sandberg hosted Dylaby (Dylaby—A Dynamic Labyrinth) *in Amsterdam's Stedelijk Museum in 1962, and in 1966 you organized the even more interactive project* Hon (She—A Cathedral) *in Stockholm, a monumental reclining* Nana, *28 meters long, nine meters wide, and six meters high. Could you say a bit about your collective adventure with Tinguely, Niki de St Phalle, and Per Olof Ultvedt?*

In 1961 and 1962 I had numerous discussions with Sandberg about doing an exhibition of site-specific installations created by several artists. He accepted, and *Dylaby* opened in Amsterdam in 1962. After that, I wanted to do something

even more collaborative, with several artists working together on one large piece. Over the years, the project had several names: *Total Art*, *Vive la Liberté*, and *The Emperor's New Clothes*. In the early spring of 1966, I finally managed to bring Jean Tinguely and Niki de St Phalle to Stockholm to work with the Swedish artist Per Olof Ultvedt and myself. Martial Raysse withdrew at the last minute—he'd been selected for the French pavilion at the Venice Biennale. The idea was that there would be no preparation; nobody would have a particular project in mind. We spent the first day discussing how to put together a series of "stations," as in Stations of the Cross. The next day we started to build the station "Women Take Power." It didn't work. I was desperate. At lunch I suggested we build a woman lying on her back, inside of which would be several installations. You would enter through her sex. Everyone was very enthusiastic. We managed to finish her in five weeks, inside and outside. She was 28 meters long and about nine meters high. Inside there was a milk-bar, in the right breast; a planetarium showing the Milky Way in the left breast; a mechanical man watching TV in her heart; a movie-house showing a Greta Garbo film in her arm; and an art gallery with fake old masters in one leg. The day of the press preview, we were exhausted; the next day, there was nothing in the newspapers. Then *Time* wrote a favorable piece and everybody liked her. As Marshall McLuhan said, "Art is anything you can get away with." The piece seemed to correspond to something in the air, to the much-vaunted "sexual liberation" of that time.

In 1968 you put together a big exhibition at MoMA, The Machine as Seen at the End of the Mechanical Age. *What was its premise?*

MoMA had asked me to put together an exhibition on kinetic art. I told Alfred Barr that the subject was too vast, and instead proposed a more critical and thematic exhibit on the machine. The machine was central to much of the art of the 1960s, and at the same time, it was obvious that the mechanical age was coming to an end, that the world was about to enter a new phase. My exhibition began with Leonardo da Vinci's sketches of flying machines and ended with pieces by Nam June Paik and Tinguely. It included over 200 sculptures, constructions, paintings, and collages. We also put together a

film program. Tinguely was really in love with machines, with mechanisms of any kind. He had had his breakthrough on March 17, 1960, with *Hommage à New York*—a self-destroying artwork. Richard Huelsenbeck, Duchamp, and myself had written for the catalogue at the time and Tinguely wanted to bring his friends Yves Klein and Raymond Hains with him to New York in 1960, but somehow it never happened.

Your machine show could be thought of as a requiem to L'Homme-machine *(1748), the famous book by the 18th-century philosopher [Julien Offray de] La Mettrie, about the machine age.*

Yes—as its culmination. It was also the height of MoMA's golden age, a period when Alfred Barr was there and René d'Harnoncourt was director of the museum.

Why was it so wonderful?

They were both great men. For one thing, no one ever mentioned the word "budget." Today it's the first word you hear. There were all kinds of possibilities. When, at the 11th hour, we had to get one of Buckminster Fuller's Dymaxion cars from Texas, they said "Boy, that costs a lot of money," but we got it. This was the last great exhibition of that period at MoMA. René d'Harnoncourt died in an accident shortly before the machine show opened, and Alfred Barr had retired the year before.

*Though there were numerous exchanges between Stockholm and the United States during your tenure at the Moderna Museet, you were the first to do big one-person shows in Europe with Claes Oldenburg and Andy Warhol. What about the Pop art show at the Moderna Museet in Stockholm [*Amerikansk POPKonst *(American Pop Art), 1964]; wasn't it the first survey show of American Pop art in Europe?*

One of them. After my visit to New York in 1959, I curated two Pop art exhibitions. The first was in 1962 with Robert Rauschenberg, Jasper Johns, and others (*Four Americans*, Moderna Museet, Stockholm, 1962). The second part was in 1964, with the second generation: Claes Oldenburg, Andy Warhol, Roy Lichtenstein, George Segal, James Rosenquist, Jim Dine, and Tom Wesselmann.

*One of your links to the United States was the electrical engineer
Billy Klüver.*

Billy was a research scientist at Bell Labs. In 1959, I came
to New York and I started to give Billy a crash course in
contemporary art; he generously accepted to act as a liaison
between the Moderna Museet and American artists. Lots of
artists needed technology. Billy started EAT (Experiments in
Art and Technology) with Rauschenberg, Robert Whitman,
and Fred Waldhauer, a collaborative effort that came to a bad
end. Pepsi-Cola had commissioned them to do the youth
pavilion at the World's Fair in Osaka (Expo 70, Osaka) where
they enclosed a dome-shaped pavilion in a cloud sculpture
by Fujiko Nakaya. In a way it came from an idea of [John]
Cage's, that a work of art could be like a musical instrument.
When the pavilion was finished, Billy insisted on doing some
live musical programming. After a month, after three or
four artists had performed, Pepsi-Cola took over the project—
they wanted automated programming.

What was the art scene like in Sweden in the 1960s?

It was very open and generous. The great art star was Oyvind
Fahlström, who died very young, in 1977. I did three shows
of Swedish art later in my career: *Pentacle*, at the Musée des
Arts Décoratifs in Paris, 1968, a show of five contemporary
artists; *Alternatives Suédoises*, at the Musée d'Art moderne de
la Ville de Paris, in 1971, which focused on Swedish art and
life in the early 1970s; and a big show, *Sleeping Beauty*, at New
York's Guggenheim Museum in 1982 that included two retro-
spectives—one of Asger Jorn, the other of Fahlström—and
occupied the entire museum.

*Many exhibitions you organized in the 1960s didn't privilege the
artwork as such. Documentation and participation in various forms
became equally important. How come?*

Documentation was something we found very exciting! It
was in the spirit of Duchamp's different boxes. We began
seriously buying books, like Tristan Tzara's library. There was
also another dimension: the museum workshops became
an important part of our artistic activities. We reconstructed

[Vladimir] Tatlin's *Tower* in 1968, using the museum's own carpenters, not specialists brought in from the outside. This approach to installing exhibitions began to create a phenomenal collective spirit—we could put up a new show in five days. That energy helped protect us when hard times came at the end of the 1960s. After 1968, things got rather murky— the cultural climate was a sad mixture of conservatism and fishy leftist ideologies—museums were vulnerable, but we also withstood the tempest by doing more research-oriented projects.

You also did political shows like Poetry Must Be Made by All! Transform the World! *in 1969 (Moderna Museet, Stockholm), borrowing a sentence from Lautréamont, which was an attempt to link revolutionary parties to avant-garde artistic practices. It included almost no originals, and a wall on which local organizations could affix documents stating their principles and goals. How was that show organized?*

It was divided into five different sections: "Dada in Paris," "Ritual Celebrations of the Iatmul Tribe of New Guinea," "Russian Art, 1917–15," "Surrealist Utopias," "Parisian Graffiti, May '68." It was about the changing world. It consisted principally of models and photographic reproductions mounted on aluminum panels. We used teams made up of people who served various functions at the museum; they acted as animators or technicians. It was like a big family, everyone helped each other out. Things were very different then. At the time there were lots of volunteers, mostly artists who helped install the work.

Another of your famous exhibitions was Utopians and Visionaries 1871–1981 *(Moderna Museet, Stockholm, 1971), which began with the Paris Commune and concluded with contemporary utopias.*

It was even more participatory than *Poetry Must Be Made by All!* Held two years later, *Utopians and Visionaries* was the first open-air exhibition of its kind. One of the sections was a 100th anniversary celebration of the Paris Commune, in which the work was grouped into five categories—work, money, school, the press, and community life—that reflected its goals. There was a printing facility in the museum—

people were invited to produce their own posters and prints. Photos and paintings were installed in trees. There was also a music school run by the great jazz musician Don Cherry, the father of Neneh Cherry. We built one of Buckminster Fuller's geodesic domes in our workshops and had a great time doing it. A telex enabled visitors to pose questions to people in Bombay, Tokyo, and New York. Each participant had to describe his vision of the future, of what the world would be like in 1981.

Poetry Must Be Made By All!, Transform the World!, *and* Utopians and Visionaries *were forerunners of many exhibitions of the 1990s that also emphasize direct audience participation.*

In addition to the shows themselves, we organized a series of evenings at the Moderna Museet that took things pretty far. During *Poetry Must Be Made By All!* Vietnam draft-dodgers and soldiers who had gone AWOL (Absent Without Official Leave), as well as the Black Panthers, came to test how open we really were. There was a support committee for the Panthers that held meetings in a room set aside for public use. For these activities, we were accused by parliament of using public money to form a revolution.

Talking about these shows reminds me of your famous plans for the Kulturhuset, Stockholm. It has been described as a cross between a laboratory, a studio, a workshop, a theater, and a museum—and in a certain sense as the seed out of which the Pompidou grew.

That's not far from the truth. In 1967, we worked on Kulturhuset for the city of Stockholm. The participation of the public was to be more direct, more intense, and more hands-on than ever before, that is, we wanted to develop workshops where the public could participate directly, could discuss, for example, how something new was dealt with by the press —these would be places for the criticism of everyday life. It was to be a more revolutionary Centre Pompidou, in a city much smaller than Paris. Beaubourg is also a product of 1968—1968 as seen by Georges Pompidou.

In your plans for the Kulturhuset, each floor was accorded one function. How could multidisciplinarity and interactivity have been promoted

in an institution structured that way?

It was designed so that as you went up a floor, what you encountered was more complex than what was on the previous floor. The ground floor was to be completely open, filled with raw information, news; we were planning on having news coming in from all the wire services on a telex. The other floors were to house temporary exhibitions and a restaurant; the latter is really important because people need somewhere to congregate. On the fifth floor we were going to show the collection. Unfortunately the Kulturhuset went awry, and the politicians and parliament took over the building for themselves. But the work I did conceiving that project proved to be a useful preparation for my work at the Pompidou.

What about the On Kawara show you brought to the Pompidou in 1977 in collaboration with Kasper König?

I had met On Kawara in Stockholm; he was living in an apartment owned by the Moderna Museet, and he stayed for almost a year. We became friends. I have always thought On Kawara was one of the most important Conceptual artists. The show included all the paintings he had done that year. There was absolutely no reaction on the part of the French press—not a single article!

How do you see the Pompidou today?

I don't go there very often. I once made the mistake of going back as an adviser. I now no longer go back, as a principle.

How does a space like the Institute of Contemporary Arts in London, where they've always operated a bar, cinema, and exhibition spaces, compare with the multifaceted, interdisciplinary role you envisioned for the Kulturhuset in Stockholm?

I think a collection is absolutely fundamental. The failure of André Malraux's Maisons de la Culture can be traced to the fact that he was really aiming at theater. He wasn't thinking about how to build a museum, and that's why his cultural institution foundered. The collection is the backbone of an

institution; it allows it to survive a difficult moment—like when the director is fired. When Valéry Giscard d'Estaing became President, there were some rather strong-willed people who asked why the Pompidou was exposing itself to all these problems with donors. Why not just leave the collection in the Palais de Tokyo and build a Kunsthalle without a collection? There was lots of pressure to go in that direction. I managed to convince Robert Bordaz that that would be dangerous, and we saved the collection and the project.

So you are against the idea of separating collections from exhibitions?

Yes, otherwise the institution has no real foundation. Later, when I was director of the Kunst- und Ausstellungshalle in Bonn, I saw how fragile a space devoted to contemporary art could be. The day someone decides that it's too expensive, it's all over. Everything is lost, almost without a trace. There'll be a few catalogues, and that's it. The vulnerability of it all is terrifying. But that's not the only reason I talk about collections with such passion. It's because I think the encounter between the collection and the temporary exhibition is an enriching experience. To see an On Kawara show and then to visit the collection produces an experience that is more than the sum of its parts. There's a curious sort of current that starts to flow—that's the real reason for a collection. A collection isn't a shelter into which to retreat, it's a source of energy for the curator as much as the visitor.

You've always insisted on the importance of a serious scholarly monograph to accompany an exhibition. This seemed especially important in the 1980s when you mounted an impressive series of retrospectives of artists who had meant a lot to you over the years.

Yes, it was wonderful to have the opportunity to do so. I loved Tinguely's retrospective in Venice at the Palazzo Grassi and Sam Francis' retrospective in Bonn. Those shows were both developed in close dialogue with the artists and marked great moments in the history of my friendship with them.

What other exhibitions do you remember most fondly?

I did a show called *Futurismo & Futurismi* in 1986, which was

the first show in Italy dedicated to the Futurists (Palazzo Grassi, Venice). It was divided into three parts: Futurism's precursors, Futurism itself, and its influence on artistic production until 1930. The exhibition is considered a classic, thanks in part to the catalogue, which reproduced all the works shown, and included over 200 pages of documentation. 270,000 copies were sold. The [Giuseppe] Arcimboldo show we did was dedicated to the memory of Alfred Barr, which really upset the Italian press, who called him a "cocktail director." In 1993 I installed the Duchamp show at the Palazzo Grassi, grouping documents and works together in sections devoted to such topics as the readymade, the *Large Glass* (1915–1923), and the "portable museum."

What about Claes Oldenburg's great happening, Il Corso del Coltello *[The Knife's Course], at the Campo dell'Arsenale in Venice in 1985?*

Oldenburg does everything himself. The exhibition organizer becomes a kind of troubleshooter, but it was a great event. One of the main props of the performance, *Knife Ship*, 1985, is now at LA MoCA. I played the role of a boxer, Primo Sportycuss. He buys an ancient costume that combines St Theodore and a crocodile, with which he confronts the chimera of San Marco. Frank Gehry played a barber from Venice; Coosje van Bruggen played an American artist who discovers Europe. The whole thing went on for three nights and there was a lot of improvisation. We had a good time.

In 1980 you were asked to head the project to build a new contemporary art museum in Los Angeles, which became the LA MoCA. How did that get started?

A group of artists, including Sam Francis and Robert Irwin, wanted to start a contemporary art museum. The artists asked me to come and work with them. I got along very well with them, less well with the patrons; there was very little financial support. The first exhibition, in 1983, was called *The First Show*, and consisted of paintings and sculptures from 1940–1980, drawn from eight different collections. It was an effort to examine what it meant to collect art. I did a second show called *The Automobile and Culture* (1984), a survey of the

history of cars as objects and images that included 30 actual cars. I tried to raise money for four years. I finally had to leave because I was no longer practicing my profession. I had become a fundraiser instead of a museum director.

After you were back in Paris, you founded L'Institut des Hautes Etudes en Arts Plastiques, in 1985, a laboratory-school, with Daniel Buren. Can you tell me a little about this project?

It was a kind of café, a place where people could meet everyday, and where there was no real structure or authority figure. It grew out of a discussion I had with the mayor of Paris, Jacques Chirac. We nominated four professors: Buren, Sarkis, Serge Fauchereau, and myself. Including the time it took to put the "school" together, this project lasted ten years. Then the city of Paris suddenly decided to put an end to it. While it lasted, we invited artists, curators, architects, filmmakers, all of whom came. There were only 20 students per year and we were all together for a year. The "students" were all artists who had already finished art school; they were actually referred to as artists, not students. They each got a stipend. We did great things together—including going on an excursion to Leningrad where we did a site-specific show, and building a sculpture park in Taejon, South Korea. It was a great experience for me.

Who were some of your students?

Absalon, Chen Zhen, Patrick Corillon, Jan Svenungsson, among others.

What were your most significant exhibitions when you took the position at Bonn's Kunst- und Ausstellungshalle in 1991?

I opened with five shows, one of which was Niki de St Phalle's retrospective (1992); the other, *Territorium Artis* [*Territorium Artis. Schlüsselwerke der Kunst des 20. Jahrhunderts* (Territory Art. Key Works of the Art of the Twentieth Century), 1992], a show of key works that marked decisive stages in the history of 20th-century art. It ranged from Auguste Rodin and Michail Wrubel to Jeff Koons, Jenny Holzer, and Hans Haacke. I also did a Sam Francis retrospective, a show called *Moderna Museet*

Stockholm Comes to Bonn (*The Great Collections IV: Moderna Museet Stockholm comes to Bonn*, 1996), in which we showcased the Moderna Museet's collection, and a similar one with MoMA's collection (*The Great Collections I: The Museum of Modern Art, New York. From Cézanne to Pollock*, 1992).

From your perspective, what does the 1990s art world look like?

I see little coherence, something of a crisis. But also moments of great courage and, most importantly, an enormous general interest in art compared with when I started in the 1950s.

What are you working on at the moment?

The Museum Jean Tinguely in Basel, which has just opened. I'm also at work on a book about the beginnings of the Centre Pompidou called *Beaubourg de justesse* [*Beaubourg, Just About*]. And I'm writing my memoirs.

Johannes Cladders

Born in 1924 in Krefeld, Germany. Lives in Krefeld.

Johannes Cladders was the director of the Städtisches Museum Abteiberg in Mönchengladbach from 1967 to 1985. He was responsible for bringing Joseph Beuys and others to international attention and acclaim. In 1972 he collaborated on Documenta 5 in Kassel, Germany, and from 1982 to 1984 was the Commissioner of the German Pavilion at the Venice Biennale.

This interview was conducted in 1999 in Krefeld. It was previously published in *TRANS>*, no 9–10, New York 2001; reprinted in *Hans Ulrich Obrist, vol. I*, Charta, Milan 2003, p. 155; as well as in French in *L'effet papillon, 1989–2007*, JRP|Ringier, Zurich 2008, under the title "Entretien avec Johannes Cladders," p. 167.

Translated from the German by Christine Stotz and Pascale Willi.

HUO *How did everything start? How did you get into making exhibitions and what was your first one?*

JC I actually had a very conventional museum career as an assistant at the Kaiser Wilhelm Museum, as well as at the Museum Haus Lange, in Krefeld. Under the leadership of Paul Wember in the 1950s and early 1960s, it was the only institution in Germany that actually had the courage to show contemporary art. It was a marvelous education for me, and gave me the opportunity to make a lot of contacts with artists, especially with the Nouveaux Réalistes and all the Pop artists, who were very popular at the time. In 1967, the directorship of the Städtisches Museum Mönchengladbach became available and so I applied for it, and from that point on, I was able to realize my own ideas independently. The first exhibition was of Joseph Beuys. At that point, Beuys was around 46 years old and had never had a major museum retrospective.

And it hit like a bomb. Suddenly, the institution was known well beyond Mönchengladbach.

Was that already in the space where later exhibitions took place?

No, this was in a small provisional space in Bismarckstrasse. Actually, it was a private house that we used for exhibitions. From the start, my focus was always on the present—the immediate present—which I considered crucial to the development of art. This means that I never made any concessions to the taste of the public, or gave room to derivative art in any of the exhibitions I organized. After all, with all due respect to the work of artists, art must move forward! I always tried to discover where the innovative ideas were … where the new idea was coming from … in the sense that "art defines art." It was from this that I developed my program. The next exhibition—because finances were tight—meant finding opportunities closer to home. I showed the cardboard works of Erwin Heerich.

How did the catalogue boxes come about?

I made a virtue of necessity. The financial situation was not very good, and I only had a small budget, but I did not want to produce flimsy pamphlets. I wanted something for the bookshelf, something with volume. A box has volume. You can put all sorts of things into it that you have money to buy. With this in mind, I went to Beuys and told him that, for his catalogue, I had a printer that would print a text and reproductions for free, though only of a limited size and not more. This size was not enough and was way too thin. "What can you contribute?" I asked him. He promised me an object made out of felt, which he would make. With that, we almost had the box filled.

The decision was made with Beuys?

He agreed with my idea to make a box. I talked to him about the form of the box … I mean the measurements. We did not want the standard size, but something unusual. It was then that Beuys defined the dimensions of the box, which we kept for all future exhibitions. I also remember telling Beuys that

I wanted to print an edition of three hundred. Beuys said, "I don't like that at all. That's a strange number. It's too smooth. Let's make it 330. 333 would be too perfect." I always maintained an irregular number, even for larger editions.

With which exhibition did you move from the provisional space to the new one?

When I came to Mönchengladbach, the museum existed only as this provisional space. I went there though because the city had stated its intention to build a new museum. The site for it had been under discussion for a long time. I went to Mönchengladbach in 1967, and the location was finally decided on around 1970. In 1972, I was able to approach the architect Hans Hollein, and the city commissioned him to design the museum. The planning lasted until 1975, and the building was finally finished in 1982. So, I was in this "residential" space for 15 years.

It's interesting how like the catalogues this interim solution was, in that you also had to make a "virtue of necessity"—something that was used to such effect by so many artists. Over and over again, artists have told me how important the circumstance of this space was to them.

It really was important. In the first place, very young artists did not have great oeuvres in those days, that is, bodies of work sufficient enough for big retrospectives. Secondly, in most cases, they had never had a solo exhibition in a museum. Usually, they had had experiences with commercial galleries only, where space was typically restricted. Thirdly, there was a tendency among artists to avoid the sanctified halls of museums altogether. The inclination to go into a museum, into those "sanctified halls," was not widely developed. There was more a tendency to avoid them. Though our institution was technically and legally a museum, it was in many ways more comparable to a private enterprise in someone's house—a fact that has something to do with the atmosphere the place had and the way I ran it. I made decisions that I was not theoretically entitled to make, but nobody seemed to mind. There were no committees to decide what artists to show or when.

Therefore, no bureaucracy?

No bureaucracy. Because of that, I had no difficulty making contact with artists who were skeptical of the museum as an institution. In other places, there were aggravations or things did not even get off the ground, but I did not have any problems.

Would it be right to say that Mönchengladbach had the advantage of being more of a laboratory situation than a representational situation?

Exactly!

If one talks to Harald Szeemann, or other curators from the 1960s, they often say that there only were a few interesting places in Europe at the time. Which ones were they?

Amsterdam, Bern, Krefeld. But I have to add that the Kaiser Wilhelm Museum in Krefeld closed for renovation soon after I left. The Museum Haus Lange shut down because it did not belong to the city, but actually to the Lange heirs, who decided not to extend its lease. Therefore, exhibitions were no longer held there. So, the only place in Germany that was internationally interesting was thus out of commission for a time. This was my chance to relieve Krefeld of its solitary responsibilities, as it were, which I promptly did.

Were there other museum directors involved with contemporary art?

Not really. There were a few—[Werner] Schmalenbach in Hannover, for example. But they all showed what was already to society's taste. Taking care of art and making a contribution as a museum to the definition of the term *art*, that nobody did. Their exhibitions served other aims than the ones in Krefeld and Mönchengladbach. I did not want my work to degenerate into a business. You know: I have such-and-such budget, I can therefore only organize a fixed number of predetermined exhibitions set to run one after another. No, some of my exhibitions occurred very spontaneously. Things happened from one day to the next. You met with particular artists you had known for some time, and asked them at a certain point: "Do you have time next month?" The question

of money did not really play a role. Of course, one needed money, but it was improvised.

Alexander Dorner's writings deal with this kind of improvisation.

I was already interested in Dorner in the 1950s because he was one of the few people seriously thinking about the function of museums. He was somebody who did not just pass through an institution without asking any questions, but who developed a comprehensive idea that I could follow. I have always believed that it is the artist who creates a work, but a society that turns it into a work of art, an idea that is already in Duchamp and a lot of other places. In most cases, museums have failed to see the consequences of this notion. I have always considered myself to be a "co-producer" of art. Now, do not misunderstand me. I do not mean this in the sense of dictating to an artist: "Listen, now paint the upper left-hand corner red!" but rather in the sense of participating as a museum—as a mediating institution—in the process that transforms a work into a work of art. So it was always clear to me that I did not need to do anything for works already declared art by common consent. Instead, I was interested in those that had not found that consent and so that were still works, not works of art.

Besides Alexander Dorner, were there any other figures who were or are important to you?

Not off the top of my head. Willem Sandberg, though, was a great influence on me. I think this is true for many others, as well.

Why was Sandberg so important?

Sandberg excited me because he totally turned the definition of a museum—which was so tightly allied to the one of art—upside down, even more than Dorner. His ideas, which he disseminated in the publication *Nü*, and which caused such a stir at the beginning of the 1960s, abandoned the old notion of the museum as a permanent exhibition. Artworks should be warehoused, he said, and brought out for specific exhibitions and shown in a leisurely fashion. All institutional

conventions governing art's veneration should be given up, and it should feel as if you could play ping-pong in the museum right next to the walls with the paintings on them.

Art and life?

To bring art and life completely together and, therefore, to give up the institution of the museum—at least as it is traditionally understood. Sandberg's ideas suited me very much, although I adjusted them to a degree when I started in Mönchengladbach.

How did this transition come about?

It was initiated by the controversy over the term *museum*. I had problems with a notion, common in those days, which held that problems with the museum could be solved by simply replacing the word with something else. Analogous to the term "anti-art," the notion of the "anti-museum" was developed to reinvigorate the concept of the museum. But, despite the prefix, I did not want to completely abandon *museum* as a term. This was probably my main difference with Sandberg. Unlike him, I tried to explain my position within the context of the history of the museum and of its development. However, in a publication I said I was not against playing ping-pong in a museum, but thought that the paintings should be removed from the walls first, since they would be a distraction …

In an interview I did with Pontus Hultén, he also talked about art and life in relation to the museum—in particular the Kulturhuset, which was very important in Stockholm at the end of the 1960s as a transdisciplinary utopian idea. It was also about the blurring of art and life through the integration of things such as restaurants, interactive rooms, workshops, and laboratories. However, he said that, for him, separation was always a very important aspect of the Kulturhuset concept, though one that was never actually realized, until he later played with it at the Centre Georges Pompidou. Still, the collection was always the priority. This is similar to what you just said: one can play ping-pong in a museum, but while the exhibition is somewhere else.

Exactly. This was basically my position on separation. I still

wanted the museum, but I said that just because you put another label on a bottle doesn't mean that the wine inside changes; it is the wine that needs to be altered. It is the inner attitude that we have to alter. We finally have to stop defining art as only those objects that have been accepted as art by society. We have to concentrate on allowing art to evolve through how it is received. It did not help me to bring art closer to life simply by setting up a cafeteria or a playground or a workshop. This will not resolve the question of the museum. The museum question can only be resolved through mediation. On the one hand our responsibility is to make works into works of art and, on the other hand, to preserve works that are already works of art, and to keep them from becoming antiquated. This was my view. As a result, I wanted a conservative museum, and I chose the term *anti-museum*, not because I understood "anti-art" to mean something that could never be art, but something rather that invites the permanent renewal of art. Not a negative, but a very positive phrase. A process of constant creation, so to speak. Although the institution itself does not make works, it takes on the role of the viewer, eventually making social consent possible and thus making works of art.

Were there artists who were important to developing your notion of a museum?

Yes, there were quite a few. The question of the museum was a major topic of discussion in the art world. I especially remember Daniel Buren and Marcel Broodthaers in this regard. I generally would do only one exhibition per artist because I did not want to work like a gallery and show the same artist over and over again. I did exhibit Daniel Buren twice though.

Looking at your catalogue boxes, it becomes obvious that there were hardly any group shows. Could you say something about this? In this respect, I also found your statement about Documenta 5 in Kassel very interesting. Harald Szeemann invited you to it in 1972. "Deepening and not extending," was your statement. You deepened individual positions and showed Broodthaers, Beuys, Filliou, among others.

Harald had the idea of a section called "Individual Mythologies,"

and asked me if I would do it. I told him, "These are terms I can no longer work with as you have conceived them. I consider every artistic work an individual mythology." I was not interested in baptizing certain styles or movements, a common proactive approach among curators. Take a term like Nouveau Réalisme. It did not come from Jean Tinguely or Yves Klein or someone else associated with the group. They were lumped together in a group that never was a group at all. I wanted art to stand for itself. I always looked at art as the solitary effort of individuals who make works. I found it important to present these works as purely as possible, which was only possible in a solo presentation. I never thought much of exhibitions in which 20 artists are shown with three works a piece. This does not provide a clear picture of an artist. The primary focus must be on works that represent an individual. This is the reason why I rarely organized group shows or thematic exhibitions.

Could you talk about your first Broodthaers exhibition?

The Broodthaers show took place around 1970 or 1971. It dealt with the subject of film and object—object and film, and how both terms turn into each other. We screened all the films he had made up to that point and exhibited the films' props—a chair, a map of the world, a pipe, calendar pages—as art objects on the walls.

Was there a dialogue with Broodthaers before the exhibition?

A very long one.

Does this mean your exhibitions originated out of intense dialogues with artists?

Yes, every exhibition. Even when they came about spontaneously, the dialogue had already begun some time earlier. I had known many of the artists for a long time.

What do you think of the increasing acceleration of the art world? The number of exhibitions is exploding!

This is basically the curse of an evil deed. People who we

have already mentioned several times, such as Szeemann and Hultén, were very successful. Whatever they did was news. Nowadays, museums go to enormous lengths to get publicity, something that just was not necessary back then. Scandal went with every new exhibition, which is inconceivable today. Today, many people are trying to profit from these earlier successes by saying, "We have to do this, too." So now—and here I am exaggerating—we have a museum of contemporary art in every town and village. The available material gets quickly used up unless you want to exhibit every local artist. Whoever is of interest at the moment will be approached by 25 institutions. Previously, the same artist would have been simultaneously asked by three, at best.

The problem is that increasingly art institutions are detached from the artists.

So it is. Institutions have become disconnected from artists. They celebrate themselves and their patrons. Their prime function, transforming a work into a work of art, has become obsolete. The institution confirms its own identity as an institution, and thus the question of the number of visitors plays an increasingly important role. What is this all about? The quality of a work cannot be measured by the quantity of people that visit an institution. One example is Holland. There, anybody who claims to be an artist gets financial support. We can only hope that the country is now producing one genius after another, since the material needs of the producers of art have been eliminated; but not one single artist has emerged from this. This is not the way to establish an artistic existence.

At some point you decided not to continue with this kind of museum. What were the reasons for your decision?

No, I think I could have mastered the matter of management. Originally, I had intended to use the opening of the museum in 1982 as an occasion to say goodbye. Then I decided not to because I thought everybody would criticize me for bringing something about that I still had not proven could work. I stayed another three years to do just that. That was one reason. The other reason really came out of the art itself.

I tried desperately to find artistic innovation, in the sense of art that defines art. I did not simply want to open a "stable" of artists like some art dealers do. The "business" of art overwhelmed me from all sides, and I was not willing to participate in it. I did not see sufficient artistic potential there.

What do you think of the way that artists in the 1990s picked up on things from the 1960s and 1970s?

By 1989, I had been out the museum for a long time. It is probably a function of my age that I recognize only too well appropriated or re-cycled elements in art. I am not saying that this does not lead to anything of value. An artist does not just copy things, but uses them as starting points to develop into something else. I recognized this as early as 1960. There were a lot of attempts in Nouveau Réalisme to refer to Duchamp and the Dadaists. I do not fault them. Nobody "falls from the moon," as they say. Everybody comes out of a tradition.

Were there exhibitions that you were interested in the 1990s?

I was interested in Franz West, for example, who drew from a number of sources from Fluxus to Nouveau Réalisme. But he also adds a strange Austrian Surrealism, which was not found in either of these movements. This brings with it a certain mentality, a world of experience, which played a strong role in Surrealism and which goes by Freud's name. I found this very intriguing. While Nouveau Réalisme and everybody who worked with trash—if I may put it so casually—was materialistically oriented, Franz West has come up with an entirely different dimension that is non-materialistic in nature. Nightmares are created that did not exist in Arman's work, for example. These were new tendencies that I believe will last. No longer the youngest, but still playing a dominant role in recent developments, is somebody like [Christian] Boltanski. Younger artists for me are people like Wolfgang Laib, Giuseppe Penone, and Lothar Baumgarten, all of whom I exhibited in the 1980s.

Finally, a question about your new [Hans] Hollein building. You had already done a Hans Hollein exhibition in the 1970s and it was from

this dialogue that the building resulted. What kind of dialogue was it?

The dialogue began with the preparations for an exhibition on the subject of death. At the time, we had the opportunity to discuss, in a hypothetical way, the idea of a museum. When I was later given the task of realizing the new building, I suggested that, instead of holding a design competition, we should commission an architect who would develop the concept from the first sketch onward in close collaboration with the museum staff. I suggested Hans Hollein. This was the beginning. The whole thing is very complex and difficult to explain. The service features of the museum were not a top priority. From the cafeteria to the painting class, the lecture hall to the "ping-pong room," I took the view that these were just service features, and the construction of the building shows it. Nevertheless, we did not want them on the margins of the museum, but embedded in it. Everybody should feel that these are just services within the museum. For that very reason, the cafeteria is only accessible from inside the building. In most cases, cafés in museums nowadays are also accessible from the street. I have always maintained that if you want a cheap cup of coffee here, you have to run the gauntlet of the art first. I also want to make clear that the architecture was not my creation. Hollein was the architect, not me. Every idea was his.

Your intention was to avoid what seems to be happening in many museums today; namely, that their peripheral functions are becoming their main ones.

I wanted to have it the other way around. While not neglecting these peripheral functions, I wanted to reemphasize that there are main functions, that a museum is a museum.

Furthermore, I wanted a democratic museum. Everything authoritarian or absolutist is symmetrical. I wanted a museum that has no predetermined route. Moreover, I wanted confrontation, which does not mean having everything confront each other in the same room. I wanted more of a transparent view. For example, I see a work in a room devoted to a particular artist, and always have other views possible of works in other rooms, even if it is just out of the corner of my eye.

No isolated white cubes?

Exactly. Furthermore, I did not want most things to be com-
municated verbally, but rather through architecture. The
labyrinth served this. Whoever gets lost in a jungle remembers
every single orchid that leads him back home because he
says to himself, "I've already seen this before." I wanted a
building with a little bit of the character of a jungle, where I
could lose myself and so be forced to find landmarks. I think
that Hollein solved this problem remarkably well. Hollein
also wanted to use certain prototypes from the history of
architecture, like the dome of the Pantheon. Thus there is,
for example, a small room with a cupola. This corresponds
to the original one in the Pantheon, which is known to us,
thanks to our education, as a legitimate cultural space.
Everything shown in such a room is consumed as culture,
meaning it becomes part of the cultural discourse. I want
works that most visitors would not consider works of art, in
an architectural context that makes people discuss them
culturally—even if one possible result is that such works do
not satisfy every individual need.

This would be the primary function of a museum?

Yes, the primary idea of a museum, but supported by the
elements of its construction. The museum is a non-verbal
mediating system. The question of points of view or the
democratization (meaning: the viewer has to decide for him/
herself), all belong to this mediation system. I did not want
to cling to any ideology that says that people have to get drunk
on art. They can still enjoy their alcohol in the cafeteria, but
they are in the context of the museum and they should feel it.

Jean Leering

Born in 1934. Died in 2005 in Eindhoven, the Netherlands.

Among other occupations, Jean Leering was the director of the Stedelijk Van Abbemuseum in Eindhoven from 1964 to 1973. In 1968 he emerged alongside Arnold Bode as the decisive figure heading Documenta 4 in Kassel.

This interview was conducted in 2002 in Leering's house in Amsterdam. It was first published in Paul O'Neill (ed.), *Curating Subjects*, Open Editions, London, 2007, p. 132.

HUO *Let's start at the beginning: how did you become a curator? What kind of studies did you undertake?*

JL I didn't study art history or anything like that. I studied architecture, in Delft. Even if I was on the way to becoming an architectural engineer, at that time I was already organizing exhibitions. My first exhibition, which I organized in the Museum Het Prinsen Hof in Delft, was about religious art of the last century.

When was this?

1958. So from 1956 to 1958 I was working on this exhibition, which took place in the first month of 1958. After I completed my studies in architecture and became an engineer, I had to do my military service (1963). Before that, in 1962, I did another exhibition with some friends, in the same museum, which was about autonomous architecture.

Who were the architects or what types of projects were included in this exhibition?

Architecture was the greatest part, starting with Piranesi, followed by Boullée and Ledoux, and reaching recent architecture through the work of American architects like F.L. Wright and Louis Kahn. The smaller part was devoted to works of art, by, for instance, van Doesburg and the then actual Zero movement.

Was it about the relations between architecture and utopia?

Well, if you take, for instance, Boullée, who lived at the time of the French Revolution, he made very few buildings, and so what remains of his work are mostly just beautiful prints. He made some large drawings, painting them in black and white only, in shades. Then there were Ledoux, Loos, De Stijl, architecture from Utrecht, and the latest architecture of that time. Because I had these experiences of making exhibitions, friends of mine told me to apply to the Van Abbemuseum in Eindhoven, because they were looking for a new director. I did, and unexpectedly, after the selection I was the only one who remained!

So you went from being an architectural engineer to the director of an art museum. Chris Dercon emphasized during our discussion that this is certainly one of the reasons your curatorial work has influenced so many people and is now so important for a younger generation of curators. Interdisciplinarity is at the core of your practice. How did you handle this as a curator at the Van Abbemuseum?

Yes, that's true. Since the beginning these crossovers have been the main point of interest. My latest book [*Beeldarchitectuur en kunst: het samengaan van architectuur en beeldende kunst*, 2001] treats this. It's about the relations between images, architecture, and art. I went back to the years of Ancient Egypt and examined those forms of relations up to 1990.

When you suddenly became director of the Van Abbemuseum, what type of ideas or projects did your have in mind?

When I got this position, my interest in interdisciplinarity

was already taking shape. I was very interested in the De Stijl artists that I had already studied for that previous exhibition in Delft. I was also very fond of El Lissitzky. But my first exhibition there was about art and theater and it was made to coincide with the opening of the new theater in Eindhoven. I organized the first exhibition on that occasion; it was September/October 1964.

Were there curators that influenced your practice? Was Willem Sandberg an influence?

Yes. I knew Sandberg already; he even wrote in favor of my nomination to Eindhoven. He was a fantastic man. And in a certain way the younger generation knew of the reputation that he had abroad. Although there were many critics who did not approve of his policies, I admired him. He was a fantastic worker; he slept only a few hours a day. Often he went to bed after dinner for an hour or an hour and a half and he would work until the morning; then he would sleep again for an hour, then he would go into the museum. He had a strong regime, he didn't eat very much, he liked to drink but not too much, and he had a lot of self-control.

And like you, he wasn't an art historian, he came from a graphic design background, and maybe this characteristic of interdisciplinary also explains why he was so important.

Yes. Another example of this kind is Edy de Wilde, my predecessor at the Van Abbemuseum, who studied law.

Like Franz Meyer.

I think that it's important to say that at that time very few museums were paying attention to architecture. And because that was my background and profession, I took a lot of interest in subjects coming from the architectural field. So I did an exhibition of Adolf Loos. Then there were three exhibitions in a row in 1965; an exhibition of Duchamp and an important show of El Lissitzky, which led to the purchase of a whole bunch of his drawings and watercolors for the Van Abbemuseum collection. In 1967 I organized a show of Moholy-Nagy, another of Picabia and van 't Hoff, and in 1968 I organized an

exhibition of Theo van Doesburg. Later on came Tatlin ...
As you can see I paid quite a lot of attention to the art of the
1920s and early 1930s. A very important moment also in
terms of what was going on in the arts was the series of exhi-
bitions starting in 1967 called *Kompass*. One was about New
York, and in 1969 I organized a show about Los Angeles and
San Francisco, called *Kompass West Coast*. Those were very
important exhibitions for me. In-between there were exhibi-
tions on architecture, and then in 1969 I also put together an
exhibition which I found quite important for civic develop-
ment, called *City Plan*. In fact the exhibition presented a new
plan for Eindhoven. Unfortunately, the plan has never been
realized on a 1:1 scale for the city, but it was beautiful. For
the exhibition there were four rooms, and I built a model of
a part of the plan, which filled all the rooms, 8 by 12 meters.
It was on a scale of 1:20, and it was built in such a way that
you could walk through it, through the streets, and get a real
sense of the design.

So you had to work with an architect for this?

Yes, with Van den Broek and Bakema; Van den Broek was
the person with whom I completed my studies and Bakema
was his collaborator. Bakema was very much in charge at that
moment of the real city plan for Eindhoven, so it was all the
more interesting to collaborate with him to make the model.

*To come back for a moment to your exhibitions about the artists and
architects of the 1920s, how was this interest in the convergence of the
realms of architecture, art, and design in the work of Lissitsky or van
Doesburg, for instance, received at that time in Holland?*

Lissitsky was a man who was both an architect and an artist.
And so was van Doesburg; he was an artist who started in
the 1920s with architecture. But it's true this exhibition was
a tactical one because at that time, in the early 1960s, van
Doesburg was mostly seen as the organizer of the De Stijl
movement, and not so much as an artist per se. My wife
is the niece of Nelly van Doesburg, and so because I had
this connection, I had the possibility to exhibit some of his
works for the exhibition in Delft in 1962. And when I was
nominated in Eindhoven I knew that I would make a larger

exhibition of van Doesburg. I wanted to open the eyes of
the art colleges. People said that van Doesburg just followed
Mondrian. Well, yes, he did, but he made something new
out of it. He connected art with the field of architecture, he
did things like rebuilding the restaurant-cabaret l'Aubette
in Strasbourg, and he also built the house in Meudon-Val-
Fleury. Although I didn't know it at the time, my wife was
Nelly van Doesburg's sole heir, and so later we decided to
give all the works that were still there to the State of the
Netherlands. The house was given on the basis that young
artists would be able to stay there for a year.

*Like a residency … Thinking of the 1920s, the first curator that
comes to mind is Alexander Dorner, the director of the Landesmuseum
in Hannover. Was he another influence?*

Yes, very much. In my new book I quote him often. I organized
the El Lissitsky exhibition with the museum in Hannover,
and I also met Dorner's widow.

Fantastic! So Dorner's legacy was very present for you?

Yes, you could say that.

For me his The Way Beyond "Art" *was some kind of bible; I found
it as a student and have read it many times ever since.*

I also read it as a student. His ideas were quite familiar to
people at the time I started in Eindhoven. I have a lot of
respect not only for his book but also for him as a person.
He left Hannover and went to America, where for a short
time he was again a museum director before becoming a
professor of art history.

*Both Sandberg and Dorner defended the idea of the museum as a labo-
ratory. Johannes Cladders also insisted on this idea of the museum as
a space in which one should take risks, a space that should be used as a
means to build bridges between various disciplines. Do you also find
this idea of the museum as a laboratory relevant?*

Yes. Well, at least in a sense … The exhibition *City Plan* I
mentioned lead in 1972 to an even bigger exhibition which

was called *The Street, Ways of Living Together*. The idea behind that exhibition was to investigate ways of living together. Why an exhibition about streets? Well it goes back to the show *City Plan* in 1969, when I had the idea that it would be very interesting to show that the experiments that were made in the 1960s—be they environments or happenings—were very connected to the idea of the city. Eindhoven was the nucleus of that exhibition, but it became so wide so that at a certain moment I decided to dedicate a whole exhibition to the plan of Eindhoven. The people from the municipality of Eindhoven said that they were very interested in following up the original idea, and that became the *Street* exhibition. So to get back to your question about laboratories, as you can see, there was an experimental aspect to it, but if you want the museum's public to be interested in art, you should not only bring in art, but you should ask what people are interested in. The street is made not only by architects, urbanists, and planners; the real streets are made by the people themselves, the people who use them. What they do in the streets and the significance they attach to the streets each day—market day, for example, gives a different significance (and outlook) to the street than a Sunday.

So how did you resolve this problematic? Did you bring in artists and non-artists? Was it well received by people not so familiar with the exhibition realm?

Well it was one of the best-attended exhibitions we ever did. I was quite keen to develop this kind of exhibition even further, but then the mayor of Eindhoven died from a tumor and the local authorities were not so interested in following that line. Finally I realized that it would be very difficult to develop that museum further, so I moved to Amsterdam. I was given the directorship of the Tropenmuseum there, and after two years I discovered that they were very pleased to have me there, but they were not comfortable with the changes I wished to bring to the museum. So I left the museum and pursued other paths: I worked for the ministry and I became professor of art history at the University of Technology in Eindhoven.

What you're describing here is how the "laboratory years" of the Dutch

museum world were suddenly interrupted in the 1970s. This also happened in the United States as Mary Ann Staniszewski remarkably demonstrates in The Power of Display, *her book about the transformations of the MoMA in New York. Do you think it's possible to speak of a global context disrupting the experimental modes of curatorial practice of the 1970s?*

Yes, take Cladders, for instance; he somehow had to build his own new museum. And his decision to do this in a little town (Mönchengladbach), which became famous only because of this museum, was not an innocent one. In September/October 1967 he organized the opening exhibition of the museum, which was then located in an old villa. This exhibition was an experimental one, which convinced me of the value and importance of the work of Joseph Beuys. So I took over this exhibition, which opened in February 1968 in Eindhoven.

Was it the first collaboration between you and Cladders? Did you know him from before?

That was not the first collaboration. Earlier he had been an assistant to Paul Wember, who was director of the museum in Krefeld, and with whom I had been working since 1964.

Can you talk about Wember?

He made the first large museum exhibition of Yves Klein and he was a fantastic museum director. He was also the first German museum director that Sandberg visited after the war because of his daring policies. It was a small museum, but it had a beautiful collection. The Haus Lange and the Haus Esters in Krefeld are two houses designed by Mies Van der Rohe. Wember became the director of the Museum Haus Lange at that time.

Are there other people who have been important for you?

Harald Szeemann of course. And Pontus Hultén ...

Can you tell me more about what went wrong in the 1970s?

Well I think it was connected to a kind of revolution, of the youth in particular, but also a sexual revolution. I think that many people were afraid, especially those in the government. I have already mentioned this mayor whose ideas about the museum corresponded with mine, but most of his peers were afraid. I remember that at that time, there was also a theater group in Eindhoven, which was very forward-looking, very avant-garde. They were strongly criticized by the elders of Eindhoven, especially by the man who was in charge of the art foundation, who wrote a very critical article in the local newspaper about this group. A week later I attacked him in the same newspaper, and this was not appreciated by the elders. I thought this theater group was doing very well, exploring new educational programs with school classes and so on. These reactions were for me a sign that further development was not possible. They chose more classical figures as successors. My successor, Rudi Fuchs, cut out many of the things that I had set up.

One could also think that it had a lot to do with fear—a fear of interdisciplinarity, a fear of pooling knowledge. And so perhaps it was also a fear of vested interests.

Yes, and also the sexual revolution that accompanied the laboratory idea. There was a new form of commitment between people.

At the time, in the late 1950s and early 1960s, there was a lot of interest in self-organization. Was this tendency—and I'm thinking here of Constant's New Babylon *in particular—important for you?*

Yes, during my studies, once a week on Wednesday afternoons, my professor, Van den Broek, opened discussions on these ideas. There were lectures about things such as Constant and his *New Babylon*, which were followed by discussions with the audience. I remember being caught in vigorous discussions with Constant and yes, I got to know him very well then. We were examining the slides that had been made from the models of *New Babylon* and I pointed out to him that the influence of Schwitters' collages was so detectable in the slides, it was striking. Aldo van Eyck was also connected with these discussions and with the exhibition about the autonomous

architecture that I mentioned earlier.

How was van Eyck involved?

There was a group of 15 students of which van Eyck was some-
how the spiritual mentor. In fact, we had asked him to be
involved in such a way, and he was. Later on, we proposed a
Professorship in Delft to him, which he accepted around 1965.

The Street *exhibition of 1972 brought this idea of the experimental
show a step further, by bringing real life into the museum. It reminds
me of Allan Kaprow, and of his desire to blur art and life. And then
you said that you wanted to push this idea further, but this was halted
by the politicians. Had it not been, what would you have liked to do
with the museum?*

As the director of the museum I thought it important to try
to make the art museum into an anthropological museum.
Therefore I went to the Tropenmuseum in Amsterdam. What
I mean is that human interests should always be at the center
of your policy as a museum director. Your job as a director
is to interest people in art, to consider the correspondences
between their interests and art, and then to use these interests
as a starting point.

What were the first exhibitions that you organized at the Tropenmuseum?

We did an exhibition about world population. This might be
a beautiful example of my handling of the theme. Population
in the third world and the underdeveloped world is a big
problem, in part because sexual life is lived in different ways
there than in our part of the world. I wanted to confront
these gaps between ideas of population, procreation, and
children, and to show how it is in the West through compari-
son. A sculpture by John de Andrea had been accepted for
Documenta in Kassel; it was a sculpture on the ground
of a young man and a young lady who were having a sexual
relationship, in a very realistic style … I thought we should
have that piece in our exhibition about population in order
to create a kind of shock, but also in order to get people
to ask themselves what the meaning of the presence of this
piece in the exhibition was, and enable them to discover

something about their sexual lives in comparison to sexual lives in underdeveloped countries. In a certain way, art was being "used" to get people to think and be aware of their own situations. This was the idea, along with addressing how such a message can be achieved in an exhibition. Then there was another exhibition, about the situation of women both here in the West and in underdeveloped countries. I tried to use the classical methods of the anthropological museum, such as showing the difference between an axe and the tool with which rice is stamped, and underlining the fact that the axe has a very streamlined design.

I interviewed Jean Rouch some time ago and he told me a lot about the beginnings of the Musée de l'Homme, about Georges-Henri Rivière, Marcel Griaule, Michel Leiris ...

I also knew Georges-Henri Rivière, who was associate director of the Musée de l'Homme in 1937 and who directed the Musée des Arts et Traditions Populaires in Paris afterward.

Can you tell me about an unrealized project of yours, about a project that for a number of reasons has never reach completion?

Well, I think that the ambition I had for the Tropenmuseum is an unrealized one. My idea of the anthropological museum, the Tropenmuseum in Amsterdam, was to have a museum liked by ordinary people. And while I had ideas about how to arrange that, there was then the problem of how to connect what I see in art and the benefits of art in human life with the ordinary interests of ordinary people. I don't necessarily think that everybody should go to the museum, but I do think that art could play a wider role than it does if the museum evolves in that direction. I wrote an article in 1999 on how the museum could learn from the public library. The public library asks its users about what they are interested in, which is already a lot more than museums do. It is professional in that way. It is not the public taste that determines the content of the library—it needs to be done thoroughly by professionals. But the public knows that the library is there for its use. I tried to reshape the Tropenmuseum to a new kind of anthropological museum based on this idea. If you compare the history of the public library with the history of museums,

it is evident that museums have come far more from the Third Estate of the population (the leading Estate after the French Revolution), than from the idea that we have to educate a Fourth Estate.

So you think the museum can learn from the public library. Certainly people feel less excluded there; the threshold of the library, as Adorno would say, is easier to pass …

Yes, that's right. I think that the average level of the audience of the public library is somewhat broader than people who come to the museum. That was one of Sandberg's main ideas. At one time the road outside the museum was being reconstructed, and Sandberg created an exhibition in which people could see the exhibition from outside by standing on the scaffolding. I thought that was wonderful idea.

What about the specificities of the catalogue? Sandberg is very famous for his catalogues, Johannes Cladders always made these boxes, and Pontus Hultén was also always very interested in the idea of playing with publications. What about you?

I must say I haven't concentrated so much on the renewal of the catalogue; my main focus was on the renewal of the ex-hibition process. I think that catalogues should follow; they shouldn't be the primary feature.

How do you understand the notion of the museum now, in 2002? How do you see the future of the museum? Are you optimistic?

The future is a big question mark. Things have regressed since the mid-1970s. I have lectured and published a lot about museums and I hope that somehow there is some interest in these ideas that I have outlined to you. I hope that they will be picked up and that things will go in the direction I have worked toward all these years. But really I can't think of any museum doing it right now. Maybe you know some museums that are picking up on these ideas.

Interestingly, I think that it happens more in smaller models of museums. I think that in some ways museums risk becoming too successful and have entered a vicious circle, always wanting to attract larger audiences.

They have become victims of their own success. Sometimes I wish that there would be small houses again, models like Johannes Cladders' project before he founded the Städtisches Museum in Mönchengladbach. And I think that Cladders was more interesting there than in a big museum. Somehow he himself realized this, resigning as soon as the big museum was built.

Have you met him? Is he still alive?

Alive and well, still working, though not curating so much, but writing books. There are, I think, a lot of parallels to be made between the two of you. He is also an artist as you probably know, and so he is working on some drawings now.

I'm glad to know.

Harald Szeemann

Born in 1933 in Bern. Died in 2005 in Tegna, Switzerland.

This interview was conducted in 1995 in a restaurant in Paris. It was first published in *Artforum*, New York, in February 1996, under the title "Mind Over Matter."

It was originally introduced by the following text:

Ever since he "declared his independence" by resigning his directorship at the Kunsthalle Bern in 1969, Harald Szeemann has defined himself as an *Ausstellungsmacher*, a maker of exhibitions. There is more at stake in adopting such a designation than semantics. Szeemann is more conjurer than curator—simultaneously archivist, conservator, art handler, press officer, accountant, and above all, accomplice of the artists.

At the Kunsthalle Bern, where Szeemann made his reputation during his eight-year tenure, he organized 12 to 15 exhibitions a year, turning this venerable institution into a meeting ground for emerging European and American artists. His coup de grâce, *When Attitudes Become Form: Live in Your Head*, was the first exhibition to bring together post-Minimalist and Conceptual artists in a European institution, and marked a turning point in Szeemann's career—with this show his aesthetic position became increasingly controversial, and due to interference and pressure to adjust his programming from the Kunsthalle's board of directors and Bern's municipal government, he resigned, and set himself up as an independent curator.

If Szeemann succeeded in transforming Bern's Kunsthalle into one of the most dynamic institutions of the time, his 1972 version of Documenta did no less for this art-world staple, held every five years in Kassel, Germany. Conceived as a 100-day event, it brought together artists such as Richard Serra, Paul Thek, Bruce Nauman, Vito Acconci, Joan Jonas, and Rebecca Horn, and included not only painting and sculpture but installations, performances, Happenings, and, of course, events that lasted the full 100 days, such as Joseph Beuys' *Office for Direct Democracy*. Artists have always responded to Szeemann and his approach to curating, which he himself describes as a "structured chaos." Of *Monte Verità*, a show mapping the visionary utopias of the early 20th century, Mario Merz said Szeemann "visualized the chaos we, as artists, have in our heads. One day we're anarchists, another drunks, the next mystics." Szeemann's eclectic, wide-ranging shows evince a boundless energy for research and an encyclopedic knowledge not only of contemporary art but also of the social and historical events that have shaped our post-Enlightenment world. Indeed, in the last few years he has mounted a number of shows that reflect his penchant for mixing artifact and art, combining as they do inventions, historical documents, everyday objects, and artworks. Two of the largest offered panoramic views of his home country and the one across the Alps: *Visionary Switzerland* in 1991 and *Austria im Rosennetz* (Austria in a Net of Roses), which recently opened at the Museum für Angewandte Kunst in Vienna.

Szeemann now divides his time between the Kunsthaus Zürich, where he occupies the paradoxical position of permanent freelance curator, and the studio-cum-archive he calls "The Factory," located in Tegna, the small Swiss alpine town where he lives. What follows is a record of the conversation I had with Szeemann last summer, in which he reflected on his more than 40-year career.

HUO *Until 1957 you were involved in theater. Then you began organizing exhibitions. What prompted this transition?*

HS When I was 18, I started a cabaret with three friends, two actors, and a musician. But around 1955, sick of intrigues and jealousies, I began to move away from ensemble work until I was doing everything by myself—a one-man style of theater that reflected my ambition to realize a Gesamtkunstwerk. At the time I had already been visiting the Kunsthalle Bern for five years. Bern is a small city where everyone knows each other, and when Franz Meyer (he took over as director from Arnold Rüdlinger in 1955) was asked if he knew anyone who could show Henry Clifford, then director of the Philadelphia Museum, around Switzerland, he proposed me, knowing my interest in all the arts, but particularly in Dada, Surrealism, and Abstract Expressionism.

We visited museums, private collections, and artists; it was a wonderful month of "vagabondage."

In 1957 Meyer also suggested me for an ambitious project, *Dichtende Maler/Malende Dichter* (Painters-Poets/Poets-Painters) at the museum in St Gallen. Four people were already working on the show, but the two main directors had health problems and the other two were reluctant to take on an exhibition of this size alone. So they asked Meyer if he knew someone who could take care of the contemporary section, and he said, "I only know one person. It's Szeemann." I was the ambitious understudy who ended up getting the main part.

The intensity of the work made me realize this was my medium. It gives you the same rhythm as in theater, only you don't have to be on stage constantly.

What drew you to contemporary art to begin with?

Until I was 19 I still wanted to be a painter, but the Fernand Léger exhibition at the Kunsthalle Bern in 1952 impressed me so much that I said to myself, "I'll never get that good." Through Rüdlinger's exhibitions—ranging from Nabis to Jackson Pollock—at the Kunsthalle Bern, one could really learn the history of painting. He was the first to show contemporary American art to a European public and later, when he became director of the Kunsthalle Basel, he bought paintings by Mark Rothko, Clyfford Still, Franz Kline, and Barnett Newman for the Basel Kunstmuseum. He was friends with many artists—Alexander Calder, Bill Jensen, and Sam Francis—and through him I met a lot of artists in Paris and New York. In Bern he did a series of exhibitions called *Tendances actuelles 1–3* (Contemporary tendencies, 1–3), a splendid survey of postwar painting from the Paris School to American abstraction. When he moved to Basel he had more space and more money, but his real adventure was in Bern.

Meyer served as director until 1961. He mounted the first exhibitions in Switzerland of Kasimir Malevich, Kurt Schwitters, Matisse's cutouts, Jean Arp, Max Ernst, and he showed Antoni Tapiès, Serge Poliakoff, Francis, and Jean Tinguely. By the time I took over the Kunsthalle in 1961, I was faced with this venerable past, so I had to change direction.

You wrote that Bern was something like a "situation."

A kind of "mental space."

I found art to be one way of challenging the notion of property/
possession. And because the Kunsthalle had no permanent
collection, it was more like a laboratory than a collective me-
morial. You had to improvise, to do the maximum with minimal
resources and still be good enough that other institutions
would want to take on the exhibitions and share the costs.

*In the 1980s the Kunsthalle became more structured. The exhibition
program was reduced from more than a dozen exhibitions a year to
between four and six. And the introduction of "midcareer retrospectives"
turned the Kunsthalle into an extension of the museums themselves.*

Yes, everything was flexible, dynamic, and then suddenly
everything changed. To hang an exhibition, to produce the
catalogue, used to take us one week, and then suddenly you
needed a four-week period between shows to photograph
everything; with this slower pace came institutional pedago-
gies, restoration, and guards. In the 1960s we had none of this.
For me, if there was a pedagogy, it was about the succession
of events; documentation was not important.
 My approach attracted a younger public and a very
young photographer named Balthasar Burkhard started to
document exhibitions and events, not for publication but
just because he liked what I did and what was happening
at the Kunsthalle. That's how I prefer to work. Actually I
stopped publishing catalogues and just printed newspapers,
which were anathema to the bibliophile collectors.

And that worked out?

Of course. The Kunsthalle had an exhibition program but it
also welcomed all kinds of participation. Young filmmakers
showed their films, the Living Theater made its first appear-
ance in Switzerland there, young composers performed their
music—groups like Free Jazz from Detroit played—young
fashion designers showed their creations.
 Naturally this provoked reactions. The local newspapers
accused me of alienating traditional audiences, but we also
attracted a new audience. The membership increased from
about 200 to around 600, with an additional 1,000 students

paying a symbolic Swiss franc to belong. It was the 1960s
and the Zeitgeist had changed.

*Which exhibitions influenced you most as you were starting to curate
your own shows?*

Well, I have already described some of what I saw in Bern and
in Paris. Also very important was the German Expressionism
show in 1953, *Deutsche Kunst, Meisterwerke des 20 Jahrhunderts*
(German art, Masterworks of the 20th Century), at the Kunst-
museum Lucerne, and, of course, in Paris, *Les Sources du XXe
siècle* (The Sources of the 20th Century, 1958), and the Dubuffet
retrospective at the Musée des arts décoratifs in 1960, as
well as Documenta II in 1959, curated by its founder, Arnold
Bode. I also visited a lot of studios—those of Constantin
Brancusi, Ernst, Tinguely, Robert Müller, Bruno Müller,
Daniel Spoerri, Dieter Roth, among others. I saw the most
fabulous show of Picasso in Milan in 1959. From the begin-
ning, meeting artists and looking at important shows was my
education—I was always less interested in formal art history.
 Of my peers, I admired Georg Schmidt, director of
the Kunstmuseum Basel until 1963. He was absolutely focused
on quality, able to choose the work he wanted for his collec-
tion and to incite fabulous gifts like the La Roche Collection.
But I also admired William Sandberg, director of the
Stedelijk Museum until 1963, who was Schmidt's opposite.
Sandberg was obsessed with information. Sometimes he
exhibited only part of a diptych, for instance, or left a good
work out of the show altogether because it was reproduced
in the catalogue. For him ideas and information counted
more than the experience of the object.
 In a sense, I combined both approaches in my shows
to achieve what I like to think of as selective information and/
or informative selection. This is how I view my Kunsthalle
years. In putting together an exhibition, I took both connois-
seurship and the dissemination of pure information into ac-
count and transformed both. That's the foundation of my work.

Tell me more about Sandberg.

Amsterdam in the 1960s was the meeting point, the whole
art world converged in the Stedelijk cafeteria under a mural

by Karel Appel. Sandberg was very open-minded. He let artists curate exhibitions such as *Dylaby*, with Tinguely, [Daniel] Spoerri, Robert Rauschenberg, and Niki de St Phalle; he was enthusiastic about new artistic directions: kinetic art, the California "light sculptors," new synthetic materials. When Sandberg left, Edy de Wilde took over and painting filled the Stedelijk. De Wilde was much more conservative.

I also have to mention Robert Giron, who had been exhibitions director at the Palais des Beaux-Arts in Brussels since its inception in 1925, an exemplary institution. Everyday at noon curators, collectors, and artists met in his office to exchange the latest art-world news. When I met Giron, he had been running the Palais for 40 years and he said, "You are too young, you'll never hold up as long as me." But out of my generation and the next, I'm the only one still going. It gives me pleasure.

What about Johannes Cladders, the former director of the museum in Mönchengladbach?

Cladders was always an idol for me. I knew him when he was still in Krefeld. He did not rely on grand gestures. He had a love of precision but precision based on intuition. His first space was an empty school building on Bismarck Street. It marked a great period. James Lee Byars presented a golden needle in a vitrine, the windows to the gardens were open, the birds were singing. Sheer poetry. And Carl Andre did a catalogue in the form of a "tablecloth." I asked Cladders to participate in Documenta V. He said, "Okay, but I won't take over a section, I'll just work with four artists—Marcel Broodthaers, Joseph Beuys, Daniel Buren, and Robert Filliou—and integrate them into the rest of the show." It was his way of working. This was a period when everybody was fighting to establish the significance of their institutions. In the late 1960s, art and culture started to be promoted by politicians and it became important which party you belonged to, especially in Germany. Cladders established his importance quietly, with artistic deeds at the museum in Mönchengladbach, while the nearby Düsseldorf Kunsthalle did it with power plays.

You said you went to Amsterdam every month. Were there other places

you visited regularly?

Yes, there was an itinerary of hope and ambition: Pontus Hultén's Moderna Museet in Stockholm, Knud Jensen's Louisiana near Copenhagen, and Brussels. In 1967 Otto Hahn wrote in *The Express* magazine: "There are four places to watch: Amsterdam (Sandberg and de Wilde), Stockholm (Hultén), Düsseldorf (Schmela), and Bern (Szeemann)."

At the Kunsthalle Bern you not only organized thematic exhibitions but also many solo shows.

The Kunsthalle was run by artists—they were a majority on the exhibition committee, so I had to deal with a lot of local art politics. There were Swiss artists I loved—people like Müller, Walter Kurt Wiemken, Otto Meyer-Amden, Louis Moilliet—but in my view they were not well known, so I organized their first solo shows. I also showcased international artists: Piotr Kowalski, [Henri] Etienne-Martin, Auguste Herbin, Mark Tobey, Louise Nevelson. Even Giorgio Morandi had his first retrospective in Bern. I usually did a thematic exhibition first—for example *Marionettes, Puppets, Shadowplays: Asiatica and Experiments, Ex Votos, Light and Movement: Kinetic Art, White on White, Science Fiction, 12 Environments*, and finally, *When Attitudes Become Form: Live in Your Head*—with both established and emerging artists, and then showed single artists such as Roy Lichtenstein, Max Bill, Jesus-Rafael Soto, Jean Dewasne, Jean Gorin, and Constant. It was logical for a small city to do it this way, to alternate between solo and group shows. In a couple of exhibitions I showed the work of young artists—young British sculptors or young Dutch artists.

You mentioned When Attitudes Become Form, *which was a landmark show of post-Minimalist American artists. How did you put it together?*

The history of *Attitudes* is short but complex. After the opening in the summer of 1968 of the exhibition *12 Environments* (which included works by Andy Warhol, Martial Raysse, Soto, Jean Schnyder, Kowalski, not to mention experimental film and Christo's first wrapped public building), the people from Philip Morris and the PR firm Rudder and Finn came to Bern

and asked me if I would like to do a show of my own. They offered me money and total freedom. I said yes, of course. Until then I had never had an opportunity like that. Usually I wasn't able to pay shipping costs from the United States to Bern, so I collaborated with the Stedelijk, which had the Holland American Line as a sponsor for transatlantic shipping, and I only had to pay for transport in Europe. In this way I was able to show Jasper Johns in 1962, Rauschenberg, Richard Stankiewicz, and Alfred Leslie, and many more Americans later on. So getting this funding for *Attitudes* was very liberating for me.

After the opening of *12 Environments*, I was traveling with de Wilde (then director of the Stedelijk) through Switzerland and Holland to select works by younger Dutch and Swiss artists for two group shows devoted to each nationality that took place in both countries. I told him that with the Philip Morris money I intended to do a show with the light artists of Los Angeles: Robert Irwin, Larry Bell, Doug Wheeler, [James] Turrell. But Edy said, "You can't do that. I've already reserved the project for myself." And I responded, "Well, if you reserved that idea when's the show?" His was still years down the road, but my project was for the immediate future. It was July and my show was scheduled for March.

That same day we visited the studio of a Dutch painter, Reinier Lucassen, who said, "I have an assistant. Would you be interested in looking at his work?" The assistant was Jan Dibbets, who greeted us from behind two tables—one with neon coming out of the surface, the other one with grass, which he watered. I was so impressed by this gesture that I said to Edy, "Okay. I know what I'll do, an exhibition that focuses on behaviors and gestures like the one I just saw."

That was the starting point; then everything happened very quickly. There is a published diary of *Attitudes* that details my trips, studio visits, the installation process. It was an adventure from beginning to end, and the catalogue, discussing how the works could either assume material form or remain immaterial, documents this revolution in the visual arts. It was a moment of great intensity and freedom, when you could either produce a work or just imagine it, as Lawrence Weiner put it. Sixty-nine artists, Europeans and Americans, took over the institution. Robert Barry irradiated the roof; Richard Long did a walk in the mountains; Mario

Merz made one of his first igloos; Michael Heizer opened
the sidewalk; Walter de Maria produced his telephone piece;
Richard Serra showed lead sculptures, the belt piece, and
a splash piece; Weiner took a square meter out of the wall;
Beuys made a grease sculpture. The Kunsthalle became a
real laboratory and a new exhibition style was born—one of
structured chaos.

*Speaking of new structures for exhibitions, I wanted to ask you about
the Agentur für geistige Gastarbeit (Agency for spiritual guest work).
I know that it served as a kind of base from which you mounted a
number of significant shows in the early 1970s, but I'm unclear how
the agency was founded.*

When Attitudes Become Form and the following exhibition
Friends and their Friends provoked a scandal in Bern. To me,
what I was showing were artworks, but the critics and the
public did not agree. The city government and the parliament
got involved. Finally they decided that I could remain the
director if I didn't put human lives in danger—they thought
my activities were destructive to humankind. Even worse,
the exhibition committee was mainly composed of local art-
ists and they decided that from now on they would dictate
the programs. They rejected the Edward Kienholz show
and the solo show of Beuys, to which he had already agreed.
Suddenly it was war, and I decided to resign, to become a
freelance curator. It was during that period that the hostil-
ity to foreign workers began to manifest itself; a political
party was even founded to lower the number of foreigners
in Switzerland. I was attacked since my name was not Swiss
but Hungarian. In response, I founded the *Agentur für geistige
Gastarbeit*, which was a political statement since the Italian,
Turkish, and Spanish workers in Switzerland were called
"guest workers." The agency was a one-man enterprise, a
kind of institutionalization of myself, and its slogans were
both ideological—"Replace Property with Free Activity"—
and practical—"From Vision to Nail"—which meant that I
did everything from conceptualizing the project to hanging
the works. It was the spirit of 1968.

Since I wasn't under contract at the Kunsthalle, I was
free of my duties in September of 1969 and then I immediately
began a film project called *Height x Length x Width*, with artists

such as Bernhard Luginbühl, Markus Raetz, and Burkhard.
But soon offers to do shows started arriving at the agency. I
organized an exhibition in Nuremberg, *The Thing as Object*,
1970; in Cologne, *Happening and Fluxus*, 1970; in Sydney and
Melbourne, *I Want to Leave a Nice Well-Done Child Here*, 1971;
and, of course, Documenta V.

Let's talk about your 1970 exhibition Happening and Fluxus
in Cologne. *In this exhibition, time was more important than space.
How did you decide on this approach?*

During the preparation of *Attitudes* I had long talks with Dick
Bellamy at Leo Castelli about the art that preceded what
I had grouped under the rubric *Attitudes*. Of course Pollock
was evoked, but also Alan Kaprow's early Happenings and
Viennese Actionism. So when I was asked by Cologne's cultural
minister to do a show, I thought, "This is the place to retrace
the history of Happenings and Fluxus." Wuppertal, where
Nam Jun Paik, Beuys, and Wolf Vostell had staged events,
was nearby. So was Wiesbaden, where George Maciunas orga-
nized early Fluxus concerts, and in Cologne itself Heiner
Friedrich had promoted La Monte Young. I chose a three-part
structure. Part one was a wall of documents that I put to-
gether with Hans Sohm, who had passionately collected the
invitations, flyers, and other printed materials that related to
all the Happenings and events in recent art history. This wall
of documents divided the space of Cologne's Kunstverein
in two. On each side, there were smaller spaces where artists
could present their own work—this was the second part of the
show. All kinds of gestures were possible: Claes Oldenburg
put up posters and publications, Ben Vautier did a perfor-
mance piece in which he provoked the audience, [Tetsumi]
Kudo imprisoned himself in a cage, and so on. A third part
consisted of environments by Wolf Vostell, Robert Watts,
Dick Higgins, as well as [Allan] Kaprow's tire piece. To cap it
all, there was a Fluxus concert with Vautier, [George] Brecht,
and others, as well as happenings inside and outside the
museum with Vostell, Higgins, Kaprow, Vautier, and of course
Otto Mühl and Hermann Nitsch.
 During the preparations, I felt something was lacking.
So a couple of weeks before the exhibition opened, I invited,
against Vostell's wishes, the Viennese Actionists—Gunter

Brus, Mühl, and Nitsch—to add some spice to what was in danger of becoming a reunion of veterans. It was the first public appearance of the Viennese and they took full advantage of the opportunity. Their spaces were filled with documents concerning the *Art and Revolution* event at the University of Vienna, which had been followed by a trial. Brus, Mühl, and Oswald Wiener were given six months detention for degrading state symbols. Their sentences were later reduced except for Brus'. It was after that that Brus and Nitsch emigrated to Germany and founded the "Austrian Exile Government" with Wiener. Their films for sexual freedom and body-oriented art, their performances, caused a scandal.

It was all very messy. Vostell, who had a pregnant cow in his environment, was forbidden by the Veterinary Institute to let her give birth. So he wanted to cancel the show. But finally, after a night of discussion, we decided to open. Since the exhibition was upsetting the authorities, it had to open and stay open.

Beuys was not in the show, but of course he came knocking on the museum's door in the name of his "East-West Fluxus." The same happened in *Attitudes* with Buren. Although I didn't invite him, he came and glued his stripes throughout the streets around the Kunsthalle.

But Buren was invited to Documenta?

Yes. And of course I knew that he would put me on the spot by choosing the most problematic locations for his striped paper. He was very critical of Documenta. He said curators were becoming super-artists who used artworks like so many brush strokes in a huge painting. But the artists accepted his intervention, which took the form of discrete white stripes on white wallpaper. It was only later that I heard that Will Insley was offended by the wallpaper along the base of his huge utopian architectural model. Beuys participated with his Office for Direct Democracy, where he sat throughout the run of Documenta discussing art, social problems, and daily life with visitors to the show. He chose the well-known medium of the office to show that you can be creative every-where. He also intended by his presence to abolish political parties, to make each man represent himself.

This was the first time that Documenta was no longer

conceived as a "100 Day Museum" but as a "100 Day Event."
After the summer of 1968, theorizing in the art world was the
order of the day, and it shocked people when I put a stop to
all the Hegelian and Marxist discussions. With Documenta
I wanted to trace a trajectory of mimesis, borrowing from
Hegel's discussion about the reality of the image [*Abbildung*]
versus the reality of the imaged [*Abgebildetes*]. You began
with "Images That Lie" (such as publicity, propaganda, and
kitsch), passed through utopian architecture, religious imagery
and Art Brut, moved on to Beuys' office, and then to gorgeous
installations like Serra's *Circuit*, 1972. You could lie down
under the roof and dream to a continuous sound by La Monte
Young. All the emerging artists of the late 1960s were pres-
ent. And their works formed an exhibition that included
performances by artists such as Vito Acconci, Howard Fried,
Terry Fox, [James Lee] Byars, Paul Cotton, Joan Jonas, and
Rebecca Horn. I also decided to use only the two museum
spaces and forget about putting up sculptures outdoors. The
result was a balance between static work and movement,
huge installations and small, delicate works.

I always felt that it was the only Documenta possible
at that time, though during the first two months the reception
in Germany was devastating. In France they immediately
grasped the underlying structure of moving from the "reality
of the image," such as political propaganda, to "imaged
reality"—Social Realist work or photorealism, for example—
to "the identity or non-identity of the image and the imaged"—
Conceptual art, loosely speaking. I also wanted to avoid the
eternal battle between two styles, Surrealism versus Dada,
Pop versus Minimalism, and so on, that characterizes art
history, and so I coined the term "individual mythologies,"
a question of attitude not style.

*Your notion of an "individual," self-generated mythology began with
sculptor Etienne-Martin.*

Yes, this expression was born when I organized an Etienne-
Martin show in 1963. His on-site sculptures called *Demeures*
(Dwellings) were for me a revolutionary idea, though the
surfaces were still in the tradition of [Auguste] Rodin. The
concept of "individual mythology" was to postulate an art
history of intense intentions that can take diverse shapes:

people create their own sign systems, which take time
to be deciphered.

What about Deleuze's Anti-Oedipus? *Did it influence your way of
conceiving Documenta V?*

I only read Deleuze (*Anti-Oedipus*) for *Bachelor Machines*,
not before. I've never read as much as people think I have.
When I curate exhibitions I barely have time to read.

*After Documenta, you founded what you called the Museum of
Obsessions. How did it come about and what was its function?*

I invented this Museum, which exists only in my head, to
give direction to the Agentur für geistige Gastarbeit. It was
Easter 1974 and the agency had already existed for five years.
Documenta had been a brutal exhibition: with 225,000 visitors,
fragile pieces were easily damaged if you did not pay atten-
tion. I reacted to that by organizing a very intimate exhibition
in an apartment, called *Grandfather*, which consisted of my
grandfather's personal belongings, and the tools of his pro-
fession—he was a hairdresser, an artist. I arranged these things
to create an environment that reflected my interpretation of
who he was. I have always maintained that it is important to
try new approaches.
 In *Bachelor Machines*, for instance, the show was slightly
different in each museum to which it traveled. New things
were constantly added, in tribute to the various towns where
the show was held: it went from Bern, to Venice, Brussels,
Düsseldorf, Paris, Malmö, Amsterdam, and Vienna. After
Documenta, I had to find a new way of doing exhibitions.
There was no sense in proposing retrospectives to my col-
leagues at the institutions; they could as easily do these shows
themselves. So I invented something else. In the Museum
of Obsessions I settled on three fundamental themes, meta-
phors that had to be given visual form: the Bachelor, la
Mamma, and the Sun. *Bachelor Machines* was inspired by
Duchamp's *Large Glass* [1915–1923] and similar machines or
machine-like men, such as those in Franz Kafka's short
story *In the Penal Colony* [1914], Raymond Roussel's *Impressions
d'Afrique* [1910], and Alfred Jarry's *Le Surmâle* [1902], and it
had to do with a belief in eternal energy flow as a way to avoid

death, as an erotics of life: the bachelor as rebel-model, as anti-procreation. Duchamp suggested that males are only a projection in three dimensions of a four-dimensional female power. I therefore combined works by artists who create symbols that will survive them—like Duchamp—and those artists who have what I would like to call primary obsessions, whose lives are organized around their obsessions, such as Heinrich Anton Müller. Of course, I also wanted to abolish the barrier between high art and outsider art. With the Museum of Obsessions, the word "obsession," which from the Middle Ages up to Jung's "individuation process" had negative con-notations, came to stand for a positive kind of energy.

Another exhibition in this series was *Monte Verità*, which embraced the themes of the "Sun" and "La Mamma." Around 1900 a lot of northerners traveled south to realize their utopias in the sun, and in what they considered a matri-archal landscape. Monte Verità, near Ascona, Italy, was such a place. Many of the representatives of the greatest utopias went there: the Anarchists ([Mikhail] Bakunin, [Errico] Malatesta, [James] Guillaume); the theosophists; the creators of paradise on earth in the form of botanical gardens; the life reform movement, which considered itself an alternative to both communism and capitalism; then the artists of Der Blaue Reiter; the Bauhaus; the revolutionaries of the new dance movement (Rudolf Laban, Mary Wigman); later on El Lissitzky, Hans Arp, Julius Bissier, Ben Nicholson, Richard Lindner, Daniel Spoerri, Erik Dietmann. Ascona is actually a case study in how what are now fashionable tourist desti-nations get that way: first you have romantic idealists, then social utopias that attract artists, then come the bankers who buy the paintings and want to live where the artists do. When the bankers call for architects the disaster starts. When I did the show with the subtitle "Local Anthropology to Form a New Kind of Sacred Topography," there was another goal: to preserve the architecture on Monte Verità, which, though it only covered a 26-year span, presented an entire history of modern utopian architecture. The life reformers who wanted to get back to nature built huts, the theosophists attempted to eradicate the right angle, then there was the crazy style of Northern Italian villas, and finally the rational style of the Hotel Monte Verità (first drawn by Mies van der Rohe but executed by Emil Fahrenkamp, who built the Shell House in Berlin).

Monte Verità involved about 300 people who were either
represented individually or in one of the sections, each
devoted to a particular utopian ideology: anarchy, theosophy,
vegetarianism, land reform, to name only a few. You can
imagine how much research it involved. Even during the
exhibition, new documents and objects kept arriving. To deal
with them, I bought a bed made by an anthroposophical sculp-
tor (who had worked for Rudolf Steiner's first Goetheanum)
where I put all the newly arrived objects and letters before
they were integrated into the show, in which documentation
was grouped thematically, while the artworks were hung in
a separate space.

Did Monte Verità *map psychogeographical connections?*

It helped me to retell the history of Central Europe through
the history of utopias, the history of failures instead of
the history of power. Looking at Hultén's great shows at the
Pompidou, I realized that he always chose an east–west
power axis: *Paris–New York, Paris–Berlin, Paris–Moscow.* I chose
north–south. It was not about power but about change and
love and subversion. This was a new way of doing shows, not
only documenting a world, but creating one. Artists were
especially comfortable with this approach.

After Monte Verità *you did* Gesamtkunstwerk?

Yes, needless to say a Gesamtkunstwerk can only exist in
the imagination. In this exhibition, I started with German
Romantic artists like [Philippe Otto] Runge, a contemporary
of Novalis and Caspar David Friedrich, and the architects
during the French Revolution; then I included works and
documents relating to major cultural figures like Richard
Wagner and Ludwig II; Rudolf Steiner and Vassily Kandinsky;
Facteur Cheval and Tatlin; Hugo Ball and Johannes Baader;
[Oskar] Schlemmer's *Triadic Ballet* [1927] and Schwitters'
Cathedral of Erotic Misery; the Bauhaus manifesto "Let's build
the cathedral of our times"; Antoni Gaudi and the Glass
Chain movement; Antonin Artaud, Adolf Wölfli, and Gabriele
d'Annunzio; Beuys; and in cinema Abel Gance and Hans-
Jürgen Syberberg. Once again it was a history of utopias.
At the center of the exhibition was a small space with what

I would call the primary artistic gestures of our century: a Kandinsky of 1911, Duchamp's *Large Glass*, a Mondrian, and a Malevitch. I ended the show with Beuys as the representative of the last revolution in the visual arts.

Since the 1980s you've focused on several big retrospectives which you organized for the Kunsthaus in Zurich: Mario Merz, James Ensor, Sigmar Polke, and more recently, Cy Twombly, Bruce Nauman, Georg Baselitz, Richard Serra, Joseph Beuys, and Walter De Maria.

Again I was lucky. After ten years of thematic exhibitions I felt the need to return to the artists I had always loved. When Felix Baumann, director of the Kunsthaus in Zurich, gave me a job with the museum, I was able to offer artists a large retrospective or a special installation in one of the biggest exhibition spaces in Europe. Of course, I tried to make the shows as splendid as I could. Actually Serra and De Maria each did site-specific installations: *Twelve Hours of the Day*, 1990, and *The Zoo Sculpture*, 1992, respectively. With Merz we pulled down the walls and all his igloos formed an imaginary city. Having worked with these artists at the end of the 1960s, it was great to do major exhibitions with them all these years later. After a 24-year wait, I was able to realize the Beuys exhibition in 1993. I secured most of his important installations and sculptures. The show was my homage to a great artist: I had always thought that after his death an exhibition should be made reflecting his concept of energy, and I was pleased when his friends who came to the show told me they felt like Beuys had just emerged from one of his sculptures.

How significant have group shows been to your curatorial practice?

In 1980 I created *Aperto* for the Venice Biennale to show new artists or rediscover older ones. In 1985 I felt that a new kind of *Aperto* was needed, there was still a predominance of "Wilde Malerei," and I wanted to introduce the somewhat forgotten quality of silence. The show I mounted was called *Spuren, Skulpturen, und Monumente ihrer präzisen Reise* (Traces, Sculptures, and Monuments of their Precise Voyage) and it was introduced by Brancusi's *Sleeping Muse*, [Alberto] Giacometti's *Pointe à l'oeil* [1932], and [Medardo] Rosso's *Sick*

Child [1893], and included sculptures by [Ulrich] Ruckriem, Twombly, and Tony Cragg at the end of the space, works by Franz West, Thomas Virnich, and Royden Rabinowitch in the center, and in triangular rooms works by Wolfgang Laib, Byars, Merz, and Richard Tuttle. It was sheer poetry. This show was followed in Vienna by *De Sculptura*, in Düsseldorf by *SkulpturSein* (To Be Sculpture), in Berlin by *Zeitlos* (Timeless), in Rotterdam by *A-Historical Soundings*, in Hamburg by *Einleuchten* (Illuminate), in Tokyo by *Light Seed*, in Bordeaux by *G.A.S. (Grandiose, Ambitieux, Silencieux)*. As you can see, the titles of the shows became very poetic. They don't weigh on the artists and their works.

You have gone back and forth, working both inside and outside official institutions. What's made you keep a foot in each world?

I wanted to organize non-institutional exhibitions but was dependent on institutions to show them. That's why I often turned to non-traditional exhibition spaces. *Grandfather* was done in a private apartment and *Monte Verità* in five locations never before used for art—including a theosophical villa, an ex-theater, and a gymnasium in Ascona—before it traveled to museums in Zurich, Berlin, Vienna, and Munich.

These shows demonstrate another tendency of your exhibits in the 1980s: an increasing number of shows in unusual exhibition spaces.

Yes, absolutely. The shows I did in the 1980s were sometimes the first contact the local public had with new art, so by necessity they were group shows. At the same time, I looked for spaces that would be an adventure for the artists. These exhibitions also allowed younger artists to show internationally for the first time: Rachel Whiteread in Hamburg, Chohreh Feyzdjou in Bordeaux. It's not a coincidence that they're mostly women. I agree with Beuys that at the end of this century culture will be the province of women. In Switzerland most Kunsthalle curators are young women and Pipilotti Rist and Muda Mathis are the liveliest artists. Their work has a truly fresh and courageous poetic aggression.

What about your current project, Austria im Rosennetz *(Austria in a Net of Roses), which just opened at the MAK in Vienna?*

How does it relate to the exhibition you did in 1991 on Swiss culture,
Visionary Switzerland?

Visionary Switzerland coincided with Switzerland's 700-year
anniversary. At the center of the show was the work of great
Swiss artists such as Paul Klee, Meret Oppenheim, Sophie
Taeuber-Arp, Giacometti, and Merz, juxtaposed with material
on those who wanted to change the world such as Max
Daetwyler, Karl Bickel, Ettore Jelmorini, Emma Kunz, Armand
Schulthess, and, of course, Müller's autoerotic machine and
Tinguely's art-producing machines, surrounded by the work
of artists like Vautier, Raetz, and so on.

This exhibition traveled to Madrid and Düsseldorf
and was perceived as a homage to creativity rather than as a
"national" exhibition. One thing that came out of is was the
Swiss Pavilion of the World Exhibition in Seville 1992,
where I replaced the Swiss flag with large banners by Burkhard
showing parts of the human body representing the six or
seven senses, and created a circuit of work that integrated
information, technology, politics, and art, which began with
Vautier's painting *La Suisse n'existe pas* (Switzerland does not
exist) and ended with his *Je pense donc je suisse.*

The Austrian Minister of Culture saw these events and
asked me if I would do a spiritual portrait of Austria. I called
it *Austria im Rosennetz.* It's a huge panorama show of another
alpine culture. Austria is a complex place—once an empire
with a flourishing capital where East met West, it is now a
small country. In the Museum für Angewandte Kunst, I begin
with a room that examines Austria's dynasty; the second
room has portraits by Messerschmidt juxtaposed with Arnulf
Rainer's overdrawings of those photographic portraits and
Weegee's photographs. In the third room are the now-classi-
cal Austrian artists and architects of the Vienna Secession.
The fourth and fifth rooms are devoted to narrative, showcas-
ing works by Aloys Zöttl, an unknown 19th-century animal
painter, Fritz von Herzmanovsky-Orlando who wrote the
book *Der Gaulschreck im Rosennetz* (Terror of the Horses in the
Net of Roses, 1928), Richard Teschner's marionettes, and,
finally, the carriage that transported the body of Crown Prince
Ferdinand, who was killed in Sarajevo. The entrance hall
is a kind of Wunderkammer with Turkish relics and Hans
Hollein's couch from 19 Berggasse, where Freud practiced

psychoanalysis. The upper floor shows Austrian inventions: Auer's lamp and its use by Duchamp; [Josef] Madersperger's sewing machine with Lautréamont's poetic image and Man Ray's *The Enigma of Isidore Ducasse* [1920]; Franz Gsellmann's *World Machine* with Tinguely's late multicolored and brightly lit sculptures. Three screening programs are devoted to Austria's influence on Hollywood: Erich von Stroheim, Fritz Lang, Michael Curtiz, Peter Lorre, Béla Lugosi, and many others (all of whom emigrated), and Austrian experimental film (Peter Kubelka, Kurt Kren, Ferry Radax). The seats in this cinema are a work by Franz West who is represented throughout the show along with other contemporary artists: Maria Lassnig, Eva Schlegel, Valie Export, Friederike Pezold, Peter Kogler, Heimo Zobernig, and Rainer Ganahl, to name just a few.

Given a century in which the exhibition is more and more of a medium, and more artists claim that the exhibition is the work and the work is the exhibition, what would you say are the turning points in the history of mounting exhibitions?

Duchamp's *Box in a Valise* [1935–1941] was the smallest exhibition; the one Lissitzky designed for the Russian pavilion of the *Pressa* in Cologne in 1928, the largest. During Documenta V, I did a section *Museums by Artists* with Duchamp, Broodthaers, Vautier, Herbert Distel, and the *Mouse Museum* [1965–1977] by Oldenburg, which I think was important. The master of the exhibition as medium is, for me, Christian Boltanski.

Which artists of the 1990s interest you?

I appreciate the intensity of Matthew Barney, although having seen his show in Bern I prefer his videotapes to his objects. I also like younger video artists such as Pipilotti Rist and Muda Mathis.

I know you have a huge archive. How do you organize the information you need for your work?

My archive changes permanently. It reflects my work. If I do a solo show I make sure to have all the documentation on the artist, if it is a thematic exhibition I keep a library.

My archive is a function of my own history. I know that I do not have to look for Wagner under the letter W but under "Gesamtkunstwerk." I also sort museum collection catalogues by location, in order to have a mental portrait of the institutions. My archive is a collection of several libraries. There is one for Ticino, which originally grew out of *Monte Verità*, one for dance, film, and Art Brut; of course there are multiple cross references. The most important thing is to walk through with closed eyes, letting your hand choose. My archive is my memoir, that's how I look at it. Too bad I cannot walk through it any more. It has become so full. Like Picasso, I would like to close the door and start another.

Despite the current increase in information about art via the Internet and other media, knowledge still depends a lot on meeting people. I see exhibitions as a result of dialogues, where the curator functions in the ideal case as a catalyst.

The problem is that information can be retrieved via the Internet, but you have to go to the site in question in order to see if there is something behind it, whether the material has enough presence to survive. The best work is always the least reproducible. So you speed from one studio to the next, from one original to another, hoping that some day it will all come together in an organism called an exhibition.

In the 1980s, hundreds of new museums opened their doors. But the number of significant venues did not increase. Why do you think that's the case?

Whether a place is significant or not still depends on personality. Some institutions don't show courage or love for art. For many new museums today all the energy and money goes toward hiring a "star" architect and the director is too often left with spaces he doesn't like and no money to change them. High walls, light coming in from the ceiling, a neutral floor are still the best bet and the cheapest one. Artists usually prefer simplicity, too.

By establishing structures of your own, you initiated a practice, which only in recent decades has come to be called curator or exhibition organizer. You were a pioneer.

Being an independent curator means maintaining a fragile equilibrium. There are situations where you work because you want to do the show though there's no money and others where you get paid. I've been very privileged all these years since I've never had to ask for a job or a place to exhibit. Since 1981 I've been an independent curator at the Kunsthaus in Zurich, which has left me time to do shows in Vienna, Berlin, Hamburg, Paris, Bordeaux, and Madrid, and to run the museums I founded on *Monte Verità* with no state funds. But of course you work harder as a freelance curator, as Beuys said: no weekends, no holidays. I'm proud that I still have a vision and that, rarer still, I often hammer in the nails. It's very exciting to work this way, but one thing is sure: you never get rich.

Félix Fénéon described the role of the curator as that of a catalyst, a pedestrian bridge between art and public. Suzanne Pagé, director of the Musée d'Art moderne de la Ville de Paris with whom I often collaborate, gives an even more humble definition. She defines the curator as a "commis de l'artiste" [an artist's clerk]. How would you define it?

Well, the curator has to be flexible. Sometimes he is the servant, sometimes the assistant, sometimes he gives artists ideas of how to present their work; in group shows he's the coordinator, in thematic shows, the inventor. But the most important thing about curating is to do it with enthusiasm and love—with a little obsessiveness.

Franz Meyer

Born in 1919 in Zurich, where he died in 2007.

Franz Meyer directed the Berner Kunsthalle from 1955 to 1961, and then became director of the Kunstmuseum Basel from 1962 to 1980.

Previously unpublished, this interview was conducted in 2001 in Meyer's house in Zurich.

Translated from the German by Judith Hayward.

HUO *I'd like to do an interview with you for a series that includes Pontus Hultén, Harald Szeemann, Walter Hopps, etc.*

FM I don't think I'm an exhibition organizer like my famous colleague Harald Szeemann. I can't be compared with him in any way. My interest was primarily the creation of a certain continuity of first-rate art in the collection of the Kunst-museum Basel. In the years before that, though, when I was working at the Kunsthalle Bern, I did do exhibitions. However, that happened as the continuation of a tradition that had been created there by Arnold Rüdlinger, the curatorial pioneer of modern art exhibitions. If he were still alive, you'd definite-ly have had to talk to him. The basis for my work at the Kunsthalle Bern was discussions about contemporary art with Rüdlinger. Above all we asked ourselves: "What counts?" "What will last?" and "What is just art for the day?"

At that time our horizon was confined to what was going on in Paris. When I came across Pollock for the first time at an exhibition in Paris, I just felt provoked. I rejected his work because at that time his painting seemed too overwhelming for me. And I didn't understand his use of the total canvas. A year later, in 1953, I stayed in New York for a few weeks. There all at once I felt very directly addressed by Pollock's works. They were suddenly accessible to me in the American environment.

And did you meet him?

Unfortunately, no.

Where did you begin in coming to terms with modern art?

In relation to the contemporary art of that time, Rüdlinger imparted the fundamentals to me.

When did you meet him for the first time?

In the late 1940s.

I've established that there's virtually an amnesia in terms of the achievements of the curators who were the first to exhibit modern art. That's true for example of Alexander Dorner who worked at the Landesmuseum in Hannover, and I've done a lot of work on him. For example, none of his writings are any longer available in book form. That obviously applies to Rüdlinger too. There's an amnesia when it comes to the history of curators, and the history of exhibitions too.

I think that's mainly because their achievements were intended for their own time. While they were influential, they have nonetheless been forgotten. I certainly benefited from Rüdlinger's work, in my Paris years too, 1951 to 1955. At the time he had the idea that I could be his successor in Bern. I hadn't yet completed my studies. But I accepted, and in 1955 started as the director of the Kunsthalle Bern. When I hung my first exhibition, it was a very big challenge for me. But I began to love the work.

What was so important for you in your conversations with Rüdlinger?

My art-history dissertation was on the stained glass windows of Chartres. I was married to Chagall's daughter, Ida Chagall. As a result I was living at the heart of the art scene. When Rüdlinger approached me, I accepted his offer gladly. Then in Bern I organized six to eight exhibitions a year. At that time it had to be done with very few staff—a caretaker, a secretary, and a cashier.

That's how Walter Hopps described the situation to me too. The bureaucratic outlay was very small, and you did most things yourself.

If we were preparing an exhibition with artists from Paris, we drove there with a truck and fetched the pictures ourselves. Everything happened very directly. Exhibitions always closed on a Sunday evening. Overnight to Monday everything was taken down. The next day the material for the new exhibition was distributed in the rooms. We began to hang the works. Then on Wednesday I generally wrote the catalogue text, which I had to hand in on the Thursday morning. The following Saturday, the official opening took place. In that period I exhibited a great many Swiss artists, because the activities of the Kunsthalle Bern were also strongly related to the regional context. Besides that there were of course also the ventures into international modern art. The ones I remember most vividly are the exhibitions of Max Ernst and Alberto Giacometti, [Oskar] Schlemmer, [Alexei] Jawlensky, and [Henri] Matisse, oh, and Odilon Redon too.

Were these exhibitions organized in direct collaboration with the artists?

Yes, only in the case of Giacometti and Max Ernst of course. I knew Alberto Giacometti from my Paris days. He was very welcoming if he sensed that the person contacting him was sympathetic toward him. He could be a wonderful story-teller. I can still hear his voice in my ear. Understanding of his work came from the experience of being with him. For me the sculptures took pride of place, the 1956 exhibition in Bern was very concentrated, I think.

Did Giacometti collaborate on the installation?

No. Just before it he had set up his first exhibition at the

Venice Biennale and arrived in Bern early on Thursday
morning by train. He was very upset, because during the train
journey it had occurred to him that the plinth of one sculp-
tures he was showing at the Biennale was a centimeter too low
or too high. We had to calm him down, and let Venice
know by phone. He was quite happy with the installation at
the Kunsthalle Bern.

*Which other exhibitions in your time in Bern were especially important
for you?*

The exhibition with works by Malevich. It was passed on to
us by [Willem] Sandberg. He'd just acquired the pictures for
the Stedelijk Museum in Amsterdam. In addition there
were pictures in private ownership in Bern. I tried to involve
other Russian artists as well. But at that time Russian art
from the modern period was still virgin territory. There was
no literature on it.

Did you travel to Moscow?

No, you couldn't do that back then, in 1958.

*It also has to be borne in mind that the institutional infrastructure was
far less developed. In the 1950s there were art galleries in just a
few towns, today there are hundreds, and to some extent their curators
collaborate closely.*

That's right. Then it was less common for exhibitions to be
passed on. One striking exception was my exhibition with
Matisse. At the time I traveled to see Marguerite Duthuit, the
artist's daughter, with the idea of staging a retrospective.
She advised me to abandon the project, as the most important
pictures in Russian, Danish, and American collections would
not be available for loan. She suggested I should put on a
first complete exhibition of Matisse's late work, namely the
gouache cutouts. That exhibition fitted perfectly into the
little Kunsthalle Bern. There was a tremendous official open-
ing. The exhibition was taken on by many European and
American museums. The influence of the show on younger
artists was huge.

Did you know Matisse?

I'd visited Matisse with my wife Ida Chagall, who knew him well. The Matisse I met was this wonderful patriarch.

Did you also have contacts with artists of the younger generation, for example [Serge] Poliakoff?

In 1951 I went with the Paris art critic Charles Estienne to his studio, which the artist had set up in a bathroom in Montmartre. I was filled with enthusiasm, and bought a picture there. The meeting with Poliakoff was very fruitful for me. Of course I also showed his work in Bern.

Which younger artists did you show in Bern?

[Antoni] Tàpies, who interested me particularly. From the Paris School, the Swiss artist Wilfried Moser, as well as [Pierre] Alechinsky, [Jean] Messagier, and [Pierre] Tal-Coat. And then Sam Francis. Also some younger Swiss artists, starting with Tinguely and [Bernhard] Luginbühl.

Was there already a network of curators in the 1950s?

There was a network in the sense that we knew one another. First and foremost Sandberg in Amsterdam was very important.

Was Knud Jensen already part of that network at that time?

Yes. He was a good friend.

The activities seem to have been very much concentrated on Europe. How did you feel about the avant-garde moving from Paris to New York?

I became aware that was happening when Rüdlinger opened the major exhibition of American artists at the Kunsthalle Basel in 1958. Rüdlinger's great achievement was the discovery of American art for Europe. Recently there's been an excellent biography of him by Bettina von Meyenburg, which underlines that. Rüdlinger "got to America" through contact with Sam Francis. In 1957 he traveled to New York for the first time and immediately made contact there with all the important artists.

Was Sam Francis the link?

Yes. Rüdlinger plunged into the New York art scene, and met Franz Kline, [Willem] de Kooning, [Clyfford] Still, [Mark] Rothko, and many others. In addition, he gained access to Barnett Newman through the collector Ben Heller. He was the very first museologist to get to Newman. Rüdlinger planned an exhibition for Basel with the artists he regarded as crucial. But Clyfford Still didn't want to take part, and that project then came to nothing. In its place there was an exhibition put together by MoMA for a European tour, less radical and rather more broadly based, which started in April 1958 in Basel because of Rüdlinger. It was only through it that the public in Europe became conscious of the importance of American painting. The second act in Basel came about with the help of the President of the Basle Art Association, Hans Theler. Rüdlinger recommended that he donate American art to the Kunstmuseum Basel to celebrate the jubilee of his firm, Schweizerische Nationalversicherung. Theler agreed, and Rüdlinger traveled to New York with 100,000 Swiss francs. He bought four superb pictures—a painting each by Still, Rothko, Kline, and Newman. Unfortunately that sum of money quite obviously did not stretch to a Pollock, he was already much more expensive by then. Thus Basel became the first museum in Europe to own pictures by these artists. That's how the discovery of America came about. Rüdlinger was the pioneer.

In the 1950s the cultural climate in Bern was downright electrifying. Paul Nizon told me that too. There was a very interesting exchange between the students and a lively cultural scene. Today Zurich, Geneva, and Basle are much more dynamic. How do you account for that?

Rüdlinger's activities certainly played an important role. He set a lot of things in motion. Furthermore Daniel Spoerri and Dieter Roth, for example, gave a very important impetus. They all restrained the influence of officialdom and rustic Bern for a few years.

When did you leave Bern and go to the Kunstmuseum Basel?

In 1962.

I'd like to talk about the duties of the museum director in terms of building up a collection. Last year in a very interesting article you expressed a critical opinion in the debate about who should take over at the Kunsthaus in Zurich.

I stressed the primacy of familiarity with contemporary art. But at the beginning of my time as a curator I was certainly not so eager to embrace the truly innovative. When I came to the Kunstmuseum Basel, I brought a handful of artists with me that I wanted to integrate into the collection. For example there was [Eduardo] Chillida, Tàpies, Poliakoff, and Sam Francis. I achieved that in my first years there. But the main controversy related to Picasso. After the acquisition of individual pictures, in 1967 we undertook to buy two very expensive, important works. There was even a plebiscite over it.

Can you tell us more about this unique occurrence?

The affair went back to the collection of the Rudolf Staechelin Family Foundation whose main works were hanging in the Kunstmuseum. A picture from that collection had to be sold because the Staechelin family was experiencing financial difficulties—an important van Gogh. Admittedly the Foundation offered the museum itself the opportunity to buy the picture. We are talking about millions, and a rapid decision wasn't possible. We then got together with the board of the Foundation and we were made this offer: if the museum would buy two Picassos from the Foundation, the whole collection would remain in the museum for 15 years as a long-term loan. The price for these two pictures was 9.5 million Swiss francs. Six million was to be contributed by the city. The authorities agreed, for the people of Basle had identified with the Staechelin pictures. Six million—it wasn't that easy. There is the referendum system, and the citizens then demanded a plebiscite. The city was in a state of agitation. Almost all those with cultural responsibilities, as well as the younger polpulation came down on the side of Picasso. And the miracle happened: the people agreed. The other millions were assembled too. Almost all from private individuals, an expression of tremendous cultural solidarity. There was even a "beggars' festival" in all the streets and bars and restaurants of the city. People wore "I like Pablo" badges. The whole

action was carried along on a great wave of enthusiasm. In this situation Basle proved its credentials as a city of culture with a centuries-old tradition. Something like that could only have happened in Basle, in my opinion. Picasso was informed of it. After the positive outcome of the plebiscite he decided to make a gift to the museum. It consisted of a drawing of *Les Demoiselles d'Avignon*, a picture dating from 1907, as well as a more recent picture, which I was allowed to select in his studio. I was torn between two very different works. Picasso then donated them both to us. In addition there was a superb gift from the Basle patron of the arts, Maja Sacher: she gave us Picasso's *Le Poète*, 1912.

That's a unique story of direct democracy. Can you tell us about any other exhibition and collecting moments that were important for you in your time in Basle?

In spite of the success with Picasso, we knew it wouldn't be possible to continue doing things that way with the classic Modern period. A change of direction was necessary. And more recent art demanded fair treatment. The major Americans were represented, in each case with one picture. We wanted to build on that. In 1969 I tried to persuade the committee to buy another picture each by Rothko and Newman. I was successful with my first request. However, the purchase of a work by Newman was turned down. The breakthrough didn't come until two years later, after the major retrospective of Newman's works, which was also shown in Amsterdam. A few members of the museum committee traveled to Amsterdam at the time to see the exhibition for themselves, and suddenly the enthusiasm for Newman was there. Thereupon I was able to buy the picture *White Fire II* [1960] at an auction in New York. Then the purchase of another picture resulted from the contact with Annalee Newman, a picture of the type I'd reserved two years earlier, and of a sculpture. Thus the museum gained possession of a superb group of works by Newman—I always liked to see him next to Giacometti. Unfortunately we were unsuccessful in trying to purchase works by Pollock, a bitter disappointment. Then of course the question arose of what should be added next. At that time I was still very committed to the art-historical concept of the sequence of innovations. But what was the next step

now, the most urgent thing? For example Jasper Johns, Robert Rauschenberg, or Cy Twombly? The decision came down in favor of Jasper Johns. After initial enthusiasm, I unfortunately ignored Rauschenberg. Twombly acquisitions followed later. Then the selection of Pop art and shaped canvases. I decided to go for Andy Warhol and Frank Stella.

At that time you also bought works by the recently rediscovered female artist Lee Bontecou.

Yes. I visited her in her studio and selected a work. However, the most important artist for me at that time was Frank Stella. Likewise I familiarized myself with Minimal art, and there again tried to reach a decision. I chose Donald Judd, Carl Andre, and Sol LeWitt. At the same time it took years for the most important works of Minimal art actually to be in the collection. The next person to come along in the American field was first and foremost Walter De Maria. I rather underestimated Arte Povera. Of course Harald Szeemann showed it in Bern, but I didn't really get into it.

The aspect I find very interesting in your remarks is that as a museum director and contemporary you pick out certain works and artists, although it has not yet been decided what will actually last. Can you say a little more about this pioneering role?

The complexity and inner consistency of a work always played a role. That counted for example in Warhol and [Claes] Oldenburg even more than in [Roy] Lichtenstein, who's also an outstanding artist.

I'd like to come back again to your line of argument in the debate about the advertisement for the post of Director of the Kunsthaus Zürich. In your article in the NZZ you expressly supported the concentration of the museum's activities on the art of the last 30 years.

It seems sensible to me that you can select from a wide offer at reasonable prices, and consequently always create a new perspective on the collection as a whole. Here the history of the reception of art is of special importance, particularly in the case of 20th-century art, as orders of importance gradually emerged. For their contemporaries, [Kees] van Dongen

too had his importance alongside Matisse. Today Matisse is supreme. What are the criteria behind this selection? Cézanne as one of the true greats made form his content. That produced an exploration of the conceptual spirit of science and technology, and accordingly of the new industrial world. All that of course steamrollered people. And the question was how we were supposed to live with it. Here exploration of the current work of art offered opportunities for integration. It enabled everyday experiences to be brought together with the spirit of the new. Cubism too played a main role to that extent. Thus this art has a forward-looking status, and, accordingly, a historical significance. The enduring topicality of great art was decisive for me, also in the sense of setting a standard for the present. I believe that if you show first-rate art from the 1990s in the museum today, visitors also experience the potential topicality of the old in a new and stronger way.

So you understand collection as a slow, evolving, and complex system?

That's right. Current art has an important stimulatory role in this. In my time at the museum, exploration of Beuys, for example, whom I haven't yet mentioned, changed everything.

You discovered him at the end of the 1960s?

I went to the official opening of the Beuys exhibition in the museum at Eindhoven. It was an impressive experience. A year later, in 1969, Dieter Koepplin, the head of the graphic collection, went along with my suggestion to do an exhibition with drawings and small objects. Following that, the decision was made to show [Karl] Ströher's Beuys collection at the museum. That produced something very intense that created quite a stir in Basle. And above all, the museum had changed. A new field of exploration opened up. Great status was now accorded to the exhibitions, generally organized by Dieter Koepplin.

I learnt from Jacques Herzog that one of the first works by Herzog and de Meuron was a carnival procession with Beuys in Basel. Were you involved in that action?

Not really. A few years after the first Beuys exhibition the

museum wanted to acquire a major work, the *Feuerstätte* [1968–1974]. As the work cost rather more than people were accustomed to for a work by a contemporary artist, we met with resistance in the parliament and among the population. Looking for a carnival subject, Herzog and de Meuron went to see Beuys. He designed something very wild and primeval for their carnival group, which linked up with *Feuerstätte*. The group turned up in felt suits with metal rods. That action was able to get rid of all the aggressive tension in a quite wonderful way. Afterward Beuys made a second *Feuerstätte* [1978–1979] out of the group's rods and felt suits, and gave it to the museum.

That's a very fine example of a public discussion about art. How do you view the present developments, which quite clearly show a move toward a privatization of museums?

I see museums as being in great danger. That privatization inevitably leads to museum curators being out-voted by the views of financially powerful circles. The interplay between the museum director and the committee such as I experienced when it came to purchases was very productive.

Today is it more and more frequently the case that American museologists in particular are becoming dependents of trusts.

And unfortunately that development is spreading to Europe.

Do you think it's necessary to resist it?

Certainly. It's just a question of how far that's possible. Of course I was also dependent on the committee, though its members were not handling their own money, but state funds, and therefore had to answer to the public for their actions.

Can you tell me which are your favorite museums?

Of course we're not talking about the Louvre or the Uffizi. For me the greatest role has no doubt been played by MoMA [New York]. But the museums of Krefeld and Mönchengladbach were also especially close to my heart.

How do you assess developments after Warhol and Beuys?

Bruce Nauman plays a major role for me there. I intervened successfully in his favor with regard to purchases in 1970. His exploration of the consciousness of oneself fascinated me. I admire [Richard] Serra's work too. But the Germans also are supremely important for me: [Georg] Baselitz and [Sigmar] Polke first and foremost. Of the artists of the 1990s I find Bill Viola, Rachel Whiteread, Roni Horn, Katharina Fritsch, Mike Kelley, and Fischli/Weiss particularly important.

Can you tell me about your projects after your time in Basel?

I left the Kunstmuseum Basel in 1981. Since then I've continued to study the art of the second half of the 20th century, but in a different way, writing and teaching. Last September I completed a work on Barnett Newman and I hope it will be published.

Is there any project that wasn't implemented, but that's very dear to you?

There still is a problem that has interested me for a long time. I ask myself how the artist stands in relation to the perception of the viewer. How does he forge a way for him through the work? There are artists like Matisse who virtually lead the viewer through the pictures, and headstrong artists like Anselm Kiefer into whose pictures we are thrust. I would like to study that in depth and take it on up to the art of today and the exploration of new media.

Seth Siegelaub

Born in 1942 in New York City. Has lived in Europe since the early 1970s, currently in Amsterdam.

Since the mid-1960s Seth Siegelaub has worked as an art dealer, publisher, and independent exhibitions organizer. His exhibitions explored conceptual art, while his books provided a new forum for artistic innovation outside of the museum or gallery.

This interview was conducted in 2000 in Amsterdam. It was published in *24ᵗʰ International Biennial of Graphic Arts,* International Centre of Graphic Arts, Ljubljana 2001, under the title "Interview with Seth Siegelaub," p. 220.

HUO *My first question concerns your most recent activity. Could you tell me about the special issue of* Art Press *magazine called "The Context of Art/The Art of Context" published in October 1996?*

ss For a number of years now, there's been a certain amount of interest in the art made during the late 1960s—perhaps for reasons of nostalgia or a return to the "good old days," who knows? As part of this interest, over the last few years I have been approached by a number of people to do an exhibition of "concept art" and I have always refused, as I try to avoid repeating myself. But in 1990, when I was approached by Marion and Roswitha Fricke—who have a gallery and bookshop in Düsseldorf—with the same request, I suggested doing a project that would try to deal with how and why people are looking at this period, and thus ask some questions about how art history in general is made.

To do this, I thought the most interesting thing to do would be to ask the artists themselves, who were active during the late 1960s and have lived through the past last 25 years, to give their thoughts and opinions about the art world; how (or if) it had changed, how their life had changed, etc. The Frickes were interested in the project, and together we began to organize it.

We began by asking artists to send us a written reply to our questions, but as not many of them had the time or interest to do this, we only had a few replies at first. Then we began to contact the artists more actively, and Marion and Roswitha Fricke began to do taped interviews with those who didn't reply in writing, and these written replies, along with the transcripts of the taped interviews—a total of about 70 responses—are what were published in *Art Press*.

To select the artists, I picked five exhibitions that were held in 1969—perhaps an arbitrary or personal selection, which finally is maybe not all that arbitrary—and all the artists who were in those five exhibitions were asked to reply; that is, all the artists who are still alive, about 110. What I liked, and still like, about the project is that we didn't just go after the artists who have been successful; we were also—maybe even, especially—interested in the people who had not been successful, who were left by the wayside for one reason or another, or changed profession, and so on. Thus, in this respect the replies are a more representative reflection of the period and the people who lived it, than if we only asked the famous artists to give their opinion, which is what is normally done—the way art history is traditionally written, i.e. through the eyes of those who have been most successful. Although I must say the replies were very uneven in the level of their reflection, ideas, or critical spirit, and so on—which had nothing whatsoever to do with who was successful or not—and the project just became a wide range of answers running from the highly intelligent to the somewhat less intelligent.

You also said it's about how the art world changed. Maybe this is linked to what we discussed earlier; you suggested that at that time, art was not necessarily work made for a general public, but more like a gang of friends.

It was a much more limited framework, in any case, a much smaller group of people; even just in terms of numbers, even before one speaks in terms of money or power or anything like that. The artist—I could say most other people in the art world too—had an entirely different relationship with the world around them, which seems to me to be very different from what I see happening today; that's all. So I wanted to know how—or if—the artists felt this change. Very few of them seemed to notice these differences, if I understand the replies correctly. It seems like the same old thing to many of them. Perhaps much of their formative ideas are still rooted in the 1960s? In any case, it is all there in their words.

It's interesting in terms of new structures. In the early 20th century, Alexander Dorner defined his museum in Hannover in Germany (the Landesmuseum) as a virtual Kraftwerk, a power plant, and he had all these ideas for a permanent transformation of the space, and so on. At the same time this remained a very solitary or singular experiment. How do you relate to the museum as a structure.

The way I have been involved with structures is by trying to avoid them, cutting across them, or at least by trying to avoid static structures, or trying to create flexible structures that correspond to real needs. In a certain way, in my specific case, this is related, on the one hand, to the type of art I was interested in, and on the other, to my personal economic situation, and my take, my analysis, of the art world. In particular, one can say that I was influenced by "guerrilla" activity—not that my activity was "guerrilla" activity in the military sense, but rather in terms of the mobility of changing situations, the possibility of freedom from a fixed location. As I have mentioned on a number of occasions, going to look at art in New York—and I would imagine this was also the case in other places—meant going to consecrated or sacred gallery or museum "art" spaces, where you would visit more-or-less automatically. For openings one would walk down the street and visit spaces expecting to see art; it was very much like a routine, it was like taking the dog for a walk, except you were the dog.

I would do this regularly, as did many other people, and in the 1960s I was struck by how much these spaces had to do with what you saw, or especially what you expected to

see. Art reality was sort of framed by galleries that were rich
and famous, or were poor artists' cooperatives, that were
upstairs or downstairs, uptown or downtown. This type of
experience, along with that of having a gallery myself for
about 18 months or so from the fall 1964 to spring 1966, led
me to think about other possibilities.

You were talking about the routine thing …

From a personal point of view, I was describing looking at
art as a spectator the way many other people, including crit-
ics or artists, do, but also from the point of view of having
had a gallery. After a brief experience of 18 or 20 months of
running a gallery, which I did not find very interesting, it
appeared to me that it was not possible to have a schedule of
8 or 10 shows a year and get them all, or even most of them,
right. The rhythm of production, the art exhibition assembly
line so to speak, was much too fast and regular. There was
hardly anytime to think and play, which for me is very, very
important. It seemed there must be a better way of doing
an exhibition when you wanted to do it, without having all
the continuing overheads, such as rents, lights, telephones,
secretary (which in fact I never had)—all the fixed expenses
needed to maintain a permanent space. That is, to try to
separate the administrative and organizational constraints of
space from possible art aspects of the space. In a certain
way, the gallery "tail" was wagging the "art" dog. These types
of limitations are even more exaggerated with museum exhi-
bitions, not just because of their very heavy administrative
structures, but especially because the "authority" of museum
spaces makes everything so "museum-like." This was the case,
for example, of the exhibition *L'art conceptuel, une perspective*
[1989] organized by Claude Gintz at the Musée d'Art moderne
de la Ville de Paris, the first institutional look at the period.
No fault of his, but it really looked dead. But isn't this one
of the more important functions of museums, to kill things,
to finish them off, to give them the authority, and thus
distance them from people by taking them out of their real
everyday context? Even over and above the will of the actors
involved with any given museum, I think the structure of
museums tend toward this kind of activity: historicization. It
is sort of a cemetery for art—I think I must have heard this

somewhere—the heaven for dead useless objects.

You formulated new forms of exhibitions, and a contract to change the relationship between artists, galleries, and collectors; have you ever been interested in formulating a new structure for the museum?

Nope. Museums were never a problem for me, as I have had very little contact with them. The problem of the museum is structural in the sense of its relationship to the ruling powers in society and their interests. Thus a museum without this authority and its subservience to power could be very interesting, imaginative, and even spontaneous, but to the degree to which it achieves this authority, it loses these possibilities. This, obviously, is true of many other institutions and people in an alienated society, including artists. I suppose if enough creative people gave enough thought to the type of exhibitions that were done there, one could probably formulate some ideas how possibly a museum could function in another way. But one has to first understand the contradictions here; to keep in mind that museums, more than ever, are directly dependent on larger interests, and regardless if you or I came up with some hot ideas about changing some aspects of museums (the social dimension of museums have changed in certain areas such as decentralization, interest in local communities, the art of minorities, etc.), the fundamental needs of the museum have very little to do with us; they have their own internal logic. And the margin for maneuver within this structure is probably less today than it was yesterday; or at least, the contradictions are different. So it's very difficult for me, here sitting on the outside, to imagine what a museum could be other than what it is, perhaps a few little touches here or there, maybe free coffee for artists every Tuesday, etc. But perhaps the real question is: Why should I be interested in changing the museum?

In 1968, you curated the Xerox Book *project. Was this a "group show" in book form?*

Yes; the first "big" group show if you like. This project evolved in the same way as most of my projects, in collaboration with the artists I worked with. We would sit around discussing the different ways and possibilities to show art, different

contexts and environments in which art could be shown, indoors, outdoors, books, and so on. The *Xerox Book*—I now would prefer to call it the "photocopy book," so that no one gets the mistaken impression that the project has something to do with Xerox—was perhaps one of the more interesting because it was the first where I proposed a series of "requirements" for the project, concerning the use of a standard size paper and the amount of pages, the "container" within which the artist was asked to work. What I was trying to do was standardize the conditions of exhibition with the idea that the resulting differences in each artist's project or work would be precisely what the artist's work was about. It was an attempt to consciously standardize, in terms of an exhibition, book or project, the conditions of production underlying the exhibition process. In fact it was the first exhibition where I asked the artists to do something, and it was probably somewhat less collaborative than I am now making it sound. But I do have the impression that the close working relationship with the artist was an important factor in all the projects, even when I was not particularly close to an artist, as for example, with Bob Morris.[1]

There is this "enlarging" from one exhibition to the next; as I go through the list of all your publications, there is also a strong continuity of many artists. I think there are these two poles with curating—on the one hand, there are "family" curators who show their same artists for decades; on the other hand there are curators with a more open system who keep researching. It is interesting how you have acted in-between.

Maybe. But I don't think you can have the "in-between," because sooner rather than later again it gets back to the business of success. When you have lived a personally satisfying moment in your life, it is only natural that you look back favorably on that period. If I were still involved in the art world, I would probably still have some kind of working contact with those artists from the 1960s. I don't find that a problem. However, on the other hand, these "good old days" relationships can lose their meaning over a period of time as people change, and for my part, I try to avoid these comfortable, often uncritical situations by transforming my interests and work every ten or 15 years. But concerning the art world, I have a greater problem with people

who look at art with their ears, to see what's happening, which has little or nothing to do with these kinds of close relationships; this I find far worse.

I think the question of personal renewal, keeping up the excitement, is a very real problem everyone has, but if you stay in the same profession, in the same job, in the same environment, with the same people, etc, I don't think you get many different chances.

Félix Fénéon is an interesting example of someone who, like you, changed professions. He was friends with [Stéphane] Mallarmé, Georges Seurat, [Henri de] Toulouse-Lautrec, and so on, and then he became a news reporter for a daily newspaper. Later he worked in a Ministry, and he organized the anarchist movement, and then he sort of disappeared in the 1920s. He did all these different jobs.

I'm not familiar with this man's life except for what you're telling me, but keeping the adrenaline and excitement flowing is a very, very serious problem in everyone's life, and not just in the art world. I think I have arrived at a modus vivendi to try to keep the juices flowing by "shifting over" every ten to 15 years. From the exterior, it may seem like a dramatic shift, but for me it is a very logical and gradual one. If I were to have stayed in the art world, I would have become trapped in it, a caricature of my own existence.

A danger for many artists is of their work becoming a cliché.

A parody of itself. And I think one can say that, even concerning people I know and respect, they get into a situation or are forced into a situation by a certain lifestyle, with a certain related conservatism.

They are expected to always do the same thing.

By society, and also by standards of living, getting older, expecting success, and being the grand old man or the grand old lady. I cannot speak for anybody but myself, but I do find it to be a very serious problem in one's life to be interested in something and really approach it in a critical new way, which I have always tried to do, whether with political publishing, left media research, or textile history. I am currently

working on a bibliography of textile history, and I have asked
myself many times why this project has not been done by a
museum many years ago.

What is the reason it has not been done?

I am not quite sure. The literature on the subject is very
diverse and broken up; there's the art literature of textiles,
the political and economic literature of textiles, there is a
literature about beautiful patterns, and all of these are very
disparate and have not been brought together. The literature
history is composed of many strands; you have books about
linen, about tapestries, rugs, clothing, silk textiles, quilts,
embroidery, printed textiles, tents, and so on, but there is no
unified field of historic textiles. My working on a bibliogra-
phy is an attempt to unify this literature and it is a political
project as well, because textiles are an art, handicraft, and
a business too, the first big capitalist industry, in fact. There
is also the idea of a craft in a certain type of society, and
the historical and social development from an "applied art"
into a "fine art" in another form of society. The reason why
I ask so many questions about the subject is because I try to
approach it with a critical, fresh eye. In the art world, Harald
Szeemann is a good example of someone who is conscious
of the problem of not trying to repeat himself.

The excitement of the first time.

Yes, even if it is only every ten to 15 years in my work—it
takes several years just to get to understand a project and its
particular history and problems. If one is involved with the
art world and you are not an artist but an organizer like
yourself, or even a dealer, it basically means finding young
artists who you work with successfully, and then either con-
tinuing your successful project with them, or trying to do
it again with another group of young artists based on your
experiences and especially the contacts you made the first
time. Having done that once, for me, it didn't seem inter-
esting to do it again—either then in 1972, and certainly not
today. What one is left with is doing "conceptual art" shows
or appearing on discussion panels talking about the good
old days, becoming a sort of professional "art personality"

or something, and that is not something I care to do for my daily bread. Occasionally it's OK.

Is that why you refuse to repeat these exhibitions?

Yes, it would be like becoming like the parody we spoke about before.

Gilles Deleuze said that if there is such a thing as art, it is always a critique of clichés.

Exactly, or even, I think I once said, art is a change from what you expect from it. But speaking historically, one should also never forget that today's critique is tomorrow's cliché.

Let's talk about the socio-economic side of art. Getting away from the object as a fetish would also mean injecting doubt into the economics involved with the fetish which would have to be replaced by another economy. This is a whole complex set of questions concerning the new economics, and also this transition to a service economy that you mentioned before. Raising the question of art as a service or non-service, in 1971 you worked with Bob Projansky on the Artist's Contract *(The Artist's Reserved Rights Transfer and Sale Agreement). How did you conceive the* Artist's Contract?

The *Artist's Contract* is a much more modest project than you suggest by your question. Its intention was just to first articulate the kind of interests existing in a work of art, and then to shift the relative power relationships concerning these interests more in favor of the artist. In no way was it intended to be a radical act; it was intended to be a practical real-life, hands-on, easy-to-use, no-bullshit solution to a series of problems concerning artists' control over their work; it wasn't proposing to do away with the art object, it was just proposing a simple way that the artist could have more control over his or her artwork once it left their studio. Period. But the broader socio-economic questions of the changing role and function of art in society, the possibility of alternative ways of art making or the support of the existence of the artist; all these important questions are not addressed here. As a practical solution, the contract did not question the limits of capitalism and private property; it just shifted the balance

of power in favor of the artist over some aspects of a work of
art once it was sold.

It would be about protecting the artist within the existing system.

Right. The problem of art as private (capitalist) property, of
the uniqueness of objects—this was certainly a problem in
the air during the 1960s and behind certain art making
projects. But it wasn't just a theoretical/political problem; in
the context of art making at the time it was also a practical
problem, in that the selling of ideas or projects was some-
thing that the art world had never come up against before on
any generalized scale. This has to do more with questions of
how to transfer property ownership of an artwork, and these
questions were "more-or-less" resolved by treating them
in a way similar to the rights and interests given to authors
or composers.

*Whenever a piece of music is played in public the author gets a royalty
on it. We could apply this to publications and exhibitions. But of course
there is the problem that it will never be popular enough for the royalties
to be significant.*

Yes, and that was precisely the problem at the beginning, be-
cause the catalogues were barely sold, or sold for $2 or some-
thing. The idea of royalties of 20 cents for four people on a
book, added to the fact that there are not that many people
interested to begin with, makes for very little real money.
But the idea or possibility is still very important. This may
change, of course, if there is more interest or if the prices
become expensive enough to make royalties. For myself, it
was only with the photocopy book that the possibility of
royalties was really there, because it was sold for $20.00. But
even here, with a 1,000-copy edition, you are talking about
$20,000—a lot of money at the time—with royalties normally
around 6–7 per cent. This still only means $1,400.00 for
seven artists, over say, five years, that is, $200.00 per artist
(or $40.00 per artist per year). This was the intention, but
it was never realized.

*The traditional art world is focused on objects. The whole other part
has never been organized as a different economy.*

That is not quite true for traditional art images, because there are a number artists' societies in Europe, within UNESCO, for example, and SPADEM, who do look after these types of interest, especially the reproduction of images. Occasionally there are even some very heavy lawsuits that come up. The heart of the problem is that, concerning new art making practices, there is usually not enough money generated by the sale of these projects to amount to a hill of beans. For example, if I organized or published ten books a year and took all of the profits for myself, I would make, say, $200.00 a year per book, which would make a maximum of $2,000.00, if all the books were selling, if I was getting paid. Perhaps for the late 1960s this was OK, I personally could get by with that; but if you divide it by 25 artists in a catalogue, it just doesn't work. I don't know if the numbers—i.e., the public interest—have changed that dramatically to make it any different today.

It seems to me that many of the people who walk around on a Saturday afternoon looking at art could also possibly spend $10 for an "avant-garde" book. Maybe there isn't any relationship between those people and these books, yet nevertheless there are places like Printed Matter that sell a certain amount of books. I am told that the amount of people who collect artists' books has increased substantially. In the 1960s when I was active there were virtually none whatsoever, and I did my own distribution for my own publications, as well as some for Ed Ruscha and others.

That leads to the book space. You said you really believe in the book as a medium.

Yes, especially as a possibility in the context of art making in the 1960s. But this doesn't preclude selling a book.

What do you think of exhibitions in printed mass media such as the "museum in progress" in Vienna which organizes exhibitions on billboards?

It is certainly another possibility—why not? It is probably closer to a mass-market type of activity, inasmuch at it is directed to a far greater audience than is really interested, perhaps reaching out to people who would never come to an

artwork otherwise. It is like jumping into the middle of the
main train station and doing your theater piece, or putting
a poster up on a very public wall as they did in China during
the Cultural Revolution. These are all perfectly valid means
to reach out into the world, and I am sure there are many
others. Now the Internet is hot; why not?

*As [Marcel] Broodthaers said, "Every exhibition is one possibility sur-
rounded by many other possibilities which are worth being explored."*

True enough. That is the one way I look upon my own orga-
nizing and exhibition projects—as so many different ways,
different possibilities, different aspects, of investigating the
production of exhibitions. For the exhibition I did at Simon
Fraser University in Canada in May–June 1969, at the insti-
gation of N.E. Thing Co., we only published a catalogue after
the exhibition was over. The exhibition took place all around
the university, but unless you were aware that it was going
on you just wouldn't know it existed; it was only afterward—
if you saw the catalogue—that you realized you were in the
middle of an exhibition during that period. But there was no
formal indication that the exhibition was taking place at
the time.

*Just the very opposite of the phenomenon of people buying the catalogue
beforehand.*

Exactly; just another possibility. I am sure there are thousands
of other possibilities I haven't even dreamt about. I am sure
you're doing things with your *Do It* project here that never
even entered my mind, which are perfectly valid in the con-
text of the present moment, as well as perhaps opening onto
other interesting possibilities in the future.

*Can you tell me more about the show you co-curated with Michel
Claura, 18.PARIS.VI.70, an exhibition that took place in Paris in
April 1970.*

One should view the exhibitions I did as series that moved
from a specific limited interest in a few artists to a more
general interest in art and its processes. The exhibition with
Michel Claura was one in which he in fact was the brains and

organizer of the exhibition, and I was just the back-up sup-
port—the practical, money, publishing, and organizational
side. In this sense it was similar to the *July/August Exhibition*
project I did with *Studio International* slightly later in 1970,
when I asked six art critics (David Antin, Charles Harrison,
Lucy Lippard, Michel Claura, Germano Celant, and Hans
Strelow) to each edit an 8-page section, which took me still
further away from the selection and promotion of specific
artists.

The curator disappears in a sense?

In a way, yes, but it is a false disappearance. I think in retro-
spect perhaps what I was doing had to do with making the
role of the curator less hidden, more clear, more open and
more aware of his or her responsibility in the art process.
Although since then, I have heard curators have become very
important, and are even spoken of as being "painters" using
the artists they show as form of "paint."

What was the role of the curator in your projects?

One aspect of our project had to do with clarifying and
changing the role of the curator, and perhaps also that of the
critic and even the collector. Before, the curator was some-
one who somehow determined and rewarded artistic genius.
He (or she) may have been a great writer, catalogue maker,
or builder of great collections, but this role was never assert-
ed as a clear force. They were certainly powerful—but only
within the context of some greater institutional power—and
their job was to select "great artists" and be the voice of the
gods, or of "quality" and correct art values. I think our prob-
lem in the area of curatorship was to become aware that this
person—in this case me—was an actor in this process, and
that he or she had an effect on what was shown; and being
aware of this was part of looking at art and understanding how
art choices were made. This is also the case for the role of
the collector, and the effect he has on what art is made by
encouraging this and not that. How to make these hidden
private decisions more visible, how to make this dimension
behind the public art exhibition and selection process more
visible, was in part what I and others were thinking about.

A demythologization?

Exactly; but the key word at the time was "demystification."
A process in which we attempted to understand and be
conscious of our actions; to make clear what we and others
were doing, so you have to deal with it consciously as part
of the art exhibiting process, for good or bad. You have to
understand what the curator does to understand in part what
you are looking at in an exhibition. Why does this artist have
three rooms and the other have one room; why this one is
on the cover of the catalogue and the other is not? You have
to try to understand all of these decisions that create the
context of the art experience, both for looking at it, but also
making it, as the "consumers" are also the "producers."

And question of feedback?

Yes, people who are looking at art are also the very same
people who are producing art, i.e. other artists. These
questions are even more important for them than for the
general public. This is especially the case between different
generations of artists.

[1] Participating artists in the so called *Xerox Book*
 were Carl Andre, Robert Barry, Douglas Huebler,
 Joseph Kosuth, Sol LeWitt, Robert Morris,
 and Lawrence Weiner.

Werner Hofmann

Born in 1928 in Vienna. Lives in Hamburg.

Werner Hofmann was the founding director of the Museums des 20. Jahrhunderts (MUMOK) in Vienna (1962–1969); he was subsequently director of the Hamburger Kunsthalle from 1969 to 1990.

Previously unpublished, this interview by Hans Ulrich Obrist and Michael Diers was conducted in 2002 in Hofmann's Hamburg apartment.

Translated from the German by Judith Hayward.

MD *Going on from an earlier remark you made that you see yourself as an art historian and don't want to be reduced to the role of museologist, I'd like to ask you, does that double role lead to conflict? Your comment sounded as if you felt your work as a museum director was secondary.*

WH It wasn't meant that way. I know myself that the boundaries are fluid. There are confluences of the most varied nature and stimulations from the other field in each case. Fundamentally I'm a person very rooted in traditions. And this double role too is in the tradition of the Vienna School. If you come from Vienna, you measure yourself against the curatorships of [Julius von] Schlosser and [Alois] Riegl. The relationship between the practices has always existed in Vienna. No doubt many a time it has resulted in the impairment of art-historical and art-theoretical doing and thinking. In spite of that, hands-on contact is very important.

The significance I've accorded to multimedia work for decades is certainly a result of the fact that I haven't encountered it only through slides.

HUO *Where do the origins of your work in both fields lie?*

I can gladly explain that to you. There was an initiatory experience: the major Goethe exhibition consisting of 15 sections that was held in the Goethe anniversary year 1949 at the National Library in Vienna. At that time I was a volunteer at the Albertina in Vienna and was given the job of designing the "Goethe und die bildende Kunst" (Goethe and Fine Art) section by Otto Benesch. In doing so I had the experience of being introduced to the three artists Johann Heinrich Füssli, Caspar David Friedrich, and Philipp Otto Runge. Three figures that were to play an important role later on in the *Kunst um 1800* [Art Around 1800] exhibition cycle. I then became aware of the period of Goethe as a quarry, as an inexhaustible conglomeration of periods of artistic experiments. I worked with these coordinates for a long time.

HUO *Were many of the later exhibitions already implicit in that first exhibition?*

To take a step over and above the task Otto Benesch had set me, I used my good, friendly contacts with Viennese artists who even today lead an almost legendary existence within the Rubrum Art Club. Therefore I expanded the theme and also dealt with how Goethe's writing had been translated into art after his death. I started with [Eugène] Delacroix and extended the line through [Max] Slevogt and [Lovis] Corinth right up to the present. As an example of the exploration of Goethe by contemporary art I showed sheets by Kurt Moldowan, who at my instigation had done a series of drawings for *Faust, Part II*. That was a first attempt to extend a theme right up to contemporary art.

MD *Was your early activity in the curatorial field a rather unusual path, or was it within the framework of what was normal at the time?*

There were no set standards at that time. There was virtually nothing on offer. It was solely due to Otto Benesch that I

had the opportunity to take on curatorial duties as soon as
I'd finished studying. At the Albertina he conducted lectures
and exercises in front of the original works. At these he began
to take an interest in me. He asked me to write short essays,
on [Alfred] Kubin and [Francisco] Goya among others. He
liked what I wrote and then took me under his wing. He also
discussed the subject of my dissertation with [Karl Maria]
Swoboda, the professor at the Art History Institute, and
supervised my dissertation. I went to Paris supported by a
bursary in 1949, with "Die geschichtliche Stellung von
Honoré Daumiers graphischer Form" [Honoré Daumier's
Graphic Approach] as my subject. I'd completed my curato-
rial work in the context of the Goethe exhibition before my
stay in Paris. In addition Benesch had also taken me on
for a Chagall exhibition and a Henry Moore exhibition. After
that I went to Paris together with Klaus Demus and Gerhard
Schmidt. When I returned from Paris, I completed the dis-
sertation and was given a contract as a scientific assistant at
the Albertina. The plan was for me to do the catalogue of
French graphic art. I made a start, although I have to admit
not with too much commitment. In the process it turned out
that I was unable to develop the knowledge required with the
requisite ambition, nor with the enjoyment of looking and
investigating necessary for the job. Otto Benesch noticed
that too, and dismissed me on some ridiculous pretext. After
that I worked as what was called an artistic secretary at the
Secession. Two exhibitions from this period merit a mention.
Firstly, 50 works by Klee from the collection in Bern. The
exhibition design was by Josef Hoffmann (1870–1956). It was
one of his last projects. (But you see—if I now ask myself
your question, I can see that the course of events in those
years did have an inner logic.) The title of the second exhibi-
tion was *Modern Art in the USA*, a traveling exhibition from
the Museum of Modern Art, which went round the main cities
of Europe. Putting that exhibition up was quite exciting. For
example, we couldn't get to grips with a mobile by Alexander
Calder. René d'Harnoncourt came and assembled it with
the composure of a practiced magician. D'Harnoncourt was
also very helpful to me in my next step, as I'd seen that
the Secession was not going to keep me interested in the
long run.

HUO *Were you in touch with d'Harnoncourt?*

Yes. He was the most delightful person you can imagine. He radiated an incredible urbanity. I'd always toyed with the idea of going to the US at some point. From my time at the Albertina I knew Julius Held, the Rubens scholar. He'd come to Vienna to go through the graphic holdings at the Albertina. Some time later, in fall 1956, I was invited by Julius Held to go to Barnard College in New York as an assistant professor. The salary was 200 dollars a month. I bought *The New York Times*, which then cost 15 cents, and thought that if the newspaper was so cheap, life there couldn't be that expensive either. When I arrived there with my wife, we quickly found out that the reality was very different. We spent almost half of the 200 dollars on the hotel. We kept 40 dollars back for income tax, and so we had to make out on 2 dollars a day. Then after two months we were able to move into Erica Tietze's flat—she'd gone to London for a while. In this situation d'Harnoncourt procured a travel scholarship for me, I believe he paid it out of his own pocket. He thus enabled me to see the important collections in Buffalo, Detroit, Chicago, Philadelphia, and Washington.

HUO *What role did the MoMA in New York play in your work?*

I profited greatly from the MoMA's library because I was able to find a great many sources for my book on modern sculpture there. When I had no lectures, I spent a great deal of time there.

MD *At that time you turned very intensively to 20th-century art. After your very historically oriented studies in Vienna, how did you manage to gain access to it?*

That's a very important question. After my dissertation I set the 19th century aside. It no longer concerned me that much. Two books for Fischer Verlag came next—*Zeichen und Gestalt: Die Malerei des 20. Jahrhunderts* [1956] and *Die Plastik des 20. Jahrhunderts* [1958]. The New York experience certainly made it easier for me to access 20th-century art. I also made my first tentative steps in journalism there. Some of those articles were published later in the volume of essays *Wegblicken* [1993].

It also contains an essay I wrote for the *Süddeutsche Zeitung* at that time. In it I described how a young European plunges into American art and museum life.

HUO *At that time you'd also already started publishing books.*

Yes. I have [Gottfried] Bermann Fischer to thank for that. Although I'd already written a volume entitled *Die Karikatur von Leonardo bis Picasso* [1956] in my time in Vienna. I'd incorporated material from my research on Daumier into it. As far as caricature was concerned, I could take Jean Adhémar and Ernst Gombrich as my reference points. Even then, during my first stay in Paris, Adhémar was completely informal in his behavior. He went out for meals with me without any awareness of his condescension. And I was in contact with Gombrich too.

HUO *It says in the foreword to a monograph on Alexander Dorner: "In 1959 Werner Hofmann put forward his conception for a museum of art from the Jugendstil onward, based on the models of the 1920s and the teachings of the Bauhaus. Hofmann wanted to see the museum understood as a place that no longer usurps life, i.e. reduces and beautifies it in museum terms, but that should be accepted in itself." Did you meet Alexander Dorner during your time in America?*

No, that didn't happen. But I no doubt got these ideas from him on the one hand. On the other they're implicit in the original concept of the MoMA: the amalgamation of the various artistic possibilities, or the media going right up to and including film. I tried to implement that later, in the Museum des 20. Jahrhunderts in Vienna. Therefore I collaborated with Peter Konlechner and Peter Kubelka from the film museum, for example.

MD *Did your journalistic activity in the second half of the 1950s form the theoretical basis for the subsequent curatorial work in Vienna from 1960 on?*

When I came back from New York, I really had nothing to expect from Vienna. In the museum field the doors were closed, as Benesch had done everything to cold-shoulder me. So we went to Paris. In 1958 and 1959 I worked there on two

volumes of the "Bildende Kunst" lexicon for Fischer Verlag,
volumes II and III: it had been initiated by Heinz Friedrich.
Prestel Verlag became interested in the idea of producing
a book on 19th-century art, which was to be structured not
according to criticism of styles, but thematically. These two
projects were what kept me going during those two years in
Paris. *Das irdische Paradies. Die Kunst im 19. Jahrhundert* [1960]
then also became a very extensive book. Though its graphic
design didn't quite match my expectations. I really didn't
want it to be laid out as a coffee table book. But perhaps it
was a good thing that the publishers launched it that way.
It was after this that the approach came from Vienna asking
whether I wanted to take on the job of running the Museum
des 20. Jahrhunderts, which was about to be founded. That
was a very bold idea of the then Minister, Heinrich Drimmel,
who himself tended to be a very conservative person. In any
case at the time there was no jostling for the post. At the
university they were barely aware of the theme. Nor had any
of my colleagues voluntarily branched out in that direction.
They were with Swoboda, and consequently with the Baroque
period. I was practically the only young candidate who was
considered. Apart from me, [Vinzenz] Oberhammer, the
director of the Kunsthistorisches Museum, was also a con-
tender. An experienced Tyrolean with good connections. In
the end they selected me. That didn't elicit any joy from the
line-up of elderly gentlemen in the Viennese museum world.
Therefore, when I started off as the founding director I was
very isolated. I sat under the roof in a huge conference room
in a building on the Minoritenplatz and had my desk with a
telephone standing there. The advantage was that I was thus
at the heart of the bureaucratic decision-making bodies. I
had rapid access to the people at the Ministry who were re-
sponsible for the crucial things. I quickly realized that they
wanted to have this museum. Now my contacts with con-
temporary, French artists also came to bear, including André
Masson, Antoine Pevsner, Sonja Delaunay, as well as Shamai
Haber—I'd got to know him through [Willem] Sandberg.

HUO *Did Sandberg inspire you?*

To be sure. I admired Sandberg in the same way as I'd perhaps
admired Ruskin. For example, I found his exhibition where

he took a section through the year 1907 fascinating. He suc-
ceeded in depicting an epoch in all its diversity by bundling
together the phenomena that belonged together. Apart from
that, he was a wonderful person and a very notable colleague
in the association of critics.

HUO *Directly before you went to Vienna, you wrote a paper on the
question of the museum that is often quoted even today.*

At that time I regularly wrote about Paris exhibitions, as well
as essays on contemporary artists such as Wols for the jour-
nals *Werk* and the *Neue Zürcher Zeitung*. There's a bibliography
of those essays in my book *Hamburger Erfahrungen* [1990].

HUO *With your vision of the museum, which you developed very early
on, you oppose the one-dimensionality that [André] Malraux's "musée
imaginaire" stood for.*

Malraux's way of thinking was always alien to me. His far-
reaching conquests of countries from one continent to the
next and from one denomination to another struck me as
a *Der Blaue Reiter* almanac in deluxe format. Though I very
much liked his "Saturn and Goya" essay. For me, in the con-
ception of the Vienna Museum des 20. Jahrhunderts, it was
really all about transferring the museum idea behind MoMA
in the sense of the "interpretation of all the creative acti-
vities and faculties" to the Viennese situation around 1900.
Not that I was hoping to be applauded for doing so, but I
thought that the Viennese situation at that time, with Otto
Wagner and the controversy between [Joseph] Hoffmann
and [Adolf] Loos, was one of the most thrilling moments in
the history of European culture.

MD *Your change from being a private scholar and author of weighty
tomes to being a practical museologist happened almost seamlessly. As
founding director of the Museum des 20. Jahrhunderts in Vienna,
you then charted out what was virtually a prototype for museums of
modern art in Europe.*

The firm cushion I could work on was indifference. Modern-
ism was not a consideration at that time. Of course I wasn't
the only person, nor was I the first. Just think of Otto Mauer.

With respect to Baudelaire, that was the height of art; also because of his vehement spiritual and religious commitment. In that respect I've never endowed myself with any charisma, nor sought any.

HUO *His activity really even had missionary dimensions.*

Yes, it did. And it was very fascinating. The man in himself was tremendous.

MD *The opening catalogue of the Museum des 20. Jahrhunderts had an unusual format and a very modern typographical layout.*

I had an outstanding graphic designer, Georg Schmid.

MD *Did the museum have its own collection right from the beginning?*

Yes. I'd already been able to buy some things during my time in Paris. For example, a large, white relief picture by Delaunay, a superb stained glass window by Matisse, a [Karl] Schmidt-Rottluff, an [Oskar] Kokoschka, a Duchamp. That was the start of the collection. For the opening exhibition we also had contributions from the Osterreichische Galerie. The other exhibits were loans.

HUO *In an interview with Robert Fleck in 1980 you said it was much nicer to create an exhibition than a book, because you see everything together.*

You can look at it that way. And the opening exhibition did in fact run like clockwork. Felix [Klee] lent me the finest works by [Paul] Klee, from [Alexei] Jawlensky's son I got a very fine group; so fine that Jawlensky was in fact somewhat overemphasized in terms of his role in modernism. At that time it was still the case that colleagues in Switzerland and Germany were very willing to lend works.

MD *At the beginning of the 1960s wasn't it also still a matter of getting modern art into museums in order to shore up its status?*

Definitely. There was also a kind of conspiracy, especially among my colleagues in Germany, to help me get the new

museum up and running. I sensed that.

HUO *Were you in communication with other curators such as Werner Schmalenbach, for example?*

Not really. If I look back, at that time I didn't have many people I was in touch with. No serious discourse developed with Schmalenbach either. I have to admit that I felt his museum was a big misconception because he didn't let sculpture come into its own.

HUO *Looking back, were there other exhibitions from your years in Vienna that were important for you?*

There was the exhibition on the theme "Gegenwahrnehmung" der Bilder im Text (Counter-perception of pictures in text) that I took over from The Hague, for example.

MD *Your last exhibition in Vienna was entitled* Plakate and Fotos des Pariser Mai 1968 *(Posters and Photographs of May 1968 in Paris).*

HUO *In 1969 you went to Hamburg as director of the Kunsthalle. In 1970 you wrote a visionary paper on the future of the museum. As Michael Diers said, the paper had a great influence on the conception of the museum from the 1970s on. One of its themes is temporary displays.*

MD *Art Historians' Day in 1970 was an important stepping-stone in the history of museums and art. At that conference it became clear for the first time that museums had to say goodbye to their isolation, to expecting mere veneration, to their function of an aesthetic church. You gave that lecture then in the museum section.*

Yes. Afterward the text was published by Gerhard Bott in the volume *Das Museum der Zukunft. 43 Beiträge zur Diskussion über die Zukunft des Museums* [1970]. The working hypothesis of the museum as a workshop and laboratory emerged in it. I wrote the paper in 1970, the year I started in Hamburg as the director of the Kunsthalle. I must admit that if I did arouse any expectations with that thesis, I was unable to fulfill them. Such a way of working results first and foremost from direct contacts with artists, by giving one or several artists a commission for a project. That could be done far more easily

in Vienna than in Hamburg. For one thing, the museum in
Vienna was created as an architectonic coordinate system for
such projects, which extended even to the misappropriation
of the façade. In Hamburg such activities are far less present
on the positive side of my recollections. Admittedly there
were a few attempts in that direction, but when it came to
misappropriating the substance of the building in a playful
way, I had no urge to do it on my own for one thing, nor was
there anyone who approached me with such an idea, for an-
other. In addition, my productive contact with the artists in
Vienna was livelier and more spontaneous than in Hamburg.
And there is also a difference between founding a museum
in Vienna as a young man, which could in any case be virtually
neglected in the museum scene, and coming to Hamburg
to an institution with an upper middle-class tradition. For one
thing the Kunsthalle has a 100-year-long history, and for
another it is limited to the genre of painting.

HUO *Did your marginality afford you protection in Vienna?*

Yes. As I said, it was the cushion of indifference that made
many things possible. In Hamburg I again tried to make
the best of the situation. But I admit to a certain reluctance
to turn the Kunsthalle upside down and inside out.

MD *I can't agree with what you've just said. The exhibitions in the
Kunsthalle's dome, for example, can be described as workshop exhibi-
tions. In addition, in the cellar there was the exhibition from the collection,*
From Image to Object. *Apart from that, the major achievement
of the 1970s was surely to intellectualize the exhibitions. In that sense
you have set important things under way.*

The material we were playing with was rather limited, though.
But there was the exhibition *Kunst – was ist das?* [Art—What
Is It?], for example, which in my opinion we staged wittily
and sensitively. For experiments and young art, the dome of
the Kunsthalle in its raw state with the pipes uncovered, was
a very rewarding place. It worked like a three-dimensional
turntable. It was renovated for the Caspar David Friedrich
exhibition in 1974. After that certain things could no longer
be done there.

HUO *What you're talking about resembles the situation in Mönchengladbach. Important exhibitions could be put on there in the temporary premises, which were then no longer possible in the new building.*

Exactly. You're aided and abetted by stopgap buildings. They play along.

HUO *You mounted a lot of solo exhibitions in the room with the dome. Can you tell us something about them?*

César extruded his polyurethane foam materials there, for example. The *Grüne Lunge* by Haus-Rucker-Co was trailblazing. At that time people still didn't know what a biotope was.

HUO *What did Mauricio Kagel do? Indeed, it's interesting that you also invited a composer.*

Yes. That was an example of the interdisciplinarity under which I thought I'd come there. The exhibition was very beautiful. Kagel put up Beethoven silhouettes, so turning Beethoven into charade theater. I'd come from Vienna remembering the collaboration with avant-garde composers there. In Hamburg there were concerts with [Dieter] Schnebel and Steve Reich.

HUO *In Hamburg you also had very close contacts with the Art History Department at the University. What form did that tie take?*

The way [Aby] Warburg was viewed was important. There's been a Hamburg-Vienna link since [Fritz] Saxl's day. There's an exchange of letters between Saxl and Warburg about it in which Saxl wrote that the most important thing for Warburg was constancy in change. That's an aspect that's very important to me too. That means that in the present situation I'm an exotic character, as people hardly know any longer what happened before 1950. My view of Warburg was not so very much influenced by looking at Warburg's writings. I experienced him more as a figure. For me he was one of the charismatic intellectual stars of Hamburg. And I thought that, just as I'd done for Runge, we should also bring Warburg closer to the people of Hamburg. That was the motive behind the first Warburg exhibition in 1979. The Warburg Prize has also been awarded since that year. We initiated the Warburg

renaissance in collaboration with the art-history seminar and the city. The first volume of the Hamburg Kunsthalle year-book, *Idea*, was published in 1981. Martin Warnke, the director of the Art History Institute, had furthermore remembered that in Panofsky's time the Institute was housed in the Kunsthalle, so that a link-up with that tradition resulted in a cohabitation at the intellectual level which was extremely fruitful.

HUO *Was there also a spatial coexistence?*

No. The Institute has since moved out from Moorweiden-strasse to Edmund-Siemers Allee. The idea of combining the libraries was raised. I wasn't at all keen on it, but Martin Warnke would have liked to merge them.

HUO *The combining of libraries is of course a concrete utopia.*

Yes. However, Thomas Gaehtgens told me not long ago how hard that utopia is to implement in the case of the planned Grande Bibliothèque d'Histoire de l'Art in Paris, with every-thing that has to be crammed in there.

MD *But basically contact with art history in Hamburg came about through your ambition to stage the* Kunst um 1800 *exhibitions. Without the relationship with the Art History Department it wouldn't have been feasible.*

Yes. And as curators we're indebted to that tradition. Even Warburg had devised his first lectures, including the one on Manet, for the audience of the Kunsthalle. And the ties between the director of the Kunsthalle, Gustav Pauli, and Warburg were also very close.

HUO *Could you shed some light on the concept of the* Kunst um 1800 *exhibition cycle?*

Gladly. But perhaps it would be better if I restricted myself. You know what I did. Therefore I'd rather talk about what I unfortunately failed to do. That was Constable and Géricault. In addition I had the very fine idea of showing van Gogh's collection of illustrated magazines from the period and the

relationship between the trivial magazine illustrations and his works. At the van Gogh Museum there was a lady who was very willing to cooperate. As she was compelled to leave the museum, unfortunately that project could never be implemented.

MD *Did the first German "blockbuster" exhibition, the Caspar David Friedrich exhibition in 1974, inspire the idea of the* Kunst um 1800 *cycle?*

When I came to Hamburg in 1969, I said at my first press conference, in reply to a question about what I wanted to do, that I was planning a Caspar David Friedrich exhibition for 1974. At the time I'd thought to myself that it would be better to announce this project straightaway because otherwise someone else would implement that idea. My strategy worked. Then in the years between 1969 and 1974 the idea of a cycle developed. But I hadn't thought up the series of exhibitions from Caspar David Friedrich to Goya in the way it happened, in advance. The course of the cycle developed little by little. Friedrich was followed by Ossian, then came Füssli, Runge, [Johan Tobias] Sergel and finally *Goya—das Zeitalter der Revolutionen* followed.

MD *How did it come about that you linked the monographic exhibitions with themed exhibitions, like* Turner und die Landschaftsmalerei *[Turner and Landscape Painting], for example?*

Here my experience was coupled with my appetite. Basically one artist alone has never interested me that much. Contextualization has always been important to me. I see myself more as a comparatist, although that discipline doesn't really exist in art history. The *Kunst um 1800* cycle was then followed by the *Europa 1789* exhibition and the Luther exhibitions, *Die Köpfe der Luther Zeit* [Heads from the Luther Period] and *Luther und die Folgen für die Kunst* [Luther and the Consequences for Art].

HUO *Can you tell us a little more about the concept of the* Kunst – was ist das? *exhibition?*

I bored into the tunnel from two ends. On the one hand from the material that was on offer, and on the other from the theory. So both deductively and inductively. Twelve

chapters arose from this about everything that can happen with art, or what it can be misused for, and what rules result from it.

MD *What's notable in this type of exhibition is how they bring the complexity of the expressive forms of art before our eyes; in addition they are useful both for art-historical exhibitions and for exhibitions of modern art.*

What seems important to me are the forms of staging exhibitions such as I developed for the *Europa 1789* exhibition. They're indicated in the subtitle *Aufklärung, Verklärung, Verfall* [Enlightenment, Transfiguration, Decline]. In the last room we telescoped three levels of perception for this so as to visualize these different ways of seeing: first [François] Gérard's picture of Napoleon's coronation, along with English caricatures expressing anti-Napoleonic sentiments, and finally the tinted engravings of the coronation in Notre Dame. Then through a series of windows you also saw Goya's *Desastres de la Guerra* [1810–1815]. So you found yourself virtually caught up in the emotional roller coaster of the French Revolution and its consequences.

HUO *Are there any utopian projects that you haven't yet been able to carry out?*

There's the idea of an exhibition entitled *Chaosmos*. A concept that came from a fusion of words by Kandinsky. It fascinates me because it's so equivocal.

Walter Zanini

Born in 1925 in São Paulo. Lives in São Paulo.

Walter Zanini was director of the Museu de Arte Contemporânea da Universidade de São Paulo
and curator of the 16th and 17th editions of the Bienal de São Paulo, in 1981 and 1983.

Previously unpublished, this interview by Hans Ulrich Obrist, Ivo Mesquita, and Adriano Pedrosa
was conducted in 2003 in Zanini's apartment in São Paulo.

Translated from the French by Judith Hayward.

wz I was a bit surprised when I heard of the type of interview you wanted to conduct with me. I may have a little difficulty in remembering some things that are already such a long time ago.

HUO *Well, perhaps we could "begin at the beginning": how did you become a curator, how did you start?*

Obviously I'm going to have to talk about myself and I don't like talking about myself. (Laughter)

IM *Could you tell us about your years of training before you took over as director of the São Paulo Museum of Contemporary Art in 1963? Were you very active before that date?*

I lived in Paris to study art history, and in Rome and London as well, from 1954. On returning to Brazil in 1962, I was accepted as a teacher at São Paulo University.

HUO *That was the start.*

*So you were in Paris before you organized exhibitions. That's more
or less the same route as Franz Meyer who was friends of artists—
Giacometti for example—before becoming an exhibition organizer. It
was the contact with artists, the dialogue with artists that drew him
to this path.*

That's true to an important extent, to be sure. As an art jour-
nalist I had been able to have contacts with artists from here
before leaving, and in Europe too. They contributed to draw-
ing me toward these goals. But first I think we have to talk
a little about the Museum of Contemporary Art of São Paulo
University, the MAC as it's called. It was a new museum set
up after an unavoidable crisis that occurred at the São Paulo
Museum of Modern Art—a private institution founded in
1948, which had given rise to the São Paulo Biennial in 1951.
With no prospect of ensuring its continuity, having only a
small number of individuals prepared to confront the finan-
cial difficulties of the body, which were constantly getting
worse, the decision emerged from a general meeting of part-
ners to hand the collection of works over to the university.
Bereft of its works, the MAM nonetheless kept its name and
subsequently restarted its activities (and still exists). Truth
to tell, the university had been simultaneously enriched by two
collections, the other being that owned privately by Francisco
Matarazzo Sobrinho, a patron of the arts and president of
the MAM, and his wife Yolanda Penteado. This group of works
is unique in this country as a representation of major aspects
of the history of modern and contemporary art.

HUO *Could you tell me about the exhibitions you organized at this
time? Which do you regard as the most important?*

I've given you some information about the origin of the MAC's
collections. Their conservation and display caused a lot of
concern, because we'd been set up under rather precarious
conditions in a temporarily lent space, a situation that would
last well beyond what had been anticipated. The budget was
mediocre, and the executive consisting of officers and col-
laborators was too small. So a start with a lot of worries. The
most important exhibitions? I think that a good initiative
for a museum in a country like Brazil which, when it came
down to it, had only a few small museums of modern

art, had been to organize traveling exhibitions of the collection, with an educational program. For several years from 1963 on they were presented in many towns in the country. One example was *Meio século de arte nova* (A half century of new art), in 1966, made up from a group of works by [Wassily] Kandinsky, [Fernand] Léger, [Umberto] Boccioni, [Jean] Metzinger, [Marc] Chagall, Max Ernst, [Alberto] Magnelli, Sophie Taeuber-Arp, César Domela, Graham Sutherland, Fritz Hundertwasser, and so on, as well as Brazilians like [Emiliano Di] Cavalcanti, Cicero Dias, Anita Malfatti, Tarsila do Amaral, Ernesto de Fiori, Alfredo Volpi, Iberê Camargo, and including the younger generation.

As a result of my knowing Edouard Jaguer, the director of Groupe Phases in Paris, who'd invited me to become a member in 1961, we presented a major exhibition at the museum in 1964, and after São Paulo it was turned into a traveling exhibition going to Rio de Janeiro and Belo Horizonte (one of the results of that initiative was the incorporation of several Brazilian artists into that international movement). Another exhibition, a solo one this time, outstanding in my opinion, was put on in 1965. The Russian painter and musician Jeff Golyscheff (1898–1970), who'd belonged to the Dada Club in Berlin, was living and working anonymously in our country, and he visited us one day. It was in 1965. He came to the Museum with his wife and told us his story as a refugee under Hitler. The Nazis had destroyed a whole exhibition of his in Berlin in 1933. He'd then decided to disappear from the art world. More than three decades later, almost completely forgotten, he nonetheless wanted to make a comeback. We gave him a heartfelt welcome. At his house he showed us a series of pictures he'd been preparing and keeping for several years, often by way of "reconstitutions" (a reference to the works that had been destroyed). We held the exhibition. In Europe they'd even assumed he was long since dead. Raoul Hausmann and other colleagues and former friends greeted him on his return. The MAC did a lot of work to rehabilitate him, including looking for possible surviving works from the Dada and November Gruppe period, an effort that produced meager results. He was invited to take part in major retrospective exhibitions of Dada staged at that time. Jaguer made him a member of Groupe Phases.

There were exhibitions that came to the MAC from

European countries, as well as from Japan and Latin America. And those resulting from our exchanges with The Museum of Modern Art in New York, for example, exhibitions of Joseph Albers, [Henri] Cartier-Bresson, and Brassaï. In the 1970s the museum put on a whole series of solo or collective conceptual art exhibitions or events: by the Groupe d'Art Sociologique from Paris (Fred Forest, Jean-Paul Thénot, Hervé Fischer), the Centro de Comunicación y Arte (CAYC) from Buenos Aires—its director was Jorge Glusberg—or again *Catastrophe Art of the Orient*, which was curated by Matsuzawa Yutaka.

HUO *You also worked with young Brazilian artists?*

It was one of my favorite fields, alongside organizing retrospective exhibitions of the Modernist movement in Brazil. From the time the MAC was opened, we organized annual exhibitions, initially alternating graphic art and printmaking (that last category was flourishing here at the time). In the late 1960s the Museum created the annual *Jovem Arte Contemporânea* (Young Contemporary Art) show. Subsequently it developed tremendously.

The country was going through a long period of military dictatorship, which got worse from 1968. The facts are well known—a military coup, repression, torture, censorship. The censorship extended everywhere, to cultural events, the media, education. Though less than the theater and cinema, the visual arts did suffer its effects too. Exhibitions were closed, pictures and exhibitions seized, there were cases of artists being persecuted, imprisoned. The university did not escape the repression, but it was a pocket of resistance. At the MAC our programs of exhibitions and events devoted to new experiments were maintained—at some risk. It was a time when conceptualism was becoming widespread. In 1972, in October, the sixth *Jovem Arte Contemporânea* show was a "very provocative" exhibition, as Ivo Mesquita puts it. Developed within the museum itself, it had a processual character. In the following years, other shows followed the *JAC*, in particular those devoted to Arte Postal, with a large national and international participation. Later on in 1981, at the São Paulo Biennial, we organized another exhibition of that kind.

HUO *It would be very interesting to go back over those various exhibitions.*

The *JAC-72* was a free show, conceptual in character in the broad sense, with works that were very ephemeral in nature, entirely constructed within the museum, open to all sorts of materials and techniques. It was intended for the young, but there were no age restrictions, one lot working alongside the others. The temporary exhibitions space (about 1000 square meters) was divided into 84 areas with different dimensions and formats, and allocated to those who had registered (individuals and groups) by drawing lots. A written proposal was required regarding what they envisaged doing in these sites, which could be exchanged. A chronogram of work was established for the two weeks the event lasted.

HUO *So they were heterogeneous spaces.*

Square spaces, circular ones, curved, beside columns, high up, or skirting the big windowed facades ... Among them there was the Greek Arte Povera artist Jannis Kounellis. He suggested the non-stop playing of "Va pensiero" throughout the event, which we did. Two pianists took turns playing Verdi's music in an exedra a few steps away from the entrance. Of course there was noise in the museum, with the use of all sorts of tools. But you could hear the music quite well just the same. There was absolutely no doubt about the intention behind the proposal. But there were some odd interpretations, because the scene was something people didn't expect.

IM *A very interesting aspect at that exhibition was its "work in progress" side: after each of the artists had gone back to his or her allocated space, his or her own corner, they succeeded in adapting their slots by negotiating between themselves. If one area didn't suit a particular person, he or she swapped it for another area that didn't suit another person, and so on. There was a remarkable working atmosphere, including daily interactions with the public, which was present while the projects were being made.*

Donato Ferrari, an artist of Italian origin with a Roman background who'd lived in Brazil for a long time, came up with the idea. He'd abandoned painting, and made a name

for himself for some years as an author of performances,
Super-8 films, and installations.

HUO *So it was artist-driven.*

Yes. For several months a whole team worked on the organi-
zation of *JAC* at the museum. Before the opening of the exhi-
bition, in September 1972, Ferrari and I went to the CIMAM
conference in Poland where they were in fact discussing the
theme of relations between museums of modern art and art-
ists. We spoke about the initiative under way and presented
a diagram with details of how we expected it to go. Colleagues
at the CIMAM showed interest in the initiative. It was in
Krakow. Ferrari gave a speech that was received with some
tension. I remember the general lines of the work that the
Polish artists were developing within the museum of Lodz at
that time. Our concept was something completely different.

HUO *But in your case, you quickly saw the benefit of collaborating
closely with artists?*

Ever since the Museum was created, it was something we
did as common practice. It has to be borne in mind too that
it was a university museum and artists who were also teach-
ers collaborated in various aspects of the activity of the new
institution.

The *JAC* has been highlighted as an important factor
in this rapprochement. The event attracted quite a large
public, with many artists among the visitors who would join
those involved in the exhibition and lend a hand in some
work processes. There were a lot of students who turned up
too. Some voluntarily participated in the climate we'd intro-
duced, for example in an intervention on the big ramp giving
access to the museum. They put a big photo of Hitler there
in front of the marble statue of Paolina Borghese in Rome,
surrounded by candles. Of course.

HUO *So it was political?*

The exhibition as a whole had a political character, often
through metaphors alluding to the restrictions of freedoms
by the military dictatorship. There was no lack of very witty

offerings along the lines of art as play. There was one instal-
lation after another lining the itinerary. Performances took
place. And so on. The question "museum as forum versus
museum as temple" was one of the subjects under debate
at that time at the CIMAM colloquiums. Serious thought
was being given to the museum as a more open institution,
better integrated into society. I have happy memories of
conversations with Werner Hofmann, Pierre Gaudibert, and
Ryszard Stanislawski at these events.

HUO *And in the 1960s and 1970s who were your colleagues in South
America? Who were the main exhibition curators in Chile, Venezuela,
Argentina, and Mexico?*

Exchanges between Latin-American countries weren't easy.
To start with you had the often-huge distances and the pre-
cariousness of communications. And then dictatorships re-
mained a feature for a long time. Even today South America
is an archipelago continent in many ways. But we did have
links, for example with the Centro de Arte y Comunicación
(CAYC) in Buenos Aires, directed by Jorge Glusberg; with
Angel Kalenberg, the director of the National Museum of
Uruguay; and with Helen Escobedo in Mexico. Another con-
tact was that with Ulises Carrión, again from Mexico, who'd
moved to Amsterdam where he created the Erratic Art Mail
International System. In 1972, during a meeting of directors
of museums from Latin America at the conference organized
by the Center for Inter-American Relations in New York,
we'd suggested the creation of an association bringing us to-
gether, but circumstances were not favorable to such a union.

HUO *Did you have any dialogue with Jorge Romero Brest, the director
of the art center of the Instituto di Tella at that time? Can you describe
to me what kind of institution the Di Tella Visual Center was?*

Unfortunately I only had a very superficial acquaintance with
Brest—I met him at the 1963 Biennial. I'd read his book *La
Pintura Europea contemporanea* well before that time. And other
things he wrote later on. I think that in South America, out-
side the museums, the Torcuato di Tella Institute played
an important role in Argentina, as the Biennial did in Brazil,
but it was short-lived.

IM *The museum's activity played a very important role in the years when it was being set up. I remember there were a lot of foreign artists too, as well as Brazilian ones, it was a lively place.*

HUO *Ivo Mesquita has talked in particular about an exhibition entitled* Poéticas Visuais.

IM *It was the same idea as for mail art. It involved works that could be shown without the artist being present, which the budgets and policies of the museums allowed to happen only very seldom at the time.*

That's true. The mail art exhibitions followed the *Jovem Arte Contemporânea*. Exchanges of works between artists (initially a common practice in Fluxus circles) underwent a public extension. Mail art has Futurist and Dadaist roots, and in my opinion became one of the important phenomena of the "dematerialization" of the art object through recourse to new media. We took part in this e-communication strategy, in recent times carried on on the Internet. It allowed us to correspond in a unique, incredible way with artists from several parts of the world, including Eastern Europe.

HUO *And do you know when you started to adopt this kind of organization?*

Ken Friedman, from Fluxus, is a very important name in this field, but there are others. Ray Johnson, again a member of the Fluxus group, had created the ephemeral New York Correspondence School in 1962. Starting in 1968 he organized circuits and meetings of mail artists.

HUO *What method of display did you prefer for these exhibitions?*

Initially we exhibited all the material received without any restriction. It was what the artists were producing in the multimedia area, sent by post as postcards, slides, folders, telegrams, artists' books, magazines, photographs, Xeroxes, Super-8, and so on. Everything was posted up (or exhibited) on big white panels. Or on tables. The large quantity of material and its diversity were exhibited in the alphabetical order of the authors' names. In 1983 I saw an Italian exhibition of mail art in Stockholm where the works were presented so

that they looked framed, and in my opinion that didn't work.

IM *Did you see the exhibition at the MAC on conceptual art? What's very interesting is that, thanks to those exhibitions, the museum created the first collection of conceptual art, insofar as all the works sent to be exhibited there remained there.*

We kept the works after the exhibitions closed. However, the collection was a consequence. There was obviously no question of sending the material back to the artists. We were of course quite outside the canonical system of the unique work, all the procedures relating to habits of transport, insurance, etc. The artists' profound intention was to communicate.

HUO *Artists such as Lawrence Weiner, On Kawara, and Yoko Ono took part?*

On Kawara had sent us one of his letters, and moreover just recently he asked us to send it back for an exhibition. Among the many foreigners I remember were Wolf Vostell, Antoni Muntadas, Matsuzawa Yutaka, John Cage, Dick Higgins, Hervé Fischer, Krzytstof Wodiczko, Mirella Bentivoglio, Jaroslaw Kozlowski, Friederike Pezold, Petr Stembera, Timm Ulrichs, Fred Forest, Klaus Groh, Clemente Padin, Xifra, Joan Rabascall, Adriano Spatola, Jorge Caraballo, Jonier Marin, Horacio Zabala, and so on. And Brazilians like Julio Plaza, Regina Silveira, [Artur] Barrio, Paulo Bruscky, Bené Fontelles, Mario Ishikawa, Lydia Okumura. Our first major exhibition of that kind, at an international level, with the title *Prospective-74*, took place in 1974.

HUO *It was the first conceptual exhibition in South America, or one of the first?*

In South America, Argentina and Brazil had conceptual art shows (with various names) from the late 1960s on. A British exhibition had come to Buenos Aires from Europe at the end of that decade. The CAYC gave support to Argentinean conceptual artists and those from abroad from the early 1970s. In Brazil, Lygia Clark, Hélio Oiticica, Cildo Miereles, Artur Barrio, are among the initiators of a non-object art

realized with the viewer's participation. Among others, we have to remember the Spanish conceptual theorist and artist Julio Plaza, from Madrid, the organizer of a mail art exhibition at the University of Puerto Rico in 1972. Plaza had settled in Brazil in 1973 to teach at the School of Communications and Arts at the University of São Paulo. And he was also very active at the MAC in organizing international exhibitions, publishing catalogues, posters, etc. We worked together in staging *Prospective-74* in 1974 and *Poéticas Visuais* in 1977, and then on the 1981 Biennial, which was probably the biggest event of that branch of conceptualism staged up to that time. This is another example of an artist who was integrated into the MAC's programs in the 1970s. It must be added that the MAC was the first museum in Brazil to establish a video art sector (in 1974). Though limited, we had the conditions enabling us to offer artists technical help. Up to 1977, as well as artists from other countries, we were able to present pioneering homegrown video makers like Anna Bella Geiger, Leticia Parente, Sônia Andrade, Fernando Cocchiarale, Paulo Herkenhoff, Ivens Machado, Jonier Marin, Regina Silveira, Julio Plaza, Carmela Gross, Donato Ferrari, Gabriel Borba, Gastão de Magalhães, and so on.

HUO *Was the exhibition* Information, *put on by Kynaston McShine at MoMA, important for the Brazilian art world? Several Brazilian artists such as Oiticica, Clark, and Meireles were represented at* Information.

Guilherme Magalhães Vaz too, for example, but not Lygia Clark. It was recognition by a young curator of the existence of an innovative artistic situation in our country. In any case, the choice was restricted. Oiticica stated in the text he wrote that he was not representing Brazil (under military dictatorship). He also said: "it's important that the ideas of environments, participation, sensorial experiments, etc., be not limited to objectual solutions." Other remarkable exhibitions were organized in the United States and in Europe during those years, of course, such as Szeemann's exhibition in Berne in 1969 [*When Attitudes Become Form—Live in Your Head*]. But new opportunities for participation by artists from here, with a few very rare exceptions, did not arise before the 1980s to 1990s (I'm thinking particularly of the Documenta and the Venice Biennale).

HUO *But there was the Biennial here, which made up for that lack.*

Of course, there are at least two things I have to say about that. On the one hand, the São Paulo Biennial—and its importance in South America and the international renown it has acquired can't be denied—had for far too long kept its structure modeled on Venice: organization by country, concentration on the traditional art categories, awarding prizes, etc. Secondly we can't forget that particularly from the end of the 1960s, with the hardening of the dictatorship and the restrictions on freedom, with the practice of censorship, etc., artists (led by Hans Haacke and Pierre Restany, if I remember correctly) had prompted an international boycott of the institution. Several countries abstained from sending their delegations of artists, or cut down on their participation. The biennials in the 1970s, with only a few exceptions, were conformist in attitude. Their recovery did not come about before the 1980s.

HUO *Was Documenta, which never subscribed to this model of national representation, something you aimed to emulate?*

To be sure. But obviously it has to be borne in mind that Documenta decides what it envisages exhibiting, with the resources of a substantial budget, while the São Paulo Biennial, which had no significant funding, was dependent on the decisions of each country, their willingness to be present, and their choice of artists. At the time when the Museum was at the Biennial (1981 and 1983), we started to change that state of affairs. We were able to issue direct invitations to a certain number of artists and we tried to influence countries to get them to follow the concept established for the exhibition. We created a team of curators, broke up the compartmented spaces allocated in advance to each country. Our interest was in current artistic languages, though without forgetting the importance of defining some historical cultural references (very necessary for a country like Brazil).

HUO *Talking about stimulating periods where curating is concerned, I'd like us to speak about your meeting with [Willem] Sandberg.*

Sandberg was an undisputed master. He came to us at the

time of the second Biennial in 1953, bringing a De Stijl
contribution, with a series of pictures by [Piet] Mondrian,
[Theo] van Doesburg and [Bart] van der Leck, as well as
works by the CoBrA group and abstract painters. He was very
active, he could talk to people easily and penetratingly, he
talked to visitors, artists, often students.

IM *He was a member of the Biennial jury.*

People listened to him in the exhibition rooms with great in-
terest because of his way of expounding ideas, the breadth of
his knowledge, and the importance of his experience—and
then we admired him for his great humility. Those are my
impressions from that time. When I was in Europe, I visited
him at the Stedelijk with my wife. He gave us a very warm
welcome. He took us on a tour as far as Utrecht in a little pick-
up truck, if I remember rightly, which he was using to have
a few pictures transported. He commented on the landscape,
the houses, the little Dutch châteaux [laughter] in the area,
and he introduced us to [Gerrit] Rietveld's house.

HUO *With regard to Sandberg, Johannes Cladders and others have told
me that he had a lot of influence in Europe in other ways, not just
through his activity as a curator: his writings and his talks on the radio in
which he spoke about the courage required to run a museum in a non-
academic, experimental way. In his writings there's a whole chapter
on the question of art and life, expounding the idea that a museum is
a place where life is sent back to itself, like in a game of ping-pong.
Are these concepts that influenced you?*

He was among the museum directors of his generation who
were fully aware of the importance of the open, experimental
character of a museum of art. The question of museums that
are closer to life, and opposition to their traditional elitism,
became a central subject in debates about them as institutions
later on. I owe a lot to him.

HUO *And in your generation, you mentioned Pierre Gaudibert, and
he is someone who interests me greatly since I work for the ARC
[Animation, Recherche, Confrontation], Musée d'Art moderne de la
Ville de Paris, which Gaudibert founded. Could you talk to me
about him?*

In the second half of the 1960s, a very important period, Gaudibert demonstrated a lot of professionalism and courage in creating the ARC. He opened a space for contemporary shows and events. He faced up to risks. He also knew how to find solutions to sometimes very tricky questions, as in the case of a "penetrable" by Jesús Rafael Soto. Do you know him well?

HUO *No, I've never met him as he's withdrawn from the art world. I know he wrote a book about African art.*

We'd invited Gaudibert to take part in the committee setting up works on site in the 1983 Biennial, which received the general submissions from countries. A long while later we also invited him to give a talk at a meeting of our national art history committee at Porto Alegre. He always turned up at the meetings of the CIMAM, which we've already talked about a little. As a museum director, Franco Russoli of the Brera is another name that must be remembered.

IM *There was also de Wilde.*

HUO *In Holland the most experimental person after Sandberg was undoubtedly Jean Leering at the Van Abbemuseum in Eindhoven. But you mentioned someone from the Brera that I don't know.*

Franco Russoli. He died a long time ago.

HUO *And he was interesting?*

He was asked to perfect a clearer, better organized nomenclature for the terms employed in modern art.

HUO *There's another question I wanted to ask. If we look at the museums that made the biggest impact in the 1960s and 1970s in Europe, there's one constant feature: all the directors of those museums were very close to the artists. For example, Sandberg really collaborated with the artists. The way Hultén aided and abetted Tinguely, as well as working with local artists, is another example. I'm curious to know whether you had a similarly close relationship with artists from São Paulo, Rio, or elsewhere.*

For me it's normal for a director of a museum of contemporary

art to have close relationships with artists and to get them to undertake some works. I must say I had a lot of contacts with them. Sometimes those contacts were very close, involving a decisive collaboration in the programs we were developing.

IM *Yes, for example I remember when you were at the museum, and at the Biennial too, you appealed to artists, the Biennial council, and the museum council. Is that where the habit of involving artists in decision-making started?*

That's true, we set up working groups with the artists. I've always liked working that way.

HUO *Adriano and I interviewed Lygia Pape and she talked to us a lot about Mário Pedrosa, and I'd like to know if you had any contact with him.*

Yes, we did. Mário Pedrosa belonged to the generation of Brazilian art critics who'd been committed to promoting modern art since the 1930s. He had a mind steeped in political and sociological knowledge. In the 1950s he was the main critic and defender of abstract geometric art in our country, influencing a whole circle of artists including Abraham Palatnik, Almir Mavignier, Ivan Serpa, Geraldo de Barros, Lygia Clark, Hélio Oiticica, and Lygia Pape, as well as the poet and art critic Ferreira Gullar, and members of the concrete and neo-concrete movements.

HUO *And did you work with people like Lygia Clark or Hélio Oiticica?*

I very much regret not having known Lygia Clark. For part of that period I was abroad. And afterward I didn't have an opportunity to get to know her. I'd met Oiticica a few times here and after that in New York in his modest apartment on Second Avenue where he'd installed one of his "nests." We were in frequent touch with Anna Bella Geiger. Around her she assembled a group of talented young artists, like Leticia Parente, Sônia Andrade, Ivens Machado, Fernando Cocchiarale, Paulo Herkenhoff—the last two became critics and curators. Other interesting contacts in Rio were those with Ivan Serpa, Artur Barrio, and Antonio Dias. We were also in regular communication with artists from other cities, for example

Sara Avila (Belo Horizonte) and Maria Carmen (Recife) who
were associated with the Phases movement; Paulo Bruscky,
a conceptual artist from Recife; and Bené Fonteles too, from
the state of Ceará; Diana Domingues, from Rio Grande do
Sul, and so on.

AP *How did the MAC differ from other museums at that time?*

The MAC was a university museum (and of course it still is),
the only one of its kind in Brazil. The collections, exhibi-
tions, and other temporary events attracted a public composed
to a considerable extent of students. As well as being a loca-
tion for events and exhibitions bringing together everyday
life and art—conceptual art exhibitions—we thought of the
museum and its permanent collection as a "laboratory area,"
to respond to the requests of the art history courses (a quite
recent phenomenon at universities here) and other disci-
plines. We put on lectures, debates. It was also a place where
theses could be presented, and so on. The Associação dos
Museus de Arte do Brasil (AMAB) came out of the network
of traveling exhibitions in the 1960s and 1970s, and it ad-
vocated the upgrading of the professional level of staff at
museums of contemporary art. Dilettantism was a frequent
phenomenon with us (a situation that hasn't completely dis-
appeared today) despite the advances in university studies.
It's regrettable, for example, to see a museum like the MASP
(Museum of Art of São Paulo), created in 1947 by Assis
Chateaubriand, under the direction of P.M. Bardi, caught up in
indecision about the route it should follow for several years.

HUO *I'd like to ask you a question about the Biennial. Ivo has told us
about the XVIth and XVIIth Biennials in 1981 and 1983, which you
organized. Could you explain to me how you transformed the Biennial
with those two shows?*

Up until then the Biennial had still been an exhibition cons-
isting entirely of delegations from different countries chosen
through diplomatic avenues and occupying predetermined
spaces. They had just started to change that state of affairs,
and I say "started," for of course we were dealing with a proj-
ect that had to be developed over the course of time. The cru-
cial change consisted of eliminating national representations

and organizing the installation of the works by means of the criteria of analogies in language, closeness, and confrontation with what the countries' submissions had in common. So we tried to influence the choices of the countries' commissioners by a regulation that gave some guidance on what we had in mind. Thus for the first time the Biennial was able to adopt an attitude of critical responsibility. We also introduced direct invitations to a certain number of artists. It wasn't easy to establish the experiment, but we had the satisfaction of seeing it deepened and broadened two years later, in 1983.

HUO *And that was the major change?*

The institution showed the will for renewal, belated no doubt, it's true, but in the end it was carried out. Certain commissioners sometimes made it clear that they disagreed, for their selections often did not fit in with the artists directly invited. It wasn't always easy to persuade countries with regard to the elimination of spaces that previously they'd been able to use as they liked.

HUO *Another very interesting thing you initiated for the Biennial was an international committee of commissioners, which came here to think about new ways and methods of displaying the works, and putting those methods into operation.*

We received very considerable collaboration from several curators and support from critics for that form of organization.

HUO *It was a conception based on dialogue, and not on the "master plan" of just one person. What I find very interesting is that in doing this you put into question the traditional function of the commissioner as an authority, and tried to break away from such connotations of the word by limiting arbitrariness and autocracy thanks to this collegiate decision-making body.*

Things have to be opened up for discussion to try and find a better way. In my opinion it was the most logical path to follow for such a huge organization involving the interests of an enormous number of artists coming from the most diverse cultural backgrounds.

IM *They subsequently kept the same system of working, in 1985 and 1987.*

And then a few years later the Biennial went back to the method of division according to national spaces.

HUO *I have a final question, it's a recurrent question for me, the one I ask everybody I interview, it relates to unrealized projects. You've done so many things, exhibitions, the organization of the Biennials, the direction of museums. I'd like to know whether in your long, rewarding career you've had projects that weren't carried through to completion, exhibitions that ground to a halt, dreams or utopias.*

Thank you. We always dream of doing better and making our utopias possible. One of those dreams was to organize an exhibition truly representative of the relations between art and new technologies. In spite of the changes introduced at the Biennial in the early 1980s, the old structure of the institution, the chronic shortage of resources, and furthermore, of course, factors such as the complexity of such an undertaking at that time as well as the restrictions on the time available, prevented the achievement of any such objective. But at least we succeeded in presenting meaningful examples of investigations in progress into these new territories of art.

AP *There was an exhibition of technological art, it was a bit like "poor technology."*

In 1981 there was a sector, including a representation of invited artists, using new media. One innovation was the mail art exhibition that brought together things sent in by more than 500 multimedia artists. At the next show the public could visit and sometimes actively participate in a whole section devoted to videotext (a technology that had just come out a year earlier, in 1982), recent video art works, the use of satellites, and computer art.

HUO *I interviewed Billy Klüver about this.*

He's an engineer who's admired, linked to artistic creation. His pioneering steps in the articulation between art and new technologies are well known. In 1966 he was one of the

creators of the Experiments in Art and Technology association in New York. With Rauschenberg he'd done *9 Evenings: Theatre and Engineering* in 1966 and he collaborated with Pontus Hultén on the 1968 anthology exhibition at The Museum of Modern Art in New York. I remember Hultén: like Professor Frank Popper, he was the curator of some major events on the interaction of art and technology in Europe and the United States. Allow me also to remind you of someone like Nicolas Schöffer, an artist and theorist in France. He'd been taking an interest in electronic art since 1955 with his project for the Parc de Saint-Cloud in Paris.

HUO *And Schöffer's utopian cities too. Did you know Schöffer?*

Unfortunately, no. Here in Brazil we used to have a few rare artists interested in technological problems, like Abraham Palatnik and Waldemar Cordeiro. Today the situation is totally different.

Anne d'Harnoncourt

Born in 1943 in Washington, DC, and raised in Manhattan. Died in 2008 in Philadelphia.

Anne d'Harnoncourt was the director of the Philadelphia Museum of Art (1982–2008). She was an expert on the art of Marcel Duchamp, among other artists.

Previously unpublished, this interview was conducted in 2006 in d'Harnoncourt's office in Philadelphia.

HUO *When I interviewed Harald Szeemann, Pontus Hultén, Johannes Cladders, and others, they all mentioned the influence of [Willem] Sandberg and [Alexander] Dorner.*

The affiliation of Szeemann and Klüvers and Hultén all very much falls into this heritage of those two main protagonists.

I was wondering what acted as triggers for you, who were your role models in terms of curatorial pioneers, what were the influences for you when you started?

ADH Well that's a very interesting and productive question. Obviously in one sense, for me it was clearly some of the people you just mentioned; it was Pontus [Hultén] and Walter Hopps in particular. It sounds as if I have too much *Familienstolz,* or whatever you would call it, if I talk about my father, but certainly he was an enormous influence on me, and my guess is that in the history of museums and the showing of art of all kinds in the US he had a lot of impact.

So René d'Harnoncourt is one, and James Johnson Sweeney, who was a fantastic figure and impresario, was another. Maybe this is true of all three of these people that I am going to mention—one of the things they were very, very focused on was installation and an interest in how the work is presented, which of course is part of what Dorner was so interested in—and most curators in fact! So Jim Sweeney, who was at the Guggenheim, and in Texas, adored the art of Brancusi, Mondrian, and Calder—a very pure and fantastic array of artists interested him. I think he was very influential, although he moved from place to place. He was briefly at MoMA; I am not very good on his chronology. And then for me also, perhaps most directly other than my father—it was more or less osmosis from my father—was a man called A. James Speyer, who was the curator of 20th-century art at the Art Institute of Chicago for a long time, from 1961 to 1986. At the beginning of my museum career I was in Philadelphia for two years and then in 1969 I went to Chicago as Assistant Curator, working for him. He was fantastic; he was brilliant at installation, he was a student of Mies van der Rohe. He was an architect himself. He built some very beautiful buildings, mostly houses, but he had an amazing range of interests and I think that is also something I learnt from him—very different, for example, from Sweeney, who had a very strong focus on artists who interested him in particular. Jim Speyer had a terrific range right across the 20th century, as well as the art of the past. He was very interested in contemporary art, he knew a lot of contemporary artists, he loved contemporary Chicago art, which at the time that I was there was the Hairy Who, Jim Nutt (and still is, of course) and his colleagues Roger Brown and Karl Wirsum. Yet at the same time he was doing installations, whether it was [Donald] Judd or Carl Andre, of very minimal work.

So it was very early.

Very early.

That is very interesting, because Sweeney and your father are well known in Europe but James Speyer is forgotten. Speyer being a student of Mies leads us back—because I had a long discussions with Philip Johnson—to display features. Mies learnt a lot about display from

Lilly Reich. Philip Johnson said it was one of the two or three biggest regrets in Mies' life not to have brought Lilly Reich to the US. It would be interesting if you could cite some concrete examples of Sweeney's and Speyer's exhibitions that most impressed you, especially in terms of the notion of display.

Jim Speyer was a really interesting man; he was born in Pittsburgh. His father was great friends with the Kaufman family who commissioned Fallingwater by Frank Lloyd Wright, and his great friend in that family was Edgar Kaufman, whose name you might know because he was curator of design at MoMA for many very important years. Jim himself was from a very cultivated family. His sister Dorothea Speyer still runs a gallery in Paris.

Yes, I met her.

So that is an interesting connection. I think the reason he might be less well known in Europe is that Jim did not write a great deal. He was not a critic/writer/scholar in the same sense, perhaps, that Pontus was; he didn't produce books like *The Machine*. But his installations were legendary in Chicago I would say for a 25-year period or longer. When I got to Chicago in 1969 he had already been there for some years and he was still there for at least another ten, 12, 17. He died in 1986 at the age of 73. But he did a Mies van der Rohe show himself; he did a sequence of exhibitions that were memorable—they were not like the Whitney Biennial by any means, but they were called *The American Show*. They included American artists he picked, and picked in many cases for many diverse points of view. They were people that he thought at any one time would be really interesting to show. It was rather like Dorothy Miller's earlier exhibitions at MoMA.

Emerging, new ...

Emerging artists and artists who might have been somewhat forgotten, as well as artists he thought important to emphasize. There was a purchase prize attached to the exhibition, so Jim Speyer always loved, of course, to try to include things in those exhibitions that the Institute could buy, for

example, a great work by Frank Stella called *De la nada vida, a la nada muerte* [1965]. Other great things that the Art Institute bought by a lot of artists came through those shows. I remember very clearly the installations themselves that Jim Speyer did. I think this is really important in the history of museums in this country: the history of installations of the permanent collection.

That is something I wanted to ask you about.

There was a fantastic space at the Art Institute (as museums grow and change obviously they use these spaces for different things), which was called the Morton Wing. On the second floor of the Morton Wing I would say the ceilings were maybe 7.60 m, maybe 9.10 m high; it was a big, tall space. Jim made complete use of it. I remember there was a huge [Francis] Picabia from the teens that he hung at one end of the gallery, very high, maybe 4.50 m up in the air, and there was a slim panel of yellow fabric in front of which stood an [Alberto] Giacometti. He figured out how to put things in the same space that were small and intimate like [Joseph] Cornell boxes and things that were large like the fantastic [Henri] Matisse *Bathers by a River.* So a lot of what you remember about the Art Institute's collection in 1960s and 1970s if you were there was how Jim orchestrated, really brilliantly, the installations. My father had the same love of installation. It's not surprising, in fact, that both of these men also had strong contacts with Europe. Jim Speyer taught architecture in Athens for many years and knew Europe well. My father was born in Vienna in 1901 and came to Mexico in the late 1920s, and to the United States in the early 1930s, and then spent ten years working with Native Americans (American Indians) on various projects. His first great exhibition project in the United States was the San Francisco World's Fair in 1939; it was a great show of Native American Indian art as art as well as ethnic material.

That exhibition has been an amazing influence on generations of curators. It was in a visionary way in advance of its time.

I think it was in many ways. The 1939 Native American exhibition was really focused on American Indians; it was one

of the early shows and perhaps the biggest to make sure that people registered the visual and aesthetic power of the objects on view as well as their context. There is always this tension that goes back and forth between anthropology/ ethnology and art history as to how to present the work of peoples for whom art making is about a great many different things as well as making art.

I'm not sure that that isn't true of all of us, but of course in certain societies it goes much deeper. My father was extremely interested in that. He spent years of his life really getting to know the people who made these objects, and so when he presented them, whether it was a sand painting, or totem poles from the north-west coast, or whatever it was, he tried to do it in this mixture of something that really respected the context in which it was made and at the same time would allow it to communicate to an audience not accustomed to seeing these things as the very, very beautiful and powerful things that they were. That idea clearly was a great influence on me, although the San Francisco Fair was before I was born. Certainly what I most remember about my father and installation was how much he loved it. He was never happier than when he was sitting at home in his shirt sleeves and short pants, whistling to himself and moving about lots of tiny little drawings or cut-outs that he had made of [Pablo] Picasso sculptures for example.

It was a pleasure for him.

It was a delight. He really loved to think in three dimensions and to try to do justice to the works of art without overwhelming them in the installation. I think the other thing that I learned from him, and this also continued through to each of the other people whom I think of as mentors in some way, was an absolute delight in working directly with artists. When he came to The Museum of Modern Art he did not come as a specialist in modern art but as someone to help make their mission possible as the museum became larger and more complex. He just joined the team, if you will. What I learned is that he felt the same strong way about a Navajo silversmith's concentrating on his art or a Mexican toy maker making fantastic birds out of gourds or contemporary artists and sculptors that he got to know much better at

MoMA, which is not to say that he reduced one to the level of the other, it was just that he viewed them all with excitement and respect.

As your father had that dialogue with artists and that proximity to certain artists, I was wondering who were the artists you encountered. It was extraordinary that you grew up in the middle of the laboratory years at MoMA. Was it then also that you met Duchamp for the first time? I am very curious about your first encounter with Duchamp.

Well, no. I met Duchamp for the first time, very appropriately, when I was in Philadelphia. The artists I met while my father was at MoMA and while he was still alive, through MoMA, were people I knew *en passant* as it were, such as [Mark] Rothko—who I remember one time sitting in my father's office, I was still a child and I had no idea I would go into art history or anything like that, I was just very impressed by meeting him—or Louise Nevelson. I really started to meet artists later in the 12-year period (maybe 14, if I add it all together), when I was in the curatorial mode. A lot of older artists had great affection for my father and here was a young woman with the same name, so it was very natural.

The artists I remember meeting very early on in my own career were [Alexander] Calder and, of course, Duchamp. Duchamp I really only met once. I went to New York to interview him when I was working here. I started in Philadelphia in the Fall of 1967 and he died in the summer of 1968. I had been a graduate student at the Courtauld; my field was early modern art. Duchamp was obviously part of that, but wasn't a special focus. But when I got here, and saw this extraordinary collection, I realized right away what a fantastic treasure Philadelphia had (as other people already knew, I wasn't the only one), and what an opportunity it was. One of the first things I wanted to do was to go to meet Duchamp, not to talk to him about himself—I didn't realize how short a time there would be to do that, nobody looks that far forward—but about the Arensbergs, who were the great collectors whose collection is here and whose collection Duchamp really enabled to be here. He was the scout for a home for that collection. He was running around the US; he went to Chicago and other places, looking, looking, looking for what would be the best place for the Arensberg collection,

which they sent to Philadelphia in 1950. So I had a wonderful several hours with him and with his wife, Teeny, and then within six months, he died.

My real plunging into the art world in a sense was the commission on behalf of the museum to write, together with Walter Hopps, an essay on *Etant Donnés*, which came to the museum as the gift of the Cassandra Foundation after Duchamp's death. It was decided that it would be a great idea to have a publication, and to do it as well as possible. My father died the same summer and of course I never put the two together; it was just one of those things that, when you look back on it, is just such a coincidence. They were two very different parts of my life, of course. My father was killed in a car accident and it was a tragedy for him and for my mother and for me and also for many of the people who loved him, but he had accomplished a huge amount in his life. But I never really had a chance to talk to him about what I might do in museum life because I was so new, I was just starting. And he thought it was very funny and very amusing, and he was apparently very proud that I ended up in museums, but he was completely surprised; it had never occurred to him. He never pushed me into the museum world; I guess you could say I never got out of it. Whereas with Duchamp it was one of these amazing times: to find that the museum was being given this incredible last work of his and to have the chance to really think about that deeply and to think about his entire work and to work with Walter Hopps, whom of course I had never met until then. In fact it was really my conversations over a long period of time with Walter Hopps, in an apartment that I shared with a great friend of mine, in which I learnt, not only a great deal about Duchamp, but also a great deal about all of modern art or contemporary art, because half of our conversation would be about Duchamp and then there would be a lot about other things that were on his mind or on my mind. He would ask me what I thought about an artist and I would never have heard of him or her, so that was fantastic.

With Etant Donnés *what is interesting is that it came to the museum after Duchamp's death; but when you met him was it still a secret?*

Completely! I had no idea.

I am very interested in this notion of the secret because obviously Bill Copley knew. Bruce Nauman always said over-exposure may be an enemy of art. I think this is a particularly big question at the moment, because over-exposure has never been bigger than now. The whole idea of the secret is gaining a lot of momentum again. I am very interested in that secret moment and how that secret was revealed.

Well, I don't know that I could tell you about the secret because I didn't know it myself. When I went to see Duchamp I had no idea.

Nobody knew.

Nobody knew. The only people who knew were Teeny Duchamp and, of course, Bill Copley. The Director of the museum at the time, Evan Turner, also knew, and the Chairman of the Board, because they had been approached by Duchamp very quietly—or by Bill Copley, or by both of them, I am not quite sure—to say "Duchamp has made a late work, a last work, and he would love it to be in the museum; would you accept it?" And they said, "Of course." But that was it! I don't think anybody knew about it except maybe four people and they had no interest in talking about it. All I remember is being asked by the Director of the museum and by Teeny Duchamp to work with Walter Hopps on the publication, and to be involved in bringing the piece here from New York and installing it in the museum. It was Paul Matisse, Teeny Duchamp's son, who was really responsible for the installation, with our conservator and myself.

Was it difficult to transport?

It was very simple.

It was in a secret studio?

It was just in a little room in New York. It wasn't really a studio by then, it was a room in a commercial building.

So by the time you revealed the work to the public, maybe only three or four people had ever seen it before.

That's right, yes. Of course everything is in retrospect; every-
thing is how you look back at it. At the time it seemed to me
just important to do this. I was aware, of course, that by
the terms of the gift, Bill Copley's gift through the Cassandra
Foundation, it was to be done very quietly. It was to be
installed—one day it was not there and the next day it was
open. And that is exactly what it was: one day it was not
there and the next day it was open.

The Foundation didn't want an opening?

No.

And you published this wonderful magazine.

It was an issue of the museum's Bulletin devoted to Duchamp
and to *Etant Donnés* and it was an enormous pleasure and
fascination to work on it. In a way it was very simple. It sounds
complicated but it was very simple. It was just to move the
piece from New York to Philadelphia, to install it in the space,
to work with Paul Matisse. Actually we also re-installed the
gallery somewhat. There were always a lot of works by
Duchamp in the Arensberg Collection, but we concentrated
them in the gallery around the *Large Glass*. And so it is now
really a Duchamp Gallery; it's a kind of pilgrimage site for
a lot of artists and it was right after this that I met so many
other artists, whether it was Jasper Johns, John Cage, or of
course Merce Cunningham. I think of them in some ways as
a kind of amazing trio, even though Jasper is younger than
they are. After the summer of the appearance of *Etant Donnés*,
in 1969, I went off to Chicago and spent two years working
with Jim Speyer, which was fantastic. Then I came back to
Philadelphia in 1971 with my husband—there had not really
been a position of curator of 20th-century art and that's what
I became. I had a fantastic period of about ten years here
being that and helping to build the collection, doing a great
Duchamp retrospective with Kynaston McShine in New
York, which was wonderful because it went to Philadelphia,
New York, and Chicago. It was in this trio of institutions, in
a sense by chance—never completely by chance—that I had
these wonderful experiences.

It sounds all very simple, but it was explosive material at that time.
How does the museum deal with explosive material?

Well I don't know. Explosions are in the eye of the beholder,
to paraphrase something from Duchamp, and I think in a
way it was more that the work was such a surprise to people
and particularly to people who had been working a long time
with and thinking a lot about Duchamp's work, whether
Robert Lebel, whether Arturo Schwartz, whether other great
scholars of Duchamp's work. I think it somehow was just
right, because here is a great, comprehensive museum with
art from many centuries, and with art of all kinds, and a fan-
tastic collection of modern art built by the Arensbergs, with
the help of Duchamp, including [Constantin] Brancusi's
work and all kinds of things: *Nude Descending the Staircase*
[1912]—speaking of explosions in its time—or Brancusi's
Princess X [1915], which was viewed as so amazingly sexy. So
in a way the appearance of *Etant Donnés*—you can't say it was
the conclusion of Duchamp's work, because I think what
Walter Hopps and I both felt was that Duchamp's work is
more like a picture puzzle that you are putting together, it's
a network, there are many strands and many pieces and you
can make as many themes, you can make as many connec-
tions. I have always found it very dangerous to categorize, to
say Duchamp is only interested in this or only interested in
that, because the minute you say it something else pops up.
I don't think I thought of it as explosive; I thought of it as a
really important and fascinating piece that had infinite num-
bers of connections with a lot of other things in Duchamp's
work and a lot of other work by other artists, like [Ed]
Kienholz, for example. That's where, again, the conversations
with Walter Hopps were so exciting, because he was great
friends with, and had spent a lot of time with, artists like
Kienholz.

[Robert] Rauschenberg also.

And Rauschenberg, of course. Rauschenberg, Kienholz, Johns.
Imagine someone who is in their 20s and is immensely excited
about art in general and artists in particular, and gets the
sort of opportunity I had—you do the work, you think, you
write, you help things to happen and then it is open and

then the world goes on in its own way. So I didn't see it the way it is easy to see it in retrospect.

And how would you then define the role of the curator? John Cage said that curating should be "a utility"; then when I spoke to Walter Hopps he was quoting Duchamp—a curator shouldn't stand in the way. Félix Fénéon said the curator should be a pedestrian bridge [une passerelle]. What would be your definition of the curator?

Oh, that is interesting. I hadn't heard the pedestrian bridge. I think the curator is someone who makes connections between art and the public. Of course, artists do that themselves very much and there are some artists, particularly now in a sense and I think that's great, who don't need a curator or don't want a curator; they prefer a kind of direct interaction themselves. But I see curators as enablers, if you will, as people who are crazy about art and they want to share their being crazy about art with other people. But I think they also have to be very careful not to impose their own reactions too much, their own prejudices, on other people. And that's hard because on the other hand you can only be yourself; you can only see the work that you see with the eyes that you have. I think of curators as opening people's eyes to the pleasure of art, to the strength of art, to the subversiveness of art, whatever it is.

That's a great definition. We spoke before about people you learnt from and now young curators are going to read the interview and learn from you. There is a beautiful text by Rilke, Advice to a Young Poet. *I was wondering what would be your advice to a young curator, given the situation of museums today, given what is happening with art.*

I think my advice would probably not change very much; it is to look and look and look, and then to look again, because nothing replaces looking. Art is all about looking—it may not be all about what you see on the surface, so it's all the more important that you have to look deeper and as you look you are obviously thinking. I am not being, in Duchamp's words, "only retinal," I don't mean that. I mean to be with art—I always thought that was a wonderful phrase of Gilbert and George's, "to be with art is all we ask."

The postcard.

Yes. I thought it would be great to inscribe it in the National
Gallery in London—"to be with art is all we ask." It's a privi-
lege, it's a responsibility, it's an honor; it's daunting to spend
a lot of time with art and with artists because you want to do
them justice. Actually I have learnt this as much from young
curators as I have from the mentors. The succession of cura-
tors that have passed through the museum, Mark Rosenthal,
Anne Temkin, now Michael Taylor and Carlos Basualdo—one
learns from them all the time. I think the main thing is first
of all to realize you never stop learning, and what you hope
is that you will have a long run before you can't see any more,
before you can only see the things that you already knew and
that you were already excited about. I also think one of the
great opportunities in a curator's life is to change one's mind
and to see an artist's work which one didn't understand or
one didn't like or one couldn't connect with 20 years ago or
ten years ago, and suddenly to walk around a corner and see
maybe the same thing, maybe something different by the
same artist, and say, "Wow! This is something that is im-
portant to look at." I am very convinced that the same work
of art can have any number of different appearances. Every
pair of eyes that sees it has a different experience, a different
background, a different visual connection, let alone a differ-
ent spiritual or mental or emotional connection. So there is
that. Secondly, you can put the same work of art in rather
different galleries, in different contexts; the same exhibition
in one museum or in one gallery or in one place is very dif-
ferent from the same exhibition in another. The Brancusi
exhibition, for example, to go into the past, at the Centre
Pompidou and in Philadelphia, was completely different.
They were both very beautiful, but they were very different.
It is even more true for a contemporary artist, I think.

*The perfect installation of a show has very often been compared to music.
I was wondering if you could define, if one can define at all, beyond
contextuality—because obviously each one is a situated, contextual
approach—any criteria that for you are the absolute criteria of what
makes a good installation?*

Ah! What makes a perfect installation? That's really hard!

When the work of art sings, when the work of art communicates, or does whatever it does. Communicate may just be a very limited word in some way. When the work of art connects with the viewer, or the listener in the case of music, in some very deep way. Certainly, I am sure, I have a certain style of installation myself. On the whole I am someone who works with white or off-white spaces; I don't have any problem, if I am hanging pictures, to suddenly hang them very high or in different places if it seems to me that is exactly right for them. We all have our own way of thinking about installation but I think you just need to be enormously sensitive to—I think you can say the needs, you can say the demands, or you could say to the character—of the art. That's what I think makes a great installation: to be sensitive to the character of the art.

So having these antennae.

Having these antennae, exactly.

Another question in relation to Duchamp is the notion of the archive, the living archive, the dead archive. There is a beautiful text Hal Foster wrote, which is in his book Design and Crime *[2002], where he talks about the archives of modern art. He talks about the archive, not the dusty archive, but the archive with a production-of-knowledge momentum. Particularly in relation to Duchamp, this seems to me to be a question about your vision of the museum ,which is of interest because you not only have an amazing chapel, so to speak, of Duchamp, but you also have the archive. Do you think that is one of the things museums should collect also—archives—and what does that imply? I was wondering if you could talk about that notion of the archive— the living archive—and also how performance suddenly entered into the presentation of Duchamp in this museum.*

That's a lot of questions all in one!

I know, yes.

First of all, I think the whole idea of an archive is great, and it is interesting that Carlos Basualdo has proposed, as the title for his new series of installations, the idea of "notations," which he takes from John Cage's book of scores by lots of

different composers/artists. I think archives are very impor-
tant; they are fascinating. For example, we have a great
collection of Thomas Eakins' work, the great 19th-century
American figurative painter, and we have a wonderful archive
about him, with some of his thinking and writing and other
people's writing. The same is true of the Pennsylvania
Academy here, which has great archives of many artists who
taught or studied there, including Eakins. Of course with
Duchamp the same is true. The archive gets yet more alive
if you are talking about fugitive works of art, or sometimes
when an artist, as in the case of Duchamp, brought so many
things to the surface for the first time. The idea of his head
with a star shaved on it that was photographed by Man Ray,
for example. I am sure that the Man Ray photograph, be-
cause Man Ray is a wonderful photographer, is a work of
art, but in one sense this is a documentation of something
that was fleetingly there and then the hair grew back from be-
ing shaved like a comet and it wasn't there any more; so the
photograph is all that remains, this perfume. Duchamp talks
about perfume lingering in the air, the kind of "belle Hélène"
beautiful breath in his perfume bottle. I think archives do
have that. I don't think the dust factor—after all there is dust
in the *Large Glass*—is important because the dust is in the
eyes of the beholder, you could say. If you are in the Calder
Foundation and reading a letter from Calder, or if you are in
the Duchamp archive in the museum and you are reading a
letter by Duchamp, that is very alive because you are hearing
the voice and maybe the mind of the artist themselves talking.

I think books of letters, for example, are fascinating.
You never know what is in archives because they are a kind
of network that surrounds the work. I think one of the interest-
ing discourses in contemporary art is always, "Do you need
an explanatory label on the wall or do you just hang the picture
and let the public cope with it?" I am always one who believes
that if the artist is not completely against it—and sometimes
you try to persuade them—a really thoughtful text of some
kind, whether it's the artist's text or whether it's the curator's
text, is really helpful, because even if you disagree with the
text, it gives the visitor something to push back against. I
love having a very important modern and contemporary col-
lection in a comprehensive museum, because the visitors here
are not only people who come expecting to have a dialogue

with contemporary art, they are everybody. They are people who just have some interest in coming to see art, whatever that is, so they go from an Indian temple and they walk into an installation of Ellsworth Kelly or they walk into the Duchamp Gallery, or they go and see a picture by Andrew Wyeth, or whatever it is that they do. It's not talking down to people to write a short label or to talk a little bit about it or to give some kind of audiotape opportunity. They don't have to listen, but they can. I think it's more just saying, "Hey. You can relax. You can just look at this, you can have your own take. This is what somebody thinks but you don't have to think like this." I don't mean dictating what people should think because that's terrible; it's just giving people a kind of framework.

Very interesting. That has been my experience working with Suzanne Pagé at the Musée d'Art moderne de la Ville de Paris; it has always been extraordinarily rich. People would come to see a Pierre Bonnard, and suddenly find themselves in a Pierre Huyghe exhibition. That happens in our museum in Paris with 20th century next to contemporary, but here it happens throughout the centuries. There is also a big focus in this museum on 19th-century displays, as well as displays of previous centuries, so that makes it even more complex.

It makes it more complex and my feeling is always that the artists themselves really enjoy that—many artists, anyway. They love being in a place, I mean physically; they love walking through a place and they often love being exhibited or collected in a place that has the art of many centuries. I will never forget one day when Jasper Johns came briefly to the museum to look at some works of his that had been installed and to have lunch, and he asked at the front desk about a Japanese ceramic vessel, a beautiful Jomon pot that was made several thousand years ago. For our visitors, sometimes the gothic and medieval period, or the Japanese teahouse, which is very beautiful and is in the museum's galleries, can be far more daunting and mysterious than something very contemporary, because with contemporary at least you feel, "This is my century." "I like it," or "I don't like it." "I feel free to criticize it," "It's my generation." Whereas often art of the past has a mystery to it and what you want to help visitors get away from is the terrible anxiety, "What am I

supposed to think?" The answer is "You are not supposed to think anything in particular, you are just supposed to think." It is not even a "supposed." You can do what you want; you can react, but the museum is there to give you information, to give you possibilities of ways to see afresh, whether it is something very contemporary, or whether you, being a very contemporary person, are for the first time encountering something from the past.

So it goes in either direction.

It goes in either direction.

What is interesting in relation to that is for me also the question of the display feature. In a long interview I carried out with Richard Hamilton last year, he went as far as to say that only exhibitions which invented a display feature would actually be remembered—the display feature obviously being very related to Duchamp's inventions. I was wondering what role the display feature would play for you, and how you see that whole idea in relation to architecture.

I think we remember art in many ways; one we certainly remember is individual encounters with works of art that are like a thunderclap. We suddenly find ourselves in front of something, whatever it is, and we are mesmerized and can't forget it. And it is not an issue of the display feature, usually, that you are talking about. It is an encounter and that can happen anywhere; it can happen in an exhibition that is so badly installed, or in a museum in a dusty corner; you can walk around the corner and have this amazing experience. We shouldn't forget that in all of our—you might say arrogance—about making the most beautiful or the most effective installation, what life depends on is encounters. I remember once going into the galleries of the British Museum; it must have been 40 years ago, my first visit, and seeing these very crowded display cases; and there in the middle of many other things was a god from the South Seas whose character is to bring all other living beings into existence. It is a figure that stands upright, and little creatures are coming into being all over the smooth body. For some reason I was riveted—I am sure it was partly my past experience and my interest with my father in lots of kinds of art from Africa and

the ethnic origin of things. Anyway, it was not a great instal-
lation, but it was a chance for me to discover.

Kynaston McShine has thought a lot about this, and
I remember his wonderful show at MoMA, *Museum as Muse*,
which had to do with the way artists do displays of various
kinds. The exhibition was really quite intense. There are a lot
of artists who think a great deal about how their work should
be shown. Joseph Cornell was certainly one and obviously
Kienholz, and there are others. There are installation artists
who do the whole Gesamtkunstwerk, the whole thing, which
I think is a strong characteristic of the 20th and 21st centu-
ries—Kurt Schwitters' *Merzbau* and so on. I think architec-
ture is always important because architecture is the kind of
shell in which things are contained. But what is interesting
to me, for example, is that here we are in a museum that on
the outside looks like a huge, rather forbidding, neo-classi-
cal temple; it is really hard to guess what the building holds
from the outside.

It's like a city, almost.

Well it's like an acropolis—but you walk inside, and all of a
sudden the actual spaces of the building are very open, very
clear; you can have completely different experiences. You
can look at something really contemporary, like a new work
by Thomas Hirschhorn that we are just installing, or you can
look at Duchamp's *Large Glass* [1915–1923], or you can look
at an Indian temple. It's not a black box or a white box, it's
something more interesting than that because it has its own
character. It provides a lot of windows onto the world; it has
light and air and it is big and ample enough so that you can
make a lot of connections. One of the places I love to look at
art is in the Menil in Houston.

What is your favorite museum?

Well, I think the Menil is certainly one of them. You have
favorite museums for many reasons. You have favorite
museums for the works of art that are there. I think the
fantastic Bellini *Saint Francis* [c. 1480] in the Frick Collection
is just one of those works of art that you will travel a conti-
nent, two continents, to see. Or *Bathers by a River* by Matisse

in the Art Institute of Chicago, or the British Museum with
that fantastic sculpture that I mentioned, or other great
things that they have. At the same time there are places that
give just sheer pleasure and excitement and intensity when
you see whatever art happens to be in them. And it's not a
chance that the Menil Foundation has this amazing feeling
because, first of all, it has fantastic works of art; second it is
a very beautiful building that reflects not only, obviously, the
talent of Renzo Piano, but also what Dominique de Menil
really, really wanted, which was to give people contemplation
space—a space that would be both beautiful in itself but
lead to interaction with the art, whether it was New Guinea
sculpture or Byzantine icons or Jasper Johns or Cy Twombly.
So it's certainly one of my favorites and I am sure there are
others. I have lots of favorites! I actually love the Pompidou.
I love the Pompidou because the French are so amazing.
When they do something they really do something and the
idea to create this kind of fantastic, colorful machine in the
middle of Paris is fantastic! I think you have one of the great-
est views in the world from the top floor of the Pompidou.
And to see the Dada exhibition there was great; I thought
both the installation was fantastic and the show was fantastic
and somehow the Pompidou never looked better. It's a crazy
place and it has all these things, the library, IRCAM (Institut
de Recherche et Coordination Acoustique/Musique); it's
both an ideal and a museum and that's always interesting.
You could say the same thing is true of the Menil; it's both
an ideal and a museum. Sometimes the installations are
better, sometimes they are less good, but I think just now
it's looking absolutely fabulous. Speaking of architecture,
there's the Sir John Soane's Museum in London, to go into
the past a bit.

*I curated a show there in 2000 with 15 contemporary artists. Douglas
Gordon came up with the title,* Retrace Your Steps, Remember
Tomorrow.

It's a revelation, the Sir John Soane's Museum. I think people
realize they are almost inside his mind when they are in there.

*I think right now, particularly in new museum architecture, there is a
risk of the very homogenizing phenomenon of globalization; the spaces*

are all big, they are all rigged to be the same. I think that whole idea of museums having big and small spaces, fast and slow spaces, noisy and silent spaces is good, so I was wondering if you could talk a little bit about this, particularly in Philadelphia in relation even to the Barnes Collection; there is a different way to see art here than in the Barnes Collection.

I agree very much, because I think the important thing is not for everything to be the same, but for everything to be different and for there to be opportunities to experience different kinds of spaces. If you think about Zen temples in Japan and you think about how you can experience works of art there, on the one hand there will be a very simple, relatively small room with sliding screens and there may be one fantastic painting on one wall and then a view outside to a beautiful garden, and that's it. The space is so small sometimes that all there is room for is you and your friend and a scroll and the tea ceremony objects. And then on the same trip to Kyoto you can go to that great temple called Sanjusangendo, which has been photographed wonderfully by Hiroshi Sugimoto ... with thousands of Bodhisattvas, all in one huge space, and in a way the space is infinite because they are infinite. You know, every Buddha has however many hands and on every hand is however many little figures; it multiplies forever. So I think it is important to offer a variety of ways to see things.

In some cases, as in this big museum, we offer that variety within the museum—not all the spaces are the same and you feel very differently when you go into the Indian temple space or into the Japanese tearoom space or into the Brancusi Gallery or into a very contemporary gallery. I think having small spaces is also really important and it's great if they don't have to be constructed every time. It's great if they exist naturally. But also it's very hard for museum architecture to anticipate future art, future collections. You build it, it's there and it can't be infinitely flexible because that's probably too expensive or sooner or later the flexibility gets old and breaks down and doesn't work as well.

The idea of Cedric Price and the Fun Palace *[1960–1961], basically.*

Exactly. And that doesn't always work and sometimes you

are better off with some fixed spaces of different sizes with which you then try to do really provocative things. I guess what always gives you hope is that of course there are always new artists, there are always new curators, there are always new visitors, and people will use something that exists to make something even more interesting than what was there before. I think what I always feel nervous about is doing something in a museum in which everything is predetermined, if you will; but then I come to somewhere like the Soane's, which is in a sense predetermined, and it's fantastic. But the Soane's is like a work of art all in itself.

That leads us to architecture. I read an interview recently where you talk about the city. Architect Jacques Herzog pointed out to me that for him there is also always the issue of urbanism connected to museums. You said in an interview that museums bring to cities a connectedness with the whole world that all cities strive to have, and that actually the great challenge is to keep that connectedness with cities part of the urban renewal, and still to keep what is special about museums, not to lose that. Mario Merz quoted the Vietnamese general Giáp—when you win territory you lose concentration and visa versa ...

I think that when a museum thinks of expanding it is really, really important to also try to figure out what your character is. What do you do best, how do you keep on doing it, how do you keep on doing it well and even better if you are bigger? I think our thoughts about our expansion really have to do with two things: the museum for a long time had very little money for realizing the potential of the museum's collections, many of which, we have to say, have been for many years very under-published and also under-known. Contemporary artists knew we had a great Duchamp collection because contemporary artists are one of the great networks of all time. They know immediately when you hang a new work of art in your museum—within seconds they are there. I always loved the fact that in the Art Institute of Chicago, because it's an art school and a great museum, within ten seconds of hanging a new acquisition there would be lots of students sitting on the bench and criticizing it. The same thing works for museums, I think, on the whole; artists catch on very quickly, but artists always see art with intensity and they see it pretty clearly whatever context you give it. So it's really

people who are not artists for whom you have to keep that intensity. Civilization in general, and cities in particular, are inextricably, in my opinion, bound up together, because it's concentrations of people and concentrations of minds and concentrations of thinking about what cities can be and what society can be and what makes life interesting that happens in cities much more than it does in very rural places. That's not to say there can't be wonderful brains in rural places, just that you need a concentration of them. If you think of the great cities of the world, they are always places where there are a lot of museums and where there are a lot of cultural things going on all at the same time. I think the challenge is exactly what you say: as the museum expands, or as there are a couple of new museums in a constellation of museums, you have to be careful that you don't lose the creative energy, and that you intensify it rather than diffuse it.

So as the Philadelphia Museum was thinking of expanding, we had to find the only place that we could possibly expand into, because this is a landmark building—you can't tear down one wing and build a wing twice as big, that would be a disaster from every point of view. There is an Art Deco building across the street that was built at the same time by several of the same architects, and now Richard Gluckman has done a fantastic combination of renovation and intervention to bring this space alive. You were talking about archives—our library, the archives, will be more visible in this new building. We have a fantastic collection of prints, drawings, and photography, and also of textiles, which go from ancient Chinese to very hot fashion, that will be in this building. It will be a very lively place. It is right across the street from the museum but it will have its own character, so it will be a place that you could visit in itself, and also a place that you can visit together with the mother ship, if you will.

Coming back to this building, and we have tried to take advantage of its character and to carve out more space, because there is more space, we just have to find it. We don't want to become so big that people lose themselves, but we really can make some great improvements and also find more space for contemporary art by rediscovering spaces we have and making more out of them.

I think it's really important that there are different kinds of museums within very short distances of each other.

The Pennsylvania Academy, which is a fantastic museum as
well as one of the great art schools, started as an art school
200 years ago and still has a fantastic building from 1876,
which has now been reinstalled and looks fabulous. They
also have an extension next door. Then there is the Rodin
Museum and the Barnes Foundation will be moving near-
by—which, as you say, is a completely different experience
of looking at art and always will be.

*It is not a new wing; you add a museum to the museum, which is like
a resonance.*

It is a resonance. It is very connected in lots of ways; it's the
same staff, but at the same time it will have its own charac-
ter. I think it will have a very contemporary feeling because
we also have a big gallery for modern and contemporary design
and one for photography and another gallery that's very
flexible: it could be for video, it could be for any number of
things. And because of the nature of what's there, we will be
rotating installations a lot. There will also be big study centers
for our print and drawing and photography collection and
our costume and textile collection. The library, which is one
of the great art libraries, as you can imagine, and has been
squeezed into almost no space at all, suddenly gets to have
a real public presence. So it will have a very different feeling
to it from this building and you can visit them both in the
same day or you can do them separately.

*My next question is whether you have any utopian projects that
haven't happened, which you have not yet been able to realize. What
would be your utopian museum? It can be something completely dif-
ferent from the museum or in relation to the museum. What would be
your as-yet unbuilt road?*

That's an interesting question in itself because I do think
museums in their very nature are very utopian enterprises.
Since the very beginning of museums, if you look back at the
founding language for the British Museum or for the
National Gallery in London or for most of the great museums
of the world, they all began with this incredibly idealistic
idea of art for the people and art as a means of educating
and widening and deepening people's lives as citizens. It's

really amazing. There is also from early on an aspect of economic impact and commercial results, thinking that museums are good in every way for the cities they are in. I don't know—in some ways every project one does in a museum is a utopian project.

Yes.

Because you try to be the best you can be. One dream of mine—but that's not utopian, that's in a way going back to the roots of museums—would be to be able to make the entire museum always free to the public. Museums have a very hard time doing that any more. In the US, there is not much government support for museums. Yes, for the National Gallery or for the Smithsonian, but not across the country. That has never been the case. I feel that a museum is like a free library and the principle is that everybody should have access to books.

Or a school.

And everybody should have access to art, which I believe very strongly. So in one sense that's a utopian project for the future, to be able to figure out how to do that, to be able to afford to do that, because I think it could have of all kinds of unknown benefits. We were once free to the public but that was a very long time ago.

When was that?

It was in the 1960s. We were so poor as a museum and we had also very low attendance because we had no money to tell people we were here, we had no money to publish the collections, we were not air-conditioned; there were many, many problems. There are a lot of people who believe that society only values what it pays for. I don't think I believe that. I think society values, for example, a beautiful view of a landscape. And of course ultimately you have to pay for it; you have to pay for it in the way you help to preserve the river or you help to preserve the mountain and you figure out ways to use less energy. That's paying for something in a way, it's preserving something. It's a question of paying for something in a different way. I don't know if I've had one

idea for a utopia. The utopia is what the next artist coming along will propose or will feel or will envision and then being able to do that. In a sense, rather than a utopian vision for the museum, I just have this constant dream that is always the same; it's been the same from the beginning, and that is just to make the spark happen. It is so interesting that it was Duchamp who said that it is the viewer who completes the work of art. I think he meant it profoundly, he meant it in every sense. So that says to me that it's not just numbers, that you need to connect more people with more works of art, but you need to connect people more deeply with works of art. So that, really, is the utopian dream. How do you do that? One of the great opportunities that we are all figuring out together is the role the Internet plays in all of this.

And blogs, and all of that.

And all of that. And obviously it is clearly a whole new world. I am very undigital as my staff is the first to know. It is not my experience, but nevertheless I find the whole concept of the Internet is unbelievably exciting. The fact that it exists. In a way it is almost Duchamp's fourth dimension or fifth dimension.

And at the same time André Malraux's imaginary museum …

Exactly. And because of it even more people want the real thing, art doesn't lose its "thingness." I think the utopia is that the real thing goes on and is of enormous value and not financial value, but moral, spiritual, and aesthetic value, all those other values. We don't know what we do about the commercial value; that will just go up and down the way it always has.

That leads to the last question I wanted to ask you, which is related to those sparks. We have been talking a lot about Etant Donnés *and about your influences and your idea of the museum of the future. One of the things we haven't mentioned and which would be interesting is that you have done such a huge number of exhibitions here, retrospectives such as your Dorothea Tanning show and the Andrew Wyeth exhibition now, and at the same time you have done lots of rehanging of the collection. If the utopias are those sparks, there is a constant searching for*

those sparks. Could you maybe mention a few other sparks, moments when you felt that you came to the fulfillment of this Duchampian idea of the explosion within your time here in Philadelphia.

To different degrees, I think every exhibition, whether it's a large exhibition or a tiny installation, has its moments of epiphany. If I were to mention a couple of them I would think of the great exhibition in 1979—I was not Director at the time, I was a Curator—the amazing scholar Stella Kramrisch, who was Curator of Indian Art did an exhibition called *The Manifestations of Shiva.* I think she was 86 when she did it, it was her life-long dream.

She was a pioneer.

She was a pioneer. It was one of the most thrilling exhibitions. She is another hero, you might say, in my pantheon of heroes that we started with.

Was there a catalogue on the show?

There was a catalogue. It was an exhibition about the being of Shiva as manifest in many different forms, and rendered in bronze sculpture, in temple sculpture, or in painting.
 I will never forget the artist Noguchi coming to that exhibition; we were walking through together and we got to the end and there was a platform with, you might say, a forest of lingams, all very different. You could see that when Noguchi got to the end he practically lost the ability to speak, he was so excited. He said, "Anne. I have to go." I said, "Isamu, we were going to have … " He said, "I have to go." I said, "Where are you going?" He said, "Back to the studio, of course. I am so excited, this is so exciting, I just have to go back to the studio."

It pushed him to make art.

It pushed him right back to the studio to do many works, actually. So that's one show that I won't forget. And another was, and in a way it may be almost related, the Brancusi exhibition of 1998.

The Manifestations of Shiva *is reminiscent of Deleuze's ideas of repetition and difference.*

Absolutely. Speaking of installation, there were three very different kinds of galleries created for that show. Stella described her idea for the installation at a curators' meeting a year before the exhibition and she said that the stone sculptures would be installed in a huge, dark space and full of plants, as you might see in India, in these great temples in an outdoor situation. And she said the paintings would be very beautiful on a clear color that is ideal for them, and the sculptures would be installed against a wall of "molten gold." It wasn't quite molten gold, but it was really, really beautiful. So she completely had the sense of how this show would look. This is an example of an exhibition in which the title was difficult—nobody really knew who Shiva was. A *New Yorker* cartoon came out maybe six months later: it was a suburban couple looking up in the night sky and they see a kind of constellation of a whirling god with many arms and one says to the other, "It's Shiva manifesting himself in all his divinity, but what he's doing in Connecticut on a Tuesday evening I have no idea." So I thought, now that's an exhibition that has sunk into the collective consciousness. That's what you want to happen.

Another thing I love to remember (it's about the permanent collection because I always like to end with something about the permanent collection) is the re-installation of all the European galleries done by Joe Rishel and Dean Walker, our wonderful curator who died last fall, which was very tragic. We re-installed about 90 galleries of our collections and they moved some things that had been in the same place for a long time. One object they moved was a tomb sculpture of a knight. I think he is 12th century; a recumbent knight who has a very simple, very beautiful worn face and on his shield he has four birds in relief. This sculpture was the subject of an 8-minute video by a young Puerto Rican kid whose brother was killed in a gang battle. His brother was 18 and the kid was 14, or something like that. He made a T-shirt with his brother's portrait on the T-shirt and he did a video of himself talking to the tomb sculpture as though it was his brother.

Extraordinary!

Just saying, "You are my hero, you are my knight in armor and you are gone." It was one of the most amazing experiences. The knight is in a beautiful gallery with the light streaming in over him from the outside window and he was moved from a very dark gallery where you could hardly see him. The knight had a whole new life in this installation and then this boy bonded so clearly with this figure of a dead knight and turned it into his own tribute to his dead brother. It was one of the great things in my experience in the museum.

That is a wonderful final statement. I want to thank you very, very much for the interview. There is just one more thing that I wanted to ask at the end. At the beginning when we spoke about the pioneers, you gave a wonderful example for René d'Harnoncourt and also for the curator from Chicago, but there was a missing example of a Sweeney exhibition and that was a show that really struck you.

That is a case where I am not sure whether I actually saw something of Jim Sweeney's or whether I was simply so aware of his standards. I think I must have, but to give you that answer I would actually have to look at the exhibition sched-ule of the Guggenheim and MoMA and to remember what I would have seen and when. I saw many shows, of course, at MoMA and some I don't remember at all, and others like *The Art of Assemblage* by Bill Seitz, for example, which was fan-tastic. Bill Seitz was another hero, but in a different way. Jim Sweeney and my father and Jim Speyer all flow together in my mind because of their love of installation. They are not exactly of the same generation because I think Jim Sweeney and my father were more the same age and then Jim Speyer was 25 years younger, something like that. But Jim was in some ways kind of poised between the world of Mies van der Rohe and very contemporary life. One person I suggest you think of interviewing some day is Anne Rorimer. She also knew Jim Speyer and is a fascinating person in her own right.

Thank you so much.

You're very welcome.

Lucy Lippard

Born in 1937 in New York City. Lives in Galisteo, New Mexico.

Lucy Lippard is a feminist art critic, author, and theorist. Among many other activities she was co-founder of Printed Matter, and has curated numerous exhibitions in the US.

Previously unpublished, this telephone interview was conducted in 2007.

Transcription by Noah Horowitz.

—To Sol LeWitt

HUO *To contextualize this interview,
it is one of a series I'm doing with
pioneers of curating. All in all there will
be 11 interviews published as a book
by JRP/Ringier. You have so many
different facets to your work, but in the
interview we will be mostly focusing
on your work as a curator.*

LL There's not much documentation
available. We didn't do much
of that in those days. I didn't even
have a camera …

*That's why the interview is important.
I realized that there's relatively little
literature on exhibitions, and also there is
an extraordinary amnesia about exhibition
history. When I started as a curator I had
to gather together various documents; there
were no books, not even on Alexander
Dorner or [Willem] Sandberg. Because
of this extreme lack of memory in
relation to exhibitions, I thought it was
urgent to start to record an oral history.
Johannes Cladders and Harald
Szeemann talk a lot about their friend
Willem Sandberg at the Stedelijk.*

Walter Hopps and Anne d'Harnoncourt talk a great deal about early pioneers in American curating. So little by little, in a patchwork of fragments, there is, hopefully, a contribution to what Eric Hobsbawm calls a "protest against forgetting."

It sounds like a wonderful idea.

So to begin at the beginning, I wanted to ask you when you came into contact with the idea of curating and how. When was the first time that you thought about curating an exhibition?

The first time I curated a show was in 1966, but I had worked for curators at MoMA—the only actual job I've ever had, from fall 1958 to late 1960 or so. I worked in the library under the marvelous Bernard Karpel, who would farm me out to various curators to do research. I was a page, and filer, and researcher. I was just out of college and had an art major that was both studio and art history. It was right after the fire, in the fall of 1958, and everything had to be reshelved, so I got a tremendous education by handling almost every book. And when I filed stuff, I looked at it, so I learned a lot about contemporary art. I did research for the curators and then I quit and did the same things as a freelancer—research, translations, bibliographies, indexes, some copy editing for curators and the publications department.

For whom did you work, specifically?

My name got on a book with Alfred Barr and James Thrall Soby about the collections; I wrote all the long captions. I did some translating from French for [Joan] Miró and [Jean] Tinguely. I worked on the Max Ernst exhibition just doing flunky work, but I ended up writing my Master's thesis on him. I saw how curating worked, but I wanted to be a writer. I was interested in prints and worked quite a bit with Bill Lieberman, who was very good to me. I worked on *The Art of Assemblage* show with Bill Seitz in 1961. Peter Selz was there and I researched for him now and then. At some point, probably around 1966, I curated a couple of traveling exhibitions for MoMA—one on Max Ernst, one on soft sculpture. Kynaston McShine and I were working together on one we called *Primary Structures* when he was hired by the Jewish

Museum and took the show with him, so I was off of it, but
we figured out the basics and the title before he went. It
opened in 1966. I'd written or was writing about something
I called "Third-Stream Art," which was published in *Arts
Magazine*. At the time a lot of painting was moving off the
wall into sculpture; the edges were painted; it was becoming
more of an object. And sculpture was moving closer to paint-
ing with polychrome and flat planes.

Around the same time, October 1966, I curated
Eccentric Abstraction at the Marilyn Fischbach Gallery; Donald
Droll directed it. We were both close to Eva Hesse, and
Frank Lincoln Viner lived upstairs from Bob Ryman and me
on the Bowery. In a way the show was based on their work.
Maybe Fischbach wasn't ready to give Hesse a one-woman
show ... I was very involved in Minimalism, but Eva's work
indicated something subversive to Minimalism, a more sen-
suous edge to that repetition and structural look.

Can you give some examples?

The show included several pieces by each artist: Eva Hesse,
Louise Bourgeois, Alice Adams, Bruce Nauman, Gary Kuehn,
Keith Sonnier, Don Potts, and Viner. Most of them became
well known. A lot of fuss was made about that show, partly
because I was a critic and critics at that point didn't really
curate shows. Eugene Goossen and Lawrence Alloway had,
but for a young woman critic to pop up caused a certain
amount of attention. Hilton Kramer, or somebody, actually
said writers should write and leave curating to curators.

So there was a critique of that mix.

Yes, there were curators who were trained in museology and
had PhDs in art history, and there were writers; most of us
were freelance and kind of scruffy, except for the academics,
who had to write to keep their jobs. They screwed us up
when we tried to start a critics' union because of course they
already had salaries and they didn't need living wages. Later,
writing and curating kind of fused.

*It's very interesting that from the outset you wanted to be a writer but
at the same time you had this experience at MoMA, this sort of contact*

zone one could say, not only with curatorial practice, but also with one of the extraordinary laboratories, so to speak, of curatorial invention.

I never learned much about installation, or practical things about handling the work. Once I had a freelance job cataloguing Edward Warburg's collection. I was recommended by the Modern and had no idea what I was doing. I shudder to think about it. But I must have exuded a certain kind of misguided confidence, because people kept asking me to do things I knew nothing about.

And were there any curators in terms of the history, or any memorable encounters with Alfred Barr?

He was just very kind to me and wrote some recommendations for me at some point, for something I didn't get. This was obviously before his Alzheimer's—he was sort of kicked upstairs at MoMA. There was a lot of internal politics going on, but I wasn't that interested until the late 1960s when we started protesting against the museum, and then I got very interested because it affected the artists.

By that time you had left MoMA and you protested.

Yes, the protests began with the Art Workers Coalition (AWC), which began in the MoMA garden over artists' rights. Later on, we protested against MoMA for not letting their employees unionize, and for artists they were blackmailing into giving them work, and for Attica and Rockefeller, and later for their neglect of women artists. My 3-year-old son almost got arrested for holding the door open so people inside could hear us yelling at one demonstration.

Before we move on, in terms of your own exhibitions I am curious to know a little bit more about this experience of MoMA. You were there in the 1950s and 1960s, still in the middle of the laboratory years, so was there anything about the MoMA of those years that you could tell me about? Obviously it was a laboratory of exhibitions and architects inventing shows, with Emilio Ambasz doing all those experiments.

That must have been later, after I left the museum. I didn't have much to do with the architecture/design departments.

I published an article on [Max] Ernst and [Jean] Dubuffet in *Art Journal* and then in late 1964 I started writing for *Art International*, when I was something like eight months pregnant. Luckily Jim Fitzsimmons was in Switzerland and couldn't see me or he would never have hired me. Bill Lieberman got me the job of writing a book, *The Graphic Work of Philip Evergood*, and around the same time I wrote and edited a book on Pop art, so writing finally became my major focus, though I continued to do jobs for the Museum off and on, I think.

You mentioned your first exhibition, Eccentric Abstraction, *but before that you mentioned your key involvement with the show* Primary Structures. *Simultaneously to* Primary Structures *you wrote an influential text and at the same time you had a dialogue with Kynaston [McShine]. Can we talk a little about* Primary Structures? *It wasn't a movement, but it was to do with something you observed, you filtered.*

You know, I was living with an artist and going to graduate school part-time and working full-time. Living with an artist was most important. People used to say, "Oh, you always knew things were happening ahead of time … " I didn't. I was just in the studios. I learned about art from artists. Outside people picked up on things later. Around 1964–1965 you could see there was a sort of post-Pop thing going on, where people were getting freer and freer with their mediums. The Greenbergian notion of art being defined by the medium was beginning to bite the dust. As far as I'm concerned he never did anything interesting after 1966. At some point he told a friend of mine, "the art world had gotten so bad that someone like Lucy Lippard could be taken seriously." It was mutual … *Primary Structures* was the first time a lot of Minimalists and a lot of their non-Minimalist peers had shown in a museum. Judy Chicago was in it with her wonderful *Rainbow Picket* sculpture. It was a great show. Even after I was out of it, Kynaston and I would still talk about it. I remember clearly a phone call where we put together the title.

It's fascinating to hear more about the show, because from all the pioneers of curating, the only person who has refused to be interviewed for this book is Kynaston McShine. He said he didn't want to talk at all about this period because for him it's like something that has nothing to

do with what he is now.

I haven't been in contact with him for many years. He was a close friend. He came with us on our honeymoon! And we were together the night that Martin Luther King was assassinated. It sounds like he turned out to be extremely conservative. But before that he also did the *Information* show in 1970, which was as radical as MoMA has ever gotten.

You said Primary Structures *was related to a text you wrote; can you tell me more about this?*

The "Third Stream" article—a jazz term about the blurred lines between painting and sculpture—was in 1965, around the same time Barbara Rose wrote her far more influential "ABC Art," and in a way they were similar. At that time it was a big deal. Bob Ryman had painted around the edges of his paintings in the late 1950s; he cited [Mark] Rothko on that. Jo Baer, César Paternosto, and others were doing it in the 1960s and there were shaped canvases—Bob Mangold, who lived upstairs from us on the Bowery, was making important work. And I remember endless conversations about the virtues of acrylic, which was new and dried fast, as opposed to oils.

You said before that you lived in studios. I was wondering if you could talk a little bit about these dialogues with artists.

I've always said that I didn't really study. I have an MA in art history from the Institute of Fine Arts at NYU but MoMA kind of forced me into it; I think they thought I was going to keep working for them and they paid for part of my graduate school. But 10th Street was still going and I came into that whole realm of exciting peripheries. I went to all the openings and I was living there on the Lower East Side. I was interested in artists making art, the ideas in the air, not in art history and not in museums. I've always been attracted by the impossibility of writing about visual art and that's what tempted me to do it. It was an interesting place to be and very interesting times. Working at the Modern I met Sol LeWitt, always a huge influence on me; he was at the night desk; Bob Ryman and Dan Flavin were guards; Al Held had

just left the production department, and John Button was at the front desk. It was before MoMA was unionized and a lot of art types worked there. They even let Ryman practice his tenor sax in the auditorium when nothing was going on.

So I was lucky enough to be there with a group of young artists who were as excited about everything as I was. Bob came to art late and Sol was a good deal older too, but both were at the same place in their art lives.

Yes, Sol had earlier experience as an architect with I.M. Pei, didn't he?

Yes, I think he was a draughtsman for I.M. Pei. He was a slow starter, but man, when he got started, he was great!

And you said that he was a huge influence. Can you talk a little bit about this?

You probably know Sol?

Yes. I interviewed him a couple of years ago.

He was always just completely unpretentious, un-arrogant, un-egotistical, and open to everything, though he certainly had very stubborn opinions of his own. Since he was a little older than some of us he became a kind of mentor, I think, to a lot of people who may not remember it that way: Dan Graham, Bob Smithson, Bob Ryman, Dan Flavin, and Eva Hesse above all. He had a very down-to-earth sense of humor. He was immensely supportive of Eva and of a lot of people. He'd look at the work, listen to the artists, exchange ideas. And he even guided our reading, because MoMA was just across the street from the Donnell Public Library and Sol read like a fiend and would pass on books. So I read, for instance, all the French nouveaux romans before a lot of people, be-cause Sol was reading them ... You could just discuss all kinds of things with him.

Dan Graham told me that he was influenced by [Michel] Butor and [Alain] Robbe-Grillet. So it was Sol LeWitt who brought you all to the Nouveau Roman?

And Nathalie Sarraute. Certainly Sol was my source. I don't

know about everyone else.

And what was it about the whole Nouveau Roman? Was it an influence for your writing?

Yes, I think so. I didn't write like them so much as I loved the object-oriented writing they did. It was more like Don Judd's criticism. I think we all liked the lack of adjectives, the sort of blunt, forceful way the physical world was presented, not descriptively, but as part of the narrative. At least that's what I recall …

It would be interesting to hear a little bit more about these dialogues before we move on to other shows, because Primary Structures *and also* Eccentric Abstraction, *as you said, grew out of these conversations that you had with Sol LeWitt, and Bob Ryman.*

When I did *Eccentric Abstraction* I was in the process of separating from Bob, so he wasn't involved. Sol of course loved Eva's work, but I don't remember his having much input into that show. I know Ad Reinhardt, who I saw a lot of at the time, humorously told me anything "eccentric" was all wrong. Mostly it came out of just the conversations that were in the air. I don't remember much that was specific to this show. It came more from my own interest in Dada and Surrealism, I think, and the blurring of roles and boundaries that led into conceptual art. Robert Goldwater was my adviser at graduate school and I knew his wife was Louise Bourgeois, but I didn't know much about her. Arthur Drexler, architecture curator at MoMA, was the one who showed me her latex work; he owned some and lent it to the show.

People were very good in those days and I don't see that happening much now—when you went to someone's studio and you were talking about an idea, they'd always say, "Oh you should see so-and-so's work," and they'd pass you on to somebody else. I went to California before I did *Eccentric Abstraction* and got passed around to studios and that's where I found Don Potts and Bruce Nauman, who was, I think, still in graduate school. He'd maybe been in one show in New York already. (Now we live in the same village in New Mexico!) Keith [Sonnier] and [Gary] Kuehn were at Rutgers. Everybody was very excited about these new directions. When

Eccentric Abstraction was up, Dwan, in the same building, had a show called *Ten* that made a great foil for it. I think Smithson was very much embroiled in that.

It was also a much smaller art world than now.

Yes, and rents were so much lower; we could live in the neighborhoods that nobody can afford any more. So we really had neighborhoods, communities. Today that's in Brooklyn.

Some of the artists are referred to now as part of Minimalism, others are more Conceptual artists and others were artists who are now considered post-Minimalist artists. But the boundaries between these groups seemed to be quite porous, while the historic avant-gardes were more cohesive and had manifestos. Was this already a post-manifesto moment?

This was certainly post-manifesto, which seemed sort of European and old-fashioned! Don Judd and Sol and Reinhardt and Robert Morris and Bob Smithson all wrote about art. That made a big difference—artists writing a sort of esoteric criticism. Maybe that took the place of manifestos. And with Conceptual art, texts became more important, like Sol's "Sentences and Paragraphs on Conceptual Art." Sol said he was a conceptualist with a small c because he made objects, and Carl Andre didn't want to be Conceptual at all, but we knew we all had something in common.

I was living with Seth Siegelaub when he began to publish artists' books and catalogues as exhibitions.

It would be good to hear a little bit more about Eva Hesse, because she's an artist you were very close to. What did you learn from Eva Hesse?

I learned from Eva how art could be vulnerable, which became, of course, an issue with women's art. But Eva died the year the women's art movement got under way so she never actually became a feminist. She was against it at the time, but I think she would have come around. She worked very intuitively, which was probably the key to *Eccentric Abstraction*. She and Viner triggered the show, but then I found that it was going on in the studios all over the place. Alice Adams was important too; her sister was then married to Jim Rosenquist

and he was a friend of all of ours. He made the cover especially for my Pop art book.

I've always thought it would be interesting to make maps of where everybody lived and where they showed and worked, who their friends were, who they were sleeping with … because our community was particularly important to me. Several of us had worked at MoMA. Eva and Tom Doyle were down the Street on the Bowery too, Sol lived nearby on Hester Street; a guy named Ray Donarski was a close friend.

Many of the shows you have curated produced extraordinary publications. It is something Seth Siegelaub also did—very often the catalogue is also the exhibition.

Seth's much more than mine.

But with you also I think the publications are very special, and I was very influenced by your 557,087 and 995,000 publications [Seattle/ Vancouver, 1969–1970].

I can never remember those numbers!

Had you already made a catalogue with Eccentric Abstraction?

Eccentric Abstraction had no catalogue as such. I wrote a long article in *Art International* around the same time, which a lot of people, even good scholars, have confused with the exhibition. It had a lot more people in it. It was probably a mistake to give the article and the exhibition the same title. For the *IL* catalogue, I went down to Canal Street to Pan American Plastics and bought sheets of a very sensuous plastic, soft, like cloth. I got two kinds, both sort of tan or flesh colored, and one had a nubbly texture and the other was very smooth. We printed the announcement on them and the short text on paper the same size, around six inches square. I bought the plastic, cut it up, designed it, and took it to the printer. I don't know how I ended up doing all that and not the gallery, but probably I wanted to have control over it all.

We are now in the mid 1960s and in 1966 there was this first exhibition you curated and your first books came out. One of the things I am very curious about is who were your heroes at that time? "Heroes"

*is a strong word, but who were figures from the past who inspired you?
Or maybe what were your toolboxes?*

I always feel like a dog in the manger about this, but I wasn't
really that influenced by anyone but my artists' community,
though they never read and critiqued my drafts. Joyce and
Beckett were my favorite writers but I didn't write like them
when I was writing art criticism. I tried to write in a way that
was empathetic with the art itself—shorter, harder sentences
about Minimalism, more poetic about more romantic work …
There wasn't really any critic who was a specific model, but
the fact that Dore Ashton was there as a woman who wrote
well, and wrote for *The New York Times* (and was fired by John
Canaday for hanging out with artists too much) was important.
She was married to an artist, Adja Yunkers. I didn't know
her that well but I always admired her.

Can you talk about her?

She was a bit older than me and had a real reputation by
then. She knew all the Abstract Expressionists and identified
with that generation. She's still around, and has published
a bunch of books. Just the fact that there was a woman there
in that kind of position was encouraging. There were oth-
ers, but you didn't hear much about them; they were mostly
reviewers. Barbara Rose was around my age but had started
writing earlier and knew a lot more people than I did, being
married to Frank Stella. We often wrote about similar things
but we weren't close. She was much closer to Greenberg for
a while but then she broke with those ideas too. Sol was my
most important influence indirectly.

*As I mentioned earlier, I was incredibly inspired by your 557,087
show, and after that you curated Twenty-six Contemporary Women
Artists.*

557, 087 was in 1969 in Seattle; it morphed into *955,000* in
1970 in Vancouver. The Buenos Aires show was in 1971 and
the women's show, *c. 7500*, in 1973–1974.

*Lets talk about them in chronological order. The 557,087 show was a
huge inspiration for me as a student because of the publication of the*

loose cards. It is a very non-linear catalogue; in each manifestation the order changes. It was hugely liberating and inspiring because it showed that sort of do-it-yourself aspect an exhibition can have; it is not necessary to wait until one gets invited to curate a museum show, one can just do it. So it was somehow one of the triggers for my exhibition Do It, which is an instruction-based show, and it was also an inspiration for all these other shows to do with lists, which were also inspired by Oulipo, Georges Perec, and Harry Mathews. I was wondering if you could talk a little about this and also the idea of the rule of the game.

Well, I must have been invited; it was a big museum, after all. The card catalogues were different from the rule thing. That was in *Studio International* in 1970, guest edited by Seth Siegelaub. There were several "curators" including, I think, Michel Claura and Germano Celant. My "exhibition" was a kind of round robin between artists: Sol, Larry Weiner, On Kawara, Robert Barry, Steve Kaltenbach, Doug Huebler, among them, not in that order. Each one was asked to pass on an "instruction" to the next. Larry wrote to Kawara something in his usual elegant language about how he couldn't bring himself to demand anything and then Kawara did one of his "I am Still Alive" telegram pieces to Sol who then did permutations of the words.

So it was almost like a group show as a chain reaction.

Yes.

And where did it end?

I think it just ended with someone's piece. Another one of these instruction shows I did was at the School of Visual Arts in 1969. I was writing a novel that was at that point just descriptions of group photographs and an index. (It was published years later, much revised, as *I See/You Mean.*) So I asked people to do *Groups*. Somebody in Britain recently did something on that but I have no information on it at all and can barely remember who was in it. Doug Huebler was as well as [Robert] Barry, Iain Baxter (the N.E. Thing Co.), Jon Borofsky, Adrian Piper, Larry Weiner … The usual suspects.

So almost like a group show about a group show.

I told them specifically how to do it but I can't remember what I said. I also collaborated at various times with Bob Barry and Sol and [Douglas] Huebler and David Lamelas … and Ian Wilson.

That brings us from the curating to collaborations with artists. Can you talk about these collaborations?

People would say, "Oh, Lucy is becoming an artist," and that really annoyed me, because as far as I was concerned this was all part of what I did, which was writing about art, being involved in contemporary art at different levels, but always through texts of some kind. I did some street works in a project by John Perreault and Marjorie Strider, about physical interactions in the street … it tied into what I was writing about. If the artists could do whatever they wanted and call it art, I could do what I wanted and call it criticism. I had to make many of the pieces in Seattle and Vancouver because we couldn't afford for the artists to come in, and I con-structed things or had them done according to the artists' instructions. Including a Carl Andre where the instructions talked about "timber" and I thought he meant raw logs and he meant finished lumber. I went through all this process of getting these giant timbers from Weyerhaeuser. When he saw it Carl laughed and said, "Well, it's your piece. It's not mine."

That brings us to these Seattle and Vancouver shows, 557,087 and 995,000. How did these titles come about? Is it the number of inhabitants that changed?

The numbers were the populations of the cities. I'd done a show at Paula Cooper's called *Number 7*, a benefit for the AWC. (I don't remember why it was *Number 7*, probably because it was her seventh show in that space.) Numbers were big; con-ceptualists were working with numbers so I followed along. Now I regret it because I can't remember those awkward large numbers. And of course the populations have changed; it dates the shows.

What was the Number 7 *show?*

I did two shows at Paula's; the opening show at Prince Street,

I think it was her first in her own gallery. It was in conjunction with Student Mobilization to End the War in Vietnam. It was a beautiful apolitical minimal show, with LeWitt, Ryman, Judd, Morris, Andre, Flavin, and Mangold. Bob Huot curated it with me, and Ron Wolin, from the Socialist Workers Party, helped organize it.

Number 7 was a sort of conceptual show; there were three rooms; the largest looked almost totally empty but had nine works in it, like Barry's *Magnetic Field*, Sol's first (I think) wall drawing, Haacke's air currents—a fan in a corner—invisible pieces by Wilson and Kaltenbach, and so forth. Plus a tiny Andre found-wire piece on the floor. The middle room had two blue walls (Huot's work) and the smallest one had tons of work on a long table.

So one can say that was also a political statement, somehow.

Oh very much so, just not at all overtly.

Your work is strongly political. To read a quote—I listened to an audio arts cassette between Margaret Harrison and yourself from the 1970s—"Political art has a terrible reputation. It may be the only taboo left in the art world. Perhaps it is a taboo because it threatens the status quo that the avant-garde supports. At the same time it thinks it's making breakthroughs. In any case, women's political art has a doubly passionate base from which to operate. The female experience is, of course, different socially, sexually, politically, from the male experience, so the art, too, is different. This does not, as some would have it, exclude concern with all people. On the contrary, the female experience is profoundly radicalizing for those who survive its brutalization." If one listens to this audiotape, it's a very political position you have and you participated in many activist movements, your writing is very political. I was wondering if you could talk a little about political curating.

Well, I've done a lot of political shows and continue to do them now and then. For instance, when Allende was overthrown in Chile, a bunch of us put up a show at OK Harris on West Broadway, which was under construction; the walls weren't up yet. We hung it on scaffolding. Then there were reconstructions of a destroyed Chilean mural on West Broadway, organized by Eva Cockcroft. I've done a lot of

those kind of collaborative cause-oriented shows. Bob Rauschenberg got so he didn't want to talk to me when I called because he knew I was going to ask him either to sign something or donate something. But people were more into that kind of thing then than they are now, I think.

What year was the Allende show?

1973, right after the coup. It was just a benefit show, with work donated by the artists. In the 1980s I organized a lot of theme shows at small museums and union halls, community centers, an old jail in LA, and so forth, many of them with Jerry Kearns. A group of us did a whole series of shows around Artists Call Against US Intervention in Central America in early 1984, which I co-founded. And then in the 1970s and 1980s of course I did a lot of feminist shows. And all these shows, about 50 of them, it's too much to get into ...

You are now curating a show about climate change.

I'm doing a show called *Weather Report: Art and Climate Change* at a small museum in Colorado (the Boulder Museum of Contemporary Art) that opens September 14 [2007]. It's the first show I've done for around 15 years. I really didn't have any urge to curate any more but a friend of mine made me do it and it has been fun. It's a big show, 51 artists and collaborative teams, 17 public pieces, outdoors, scattered all over town—a strategy to attract larger audiences that I began with *557,087*. It will take place at the museum, and also at the National Center for Atmospheric Research and at the University of Colorado Library and Atlas Building. A lot of the artists are collaborating with scientists. Interestingly there are 27 women, 10 men, and 7 mixed teams. I didn't do that on purpose at all, but a lot of women work on ecological issues.

To come back to 557,087 and 995,000, we mentioned the catalogue and the idea that people threw things out; it was very much a do-it-yourself approach. Can you tell me a little bit more about how this exhibition actually worked, because it's also a very special way of doing a traveling show.

Well, that show only went to two places and when the women's

show traveled the title didn't change, because I didn't know ahead of time where it would go. *557.087/955,000* changed quite a bit between Seattle and Vancouver, where it took place at the Vancouver Art Gallery and the Student Union at the University of British Columbia. Much of the work was temporary, so once the Seattle show was down, none of the pieces could be dragged around; it wasn't that kind of art—site works and so forth. For instance Smithson wasn't in Seattle and I executed his photography piece for him there. But he did get to Vancouver and made *Glue Pour* [1969], an important work.

There is so little photographic documentation on these shows that I never could figure out how they worked spatially.

They were big museum spaces. I don't ever have any installation method or style, I just sort of move things around and see how they look. I don't think the installations were that innovative visually or spatially. (I do have some pictures of Seattle.) There were a lot of object pieces and a lot of dematerialized ones, both large and small scale.

Eva Hesse had died a few months earlier and her work was *Accretion* [1968], a beautiful series of opaque resin poles leaning against the wall. At the opening some dressed-up ignoramuses picked them up and dueled with them. I was livid. Thank god they weren't damaged. There was a "reading room" ... and all the outdoor works around the town. I've always liked to do that. That interests me more than installing indoors. I've always liked things that happen in the public eye and seeing how people respond to them and if they have any effect and so forth, so there were things all over both Seattle and Vancouver.

So the boundaries between museum and city got blurred somehow.

Yes. That was the idea. I just kept using these card catalogues for shows I did because I liked the idea of randomness. I made a series of shows that weren't necessarily connected, so *557* and *955* were more or less the same show, and then the Buenos Aires show was made up of artists who were not in Seattle and Vancouver, people I'd found out about later.

I went to Argentina in 1968 to jury a show at the

Museo de Bellas Artes; I went to Peru alone afterward. I was talking to artists and trying to start something. I was trying to do shows that would be so dematerialized they could be packed in a suitcase and taken by one artist to another country, then another artist would take it to another country, and so on, so artists themselves would be hanging these shows and taking them around and networking. We would bypass the museum structure.

I didn't really get that much going in Latin America, although the later card show in Buenos Aires came out of that in a sense because I met Jorge Glusberg there. I came back to New York and the Art Workers' Coalition started and I met Seth Siegelaub through that. He was talking about exactly the same things, so we had a meeting of minds around trying to dematerialize shows that bypassed the institutions.

So the idea was really, one could say, about finding other circuits.

Yes, alternative venues, alternative circuits. It wasn't just Seth and me; the idea was in the air at that point. My idea was a show that could physically be put in a box; but actually the Buenos Aires show came next.

Can you tell me about this show?

2,972,453, at the Centro de Arte y Communicacion (CAYC) in Buenos Aires. I've always liked to do shows with new people, so that one included artists who hadn't been in any of my previous card shows, mostly younger artists I'd found out about since 1969. I can't for love nor money remember who was in it—Gilbert & George, Siah Armajani, Eleanor Antin, Don Celender, Stanley Brouwn ... It's all in the *Dematerialization* book, I think.

Very early on you pioneered this idea of venturing into other cultures and also making a more polyphonic art world. That is something that I think should be emphasized in this interview. I was curious that already in the 1960s and 1970s you would curate a show in Argentina. There is also the fact that you include Eastern Europe in your Dematerialization *book.*

I'd hardly covered it, but I was raised with good politics and

I didn't like racist exclusion. In the Art Workers Coalition I worked with a lot of African-American artists so I knew what was going on and how they were being omitted from everything, so whenever I could include somebody I would, when I liked their work. I'm sure I went to a lot more studios out of the mainstream than most people did. I remember being asked in the 1980s, by a curator at MoMA, "How do you find all these people?" I was furious. I said, "Well, you know there is the Museum of Contemporary Hispanic Art, there is the Asian American Art Centre, there is the Studio Museum in Harlem, there is the American Indian Community House. They all have shows every single month. That's how you find these people." It was just so annoying to hear in New York, which is so full of everything, that the curators didn't bother to go out of their own little bailiwicks to these places that had existed for years. I'd always had friends of color and was aware of some of what was going on.

And when did this awareness grow in your work—that there was not only a Western avant-garde but all kinds of different Latin-American avant-gardes in the 1960s? There was also Japan.

I was very lucky because in the late 1960s one of my best friends was Susana Torre, an Argentine architect who has lived in New York for most of her life. Sol met her in Buenos Aires and introduced us when she came to New York. (He said he'd met "the Argentine Lucy Lippard.") She knew Eduardo Costa and César Paternosto and Fernando Maza and others. She was married then to the sculptor Alejandro Puente. I met Luis Camnitzer and Lileana Porter, just a whole bunch of really interesting people. I vaguely knew Hélio Oiticica. I knew about Lygia Clark; I didn't meet her. That was in the late 1960s.

So you met Oiticica?

Yes, just at parties and things. He was obviously a very interesting artist; I liked his work but I never worked with him. There was a whole Latin-American community in New York that was very annoyed that they weren't being considered by the mainstream. A lot of them were doing things the Minimalists had done but they weren't acknowledged. The

usual stuff. And there was a lot of interesting conceptual stuff going on: Camnitzer and Porter were two of the most interesting artists. Unlike most American artists, Luis had real politics and political experience and an intellectual analysis that was, to me anyway, unfamiliar.

When I went to Argentina in 1968 Jean Clay and I were jurying a show there. It was during the dirty war. We were staying at a hotel guarded by soldiers with rifles who would level them at you whenever you came into the hotel. The organizers of the show we were jurying tried to tell us who to give the prizes to and we refused.

Jean Clay, besides Kynaston McShine, has been the only person who did not want to be interviewed. His reason is a very different one from Kynaston McShine's. Jean Clay's reason is one of becoming anonymous.

Good for him. Probably a good idea. Why didn't I think of that!

Anyway, 1968 in Argentina was one of my radicalizing moments. Jean had just come off the barricades in Paris and I was getting involved in the anti-war movement, and we were censored by the Argentine institution that we were judging this show for; it was a plastics corporation or something. When we didn't choose the person they wanted to get the prize they came up at a dinner party with another prize. We said, "Good. Give it to so-and-so." They said, "No. It has to go to so-and-so." It was chaos; we almost didn't get out of Buenos Aires. It was really frightening at one point. We were trying to get to the airport and they wouldn't pay us and pick us up or do anything. They just dropped us like a ton of bricks. I went back to New York and became much more radical than I had been before.

The important part of it was that we met with the Rosario group, who were working in Tucumán with workers during a big strike. This was the first time I had ever heard an artist say, "I am not going to make art as long as the world is this bad. I'm going to work to make the world better." Something to that effect. I was stunned by that because the artists I knew in New York were more formalist and less politically involved. When I went back I discovered other artists who were more politically knowledgeable and the Art Workers

Coalition started and so forth. The rest of the story is the rest of my life.

Were you in contact at that time with the Di Tella Institute in Argentina?

I knew of it, but I don't think we were directly in touch. Glusberg was running the CAYC [Centro de Arte Y Communicacion] and he was the one that took us to meet the Rosario group. The people who ran the exhibition at the Museo de Bellas Artes that Jean and I were down there for didn't want us to meet any artists, and especially not the artists we wanted to meet, and so Glusberg was the one who got us out of that milieu.

I was wondering if there were any non-Western curatorial pioneers that come to your mind of your generation who you think I should interview.

There were a lot of people in Latin America, but I don't now remember their names. I remember Glusberg partly because he was good to us when we were there and partly because he tried to claim he co-curated my 1971 exhibition! I have to admit that I've never paid a whole lot of attention to curators. That's not a very nice thing to say but I really have been focused on artists my whole life.

What about c. 7500?

c. 7500 started at CalArts in Valencia, California, in 1973. That's why it's a small number. I was really annoyed by people saying that women didn't do conceptual art and didn't do this and that, so I made a show just of women conceptual artists. It traveled all over the place; it went to London and to the Walker Art Center and Smith College. It went to the Hartford Athenaeum. It was in important museums, to my great surprise. Of course it was cheap, easy to transport. Each piece had to fit into a manila envelope.

What is fascinating is that you had this curatorial practice of these light luggage exhibitions but at the same time you also crystallized all your experience and observations in a ground-breaking book which has been a toolbox for generations of curators, Six Years: Dematerialization

of the Art Object *[1973]. And it is not only an extraordinary book but also the invention of a format of an art-history book because it almost works like a chronicle. It seems related to the things you just described in terms of your curating.*

Yes. That was just the way I was thinking in those days. It was the climate. I was connected with all these artists and by that time I knew Daniel Buren and various people in Europe and so on, through Seth's connections really, and I was in Europe a couple of times. I've seldom worked in Europe but in that period I was there a bit more. My son and I lived in Spain for a few months in early 1970 (in Jean Clay's empty summer house) and we went through Paris. Anyway, John Chandler and I had written an article in 1967 (published in *Art International* in February 1968) called "The dematerialization of the art object." The whole dematerialization idea was key to much of what I did. (By the way, last year I ran into a Latin-American curator who said, "You borrowed that from Latin America!" I said, "I did?" There was some Latin American critic who had used the word "dematerialization" around the same time. I had never seen anything he did but I was accused of plagiarizing from Latin America.)

I decided I wanted to chronicle all this stuff that was going on; it was really hard to keep track of, because it was happening in such dematerialized ways and in unexpected venues. It wasn't like you could go to a museum and see these things, so because I am an historian and archivist when it comes right down to it, I wanted to be sure this stuff didn't all vanish. I decided to just collect them all in a book. Originally it was much longer. I don't know what happened to the original manuscript.

Do you still have it or is it lost?

If it still exists at all, it's in the Archives of American Art. Over the years I've just given boxes of stuff to them, whenever the house got too full of things. But anyway, the manuscript for *Six Years* was longer and the publisher made me cut it down. It's amazing that they let me publish the thing at all, because it wasn't at all readable. I think I said in the preface, "Nobody will ever read this thing right through," and since then people have told me they did read it through. Isn't that

interesting! It was a lot of fun. I've always been a pack rat and I live in a sea of paper. People were always sending me things so I had a lot of stuff to work from and I just put it all in chronological order with a little annotation. It seemed like the only way to deal with this mass of stuff. Carl Andre offered to do the index, which turned out to be a bit prejudicial rather than all-inclusive.

The format of the chronicle is interesting. Was there anything that inspired that?

No, it just seemed like the obvious way of doing it. I had done bibliographies for The Museum of Modern Art and the librarian, Bernard Karpel, liked annotated bibliographies. I didn't want to write an essay because I couldn't possibly have mentioned all these things in an essay; it would just have been a list, so why not just publish the list? Just plunk it down and say, "Here's what's been going on; here's the information: You do your own thing with it." Sort of like the cards as catalogues.

So one could say that these exhibitions exist through that book because they were so scattered.

In fact, I say that *Six Years* was probably the best show I've ever curated—a show that includes other shows. It's not just exhibitions; it's mostly works of art and projects and panels and publications and whatever came along that I liked. The title that went over the whole cover was very important because whatever I liked I put into it, anything that had anything to do with any of those things. (When they published it in Spanish a couple of years ago they didn't use that cover, which had I known, I would have objected to, since the ridiculous title was very much part of the book.)
 I'm sure I missed a whole lot of stuff happening at the time, because when they did that *Global Conceptualism* show at the Queens Museum [in 1999] there were things I'd never heard of, though a lot of that work was done later.

What about Eastern European?

Well, I knew quite a lot about European stuff—not everything

by a long shot—I included the OHO group from Yugoslavia in it. (But I didn't know much about Tadeusz Kantor and all the stuff going on in Poland, which I just heard about recently from Pavel Polit.) I knew a fair amount about Latin America because I had a lot of Latin friends in New York, but I didn't know anything was going on in Africa or China. I knew a little about the early Japanese but that was it. Obviously this kind of thing was happening all over the world far more than I realized at the time.

To bring it back to politics, one of the things I have always thought is so fascinating about this book is that it remains a kind of manifesto, an act of resistance in terms of an art world dominated by objects. How was it at that time? Did you feel in a minority position with that statement in the art world?

Of course there are always a lot of art worlds co-existing at the same time, or there used to be. It's more homogenous now. I didn't feel isolated because all my friends were into the same kinds of things. Greenberg, as I said, just hated the whole idea of Minimalism and conceptualism. All the high art people hated it. I think they saw it as a sort of betrayal on my part because I had been, briefly, a formalist critic in *Art International* in the mid 1960s. I don't know. It's never bothered me that people don't like what I'm doing. I've always been a contrarian on some level—which is one of the reasons I wrote a book on Ad Reinhardt.

I'm also a populist, which is something that needs mentioning in this context. Especially with artists' books, which always appealed to me for obvious reasons (the fusion of texts/images). In the mid-1970s I got involved with Printed Matter with Sol LeWitt, because part of all this was the idea that art would be accessible and affordable to a far greater number of people than the art world allowed through its doors. Art was getting so precious, so elitist, during that Greenbergian period ... and so expensive; this was a way of getting away from that and trying to make art that would attract a lot of different people. I'm not so sure it worked! But that was the idea.

We were speaking before about artists of your generation with whom you worked. We spoke about Eva Hesse, we spoke about Sol LeWitt and

Robert Ryman. Someone we didn't talk about was Robert Smithson.

We had a kind of cantankerous relationship. We liked to argue, or I thought we liked to argue. I liked to argue. One time he said to me kind of plaintively, "Why do we always argue?" But he did love to talk. He was good company. He used to go to Max's Kansas City with an idea for the night and get people at the table talking about whatever he wanted to talk about. So I had a slightly contentious relationship with him because I wasn't that fond of the mirror sculptures and the early sculptures; I liked the sites and the non-sites, but the objects before that were a little too complex for my taste, and I found him a little pretentious. I always thought he was a better writer than he was an artist, but *The Spiral Jetty* is an absolutely magnificent work of art. So I have to take that back on some level. His writings have become increasingly important and influential, so in some ways I think I was right. The concept of earthworks was an incredible breakthrough, however macho it may look in retrospect. What he would have done, I hope, had he lived, would have been to get more and more into the restoration aspect of the earth works. His early death was certainly tragic.

With artists' work that gets so tragically interrupted like Eva Hesse or Robert Smithson, there is always the question of what they would have done.

Who knows? I'm convinced that Eva would have eventually become a feminist. I would have convinced her!

And Smithson?

Who knows? He was really just getting going when he died. But there was a very intellectual aspect to this group. I had known a lot of the Abstract Expressionists and younger late and post-Abstract Expressionists, and so on; they were very eloquent and articulate, and they knew a lot about novels, poetry, and jazz. But my generation read a lot more non-fiction. The artists were really looking for ideas in all sorts of other fields, rather than just moving on from previous art.

That is something I discussed also a lot with Dan Graham. So it was

*other forms of literature that were important. Can you talk about
these sources?*

I always dutifully read what the artists were reading but I'm
no philosopher. I've never been interested in theory particu-
larly, so I would read these rather academic tomes and use
them in my writing sometimes—to show I was reading them,
I guess! But I'm not the right person to talk to about that.
Sol, again, was the person who translated those concepts from
a lot of highfalutin stuff into a very direct idea that you could
grasp; he was in a sense my mediator. And I was increasingly
interested in politics, rather than abstract concepts.

Were people like Richard Rorty important for you?

No, I don't remember Richard Rorty being mentioned at all
at that time, which isn't to say people weren't reading him.

Science fiction, according to Dan Graham, was relevant.

Well, Bob Smithson read a lot of science fiction. I'm not
sure a whole lot of other artists did. He was a great influence
on Mel Bochner, too, who did some of that type of thing.
But a lot of the time it was linguistics and philosophy, Merleau-
Ponty, Wittgenstein, A.J. Ayers. I remember very little. If I
looked back in my writings of those days I would be able to
make a list …

Were ecology and environmentalism important for Smithson?

Maybe people are reading that into his work. He wasn't an
environmentalist in any real sense; he really didn't see him-
self as an environmentalist or an ecologist. I am sure he
would have had some wonderful doom-ridden things to say
about global warming, entropy coming, and so on. He would
have probably enjoyed it in some gruesome way. A lot of the
environmental artists I know are not really that influenced
by Smithson. It's the postmodern artists who are—whatever
that means.

You mentioned before that he might have got more into restoration.

He was looking for mines and "brown fields" that he could
work in, ways of remaking polluted sites into sculpture
(which is happening a lot, of course, today, architecturally,
especially in Europe, I gather). He was looking for raw mate-
rials for earthworks, making things out of recycling places,
really, I guess is the best way of putting it. I'm not sure he
was thinking of it in a particularly altruistic sense. As I say,
he was not an environmentalist per se but he had these bril-
liant ideas, this off-center way of thinking that made people
think about doing things they wouldn't have thought about
doing otherwise.

I forgot to ask you about Gordon Matta-Clark.

That was later, and I was more involved in the women's
movement by the time he came along. I have never quite
understood the great fuss made over Gordon. I thought
he was a good artist, an interesting artist, but I am surprised
to find him becoming an iconic artist.

*That takes us perfectly to your being a protagonist in different feminist
movements. I have done long interviews with Nancy Spero about this
and also with Carla Accardi, who was very close to Carla Lonzi at
that time. Carla Accardi was telling me that she always believed in art
and that toward the end of her life, Carla Lonzi wanted to get out
of art and the idea was that really art would dissolve in this feminist
mood. Carla Accardi wanted to stay within art. I think in America
there was a similar thing going on in that some artists' practice dis-
solved, somehow, in this activist movement. I wondered if you could
talk a little about your position in relation to that and to what extent
it affected your curating.*

I never liked the either/or part. In fact, when the women's
movement came along I did, for ten years, much more con-
ventional exhibitions of women's art, just shows of women's
objects, and writing about women's work. Conceptual art
had me moving in a direction that probably would have taken
me out of the art world a lot sooner than when I finally left,
years later. In a sense I feel I kind of went backward, certain-
ly in terms of innovative curating, for that decade. Most of
the shows I did with women, except for the conceptual show,
were conventional exhibitions. Women's art shoved me back

into the art world, because women wanted to be in exhibitions and they wanted to be written about in the magazines and I felt that I shouldn't leave at this point because I was a little better known than some of the other women writers, and I could have some impact on women being written about. I'd suggested that *Artforum* do a whole series of short articles on women—double spreads or something. There were so many good women artists coming along, and if they all had to wait for long articles it would take forever. This would at least get them out there. An editor at *Artforum* said, "No. We don't want any featurettes."

Anyway we never succeeded in the 1980s in getting a big women's show into a New York museum to remind people what feminism had been doing. Harmony Hammond and Elizabeth Hess and I made a proposal, but nobody would touch it with a stick. That's probably one of the reasons I lost interest in curating. It's so interesting that now, as you probably know, these two huge shows—*Global Feminism* [Brooklyn Museum, New York, 2007] and *Wack! Art and the Feminist Revolution* [Museum of Contemporary Art, Los Angeles, 2007] —are going round the country and getting a lot of attention. The time finally came.

This leads to the only recurrent question in all my interviews, the question about the unrealized projects; the projects which have been too big to be realized, or censored projects, or utopian projects. That seems to be one of your unrealized projects, that big museum show of women artists in the 1970s or 1980s.

By the time it became possible I was no longer interested in doing it. And of course nobody ever asked me to do it, either. There came a point in the 1990s where I might have been able to do something, but by that time I was totally embroiled in a different field. I have no real interest in doing a great big museum show. I'm working in Boulder because it's a small museum. I like small things and I like grungy things and I like hands-on stuff; I like to be able to hang the show myself and not have people telling me how it should be done.

Are there other unrealized projects of yours, censored or impossible projects?

I haven't really thought about it. I always have a large folder

of projects, things that pop into my mind and I scribble them down on paper and stick them in the folder. I haven't looked at that folder for a long time, so there probably were things I wanted to do. I guess the most utopian project is one I've been working on for about a decade now—a tome on the history of the area I live in, the Galisteo Basin in New Mexico. If I ever finish it I'm not sure anyone will ever want to publish it.

Nothing off the top of your head that you really wanted to do? A regret?

No, there isn't anything now. I've always got too much work, so I don't spend time crying over spilt milk.

Of course there are odds and ends of projects that didn't follow through. Years ago a local woman artist and I talked about doing a show in Santa Fe on water—during a drought. But then it rained and there wasn't much interest. I'm still vaguely interested in doing a good show on water in the West, but it would have to be in some new format.

When SITE Santa Fe had been open a few years, a new director asked me what I would do if I could do a show there and I said I'd do it on tourism, and install it all over this tourist town, and most of the art would be local. That would have been fun, but that was the last I heard of it.

There was a moment around 2000 when I wished I was writing or republishing more activist art essays. It's still a topic I often lecture on. I got together a book called *Hot Potatoes* that never came out, but now the Nova Scotia College of Art and Design is interested in reviving it. I really lost interest in curating. I always wanted to curate to make a point. I've never been a connoisseur as such. I think I've got a pretty good eye but I'm not a connoisseur and I don't really care about discovering the next great artist or whatever. I like to work with artists who are trying to make a point about things in the world that I care about, and there isn't a great demand for that, really.

Before we move on to this time when you lost interest in curating, maybe we could stay with this feminist moment when you said you did more conventional shows because the artists wanted to have that. Can you talk about these shows? One was Twenty-six Contemporary Women Artists.

Well that one, in 1971 at the tiny Larry Aldrich Museum in Ridgefield, Connecticut, I was dying to do. They asked me to do a show, any show. When I said sure, I'll do a women's show, they were a little like, "Eugh." Larry Aldrich was not that supportive, but the curator was a woman and she went ahead with it. It was the first women's show in a museum in the new wave of feminism in the US so it was kind of a big deal. Since I knew so many artists, I was having a terrible time trying to figure out who to include, so I decided to have only women who had never had a one-woman show in New York. That cut out a whole lot of people. Adrian Piper was in it, and Howardena Pindell, Merrill Wagner, Alice Aycock, all kinds of people who hadn't yet had a show in New York. I'd have to look at the catalogue for the whole list again. A couple of them I've never seen since.

C. 7500 was a more conceptual show.

Yes, that was the only women's show I did that was entirely conceptual and tied into the earlier work. It was in 1973–1974 and was the last of those card catalogue shows. By that time, gender was the issue I was concerned with.

Were there any women curators of your generation with whom you had an exchange or a dialogue?

Marcia Tucker, of course. And now there are a lot of women working, like Deborah Wye and Connie Butler at MoMA. When I was curating more it tended to be mostly men. (In fact when I came to New York all the curators were White Anglo-Saxon Protestant men—WASPs—and all the critics were Jewish, so everybody thought I was too. Now of course it's all mixed up, gender too.) And then there were women's groups on the West Coast.

And what were those West Coast collaborative initiatives?

I'd have to go back and look at the archives, but there was a lot of activity in the feminist movement. Sheila de Bretteville, Judy Chicago, and Arlene Raven founded the Woman's Building in LA in 1971. All the wonderful stuff they did there was a real model for me. Arlene was an art historian, Sheila

is a graphic designer who is now at Yale, and Judy of course is an artist. They did a lot of cross-disciplinary stuff. Sondra Hale was very involved, she is an anthropologist. Terry Wolverton, who was a young artist then, has written about that period. Jerri Allen was involved in all the performances and we worked together in New York off and on. The building was full of groups of women's collectives and so on; people did a lot of things together. Judy Chicago's *Dinner Party* [1974–1979], too, although Judy was definitely the dictator there; she worked with a vast number of people and a lot of other people helped make it happen.

I've always loved collaborations. I co-founded and worked with a group called Political Art Documentation Distribution in New York for several years, starting in 1979. We did a whole bunch of shows, some of them in the streets, some scattered all over the city, some indoors. But first there was the Heresies Collective, which we founded in 1976. Heresies did an interesting show at the New Museum—"big pages" as though from the magazine we published. We executed all of it collaboratively. I worked on a couple of them myself. I even did a drawing of a horse on one!

And then in the early 1980s I curated a bunch of exhibitions with Jerry Kearns, who was an artist friend. We did some hard-core political shows in colleges, and some unconventional venues, like union halls. One at District 1199 in New York was called *Who's Laffin' Now?* It was about the Reagan administration, comics, and comic-based art; Keith Haring did a frieze along the whole room; Mike Glier did a big mural ... Another show was at SPARC in LA, in an old jail. And so forth ... but that's another whole story.

Wow! And what were the shows your previous collective did? You said there were many shows with that other collective; are there any examples that come to your mind?

PAD/D, that was after, or rather during, Heresies. There was a time in the late 1970s where I couldn't sit down at a kitchen table with a bunch of artists without some group or project getting started. Let's see. PAD/D did one called *Death and Taxes*, which took place all over town. My pieces were in the stalls in women's public bathrooms. Somebody stuck labels in phone booths that told how much of the telephone

tax went to the Defense Department for war. Other people did things in store windows … There was a project called *Street* that involved some performances. We did demonstration art alone and with other groups and published a little magazine called *UpFront* … Then there was *Not for Sale: A Project Against Gentrification* in 1983 and 1984; it was about the gentrification of the Lower East Side; there were "museum openings" with plastic wine glasses on the street corners. I'm trying to remember the titles of other things. My lousy memory drives me nuts …

It's perfect! You remember everything.

One of my favorite curatorial ventures was when Printed Matter was on Lispenard Street. Printed Matter was a non-profit artists' book collective we started in 1975 or so. I organized works for a big double window facing the street and for several years we showed artworks made specifically for it. All kinds of people did things—Barbara Kruger did one, Hans Haacke, Julie Ault, Andres Serrano, Jenny Holzer, Greg Sholette, Leandro Katz, Richard Prince … a huge number of people.

We haven't really spoken about it, but one can see that Printed Matter is a form of curatorial project because Printed Matter has given visibility to the very under-rated art form of the artist's book. Let's talk more about Printed Matter which you invented with an artist friend.

Yes. Sol and I began it. Sol was really the one who came up with it because he was doing artists' books very early and his dealers were not treating them with any respect. They saw them merely as something they could give to collectors to grease them up for a big sale. Sol saw them as legitimate works of art and not as throwaways, and so he wanted to engender more respect for the artists' book. Right away we brought in Edit DeAk and Walter Robinson, who edited a little magazine called *Art-Rite* at that point. And then a bunch of other people came in—Pat Steir, for instance. Ingrid Sischy was involved for a while. It was run as a collective for the first few years and then it became a business later. Julie Ault organized the windows when they were on Wooster

Street. AA Bronson, the Canadian artist, runs it now in
Chelsea. Max Schumann, a young artist, who was the son of
the Bread and Puppet people, has worked there forever
and does small exhibitions. I don't know how many of these
names are familiar to you.

And did you have a mentor relationship to Group Material?

I wouldn't call it mentoring, Group Material just did won-
derful stuff; they influenced me as much as I could possibly
have influenced them. I loved what they did—like *Arroz
con Mango: The Art of 13ᵗʰ Street*, when they borrowed work
from everyone living on their block. At the same time I was
working with PAD/D (the name changed to Political Art
Documentation/Distribution when we started doing projects),
there was a whole bunch of young collectives, Co-Lab,
Group Material, Fashion Moda, Carneval Knowledge. PAD/D
was the furthest Left; we were really doing political work,
but it was all with artists. And we started an archive of social-
ly engaged art that ended up in The Museum of Modern Art
library. A lot of these "shows" were exhibitions as artworks;
the parts were less important than the whole as a statement.

*It is certainly true that you suddenly left the world of exhibitions and
curating to pursue political work. However, I have the feeling, and
that is also true for Group Material, that the exhibition as a medium
still played a role. It is maybe not an art exhibition, it's maybe more
a political exhibition, but you still did exhibitions.*

Yes. I did a lot of stuff in the late 1970s and early 1980s. I
lived in England for a year on a farm in 1977–1978 and met
a lot of British artists who were so much more sophisticated
politically than most of the people I knew in New York.
When I got back home I did a small show on British political
art at Artists' Space, in 1979. On the announcement card I
said, "Let's have a meeting to talk about an archive of po-
litical art around the world because we don't know what's
happening in other countries." I was horrified at how little
I knew about what was going on in Britain and elsewhere.
PAD/D came out of that.

Who were the British artists?

Margaret Harrison, Conrad Atkinson, Rasheed Araeen, Mary Kelly, Tony Rickaby, Steve Willats … I'm forgetting a lot of names …

What was the title of this show of British artists?

Some British Art from the Left.

Were people like Metzger and Latham in it?

No. It was more specifically activist artists. Latham I admired, but it was younger people.

We have STRATA *and* In Touch With Light. *There are two shows we haven't spoken about.*

That was a long time ago! *In Touch With Light* was a conventional show I did with Dick Bellamy. For some reason the museum in Trenton, New Jersey, asked us to do a show and we did that. I don't think that was much of a milestone. For *STRATA* I just wrote the catalogue; I didn't select the artists. There are a lot of other shows we haven't talked about; I'd have to look at a list I made years ago; there were some 50 exhibitions at that point. There's *Acts of Faith*, which was primarily "multicultural," it was in Ohio. Another one that bears mentioning is *2 Much* at the Student Union of the University of Colorado—work by gay and lesbian artists from Colorado and New Mexico to protest the pending homophobic Amendment Two in Colorado, which was coming up for a referendum. Pedro Romero and I did a show at a Denver alternative space called *Image Wars*, which was also the title of an earlier show with Jerry Kearns, with totally different contents and a Latino emphasis. These were in the early 1990s.

You did a show in Chicago in 1979 called Both Sides Now: An International Exhibition Integrating Feminism and Leftist Politics …

That was at the feminist gallery Artemesia. It was about reconciling essentialism and deconstructivism. I've never been very interested in either/or and never felt you had to be one or had to be the other. I did another in the Midwest, I can't

recall where, called *All's Fair in Love and War*—all women too; it was in the 1980s ... Martha Rosler and many other artists have talked about placing art in different contexts; a lot of us were thinking very much in that direction. You made certain kinds of works if you were doing it in an art context and certain kinds of work if you did it in a street context and it wasn't like you were being two different people, you just gave your practice a different slant depending on the context.

And you did lots of work with Margaret Harrison, with whom you collaborated on the tape. Are you still working with her?

Oh yes, in fact I wrote a catalogue for her two or three years ago.

Can you talk about that? It seems to be a special dialogue?

She and Conrad Atkinson, who were married, were the most active and most known British unabashedly leftist artists that I knew during that period when I was living there. They became very good friends. I wrote a catalogue for Conrad at some point and he ended up teaching at Davis in California and is back in London now, I think. I haven't really had much contact with them for the last 20 years, I guess, but they are very well known in England, so they were hardly forgotten. And Margaret was a feminist so we spent a lot of time strategizing together. That tape was done through something called Audio Arts; Bill Furlong, I think, runs that. Susan Hiller is another British artist whose politics are far more complex and I often left her out of the kind of simplistically political shows I was doing, but I admire her work immensely.

This has been an incredibly exciting interview. There are two or three things we haven't yet covered. I was wondering about your whole relationship to museums and to what extent you see the situation of museums now and what your favorite museum is.

Oh God! I don't really have one. I guess the Museum of Jurassic Technology would be my favorite museum. Because it's an artwork. I love going and looking at things in big museums, but it's not a context I'm particularly interested

in working in unless I can work outdoors too and make the show issue-oriented.

There was another show I did that I really liked in 1980; it was called *Issue: Social Strategies by Women Artists* at the ICA in London. I called myself a feminist socialist then, and I suppose I still would.

Can you talk about this show?

It was mostly American and British feminists, but there was Nil Yalter from Turkey and Nicole Croiset from France working together, and Miriam Sharon from Israel. There was Margaret Harrison and several other Brits, and Jenny Holzer, Martha Rosler, Nancy Spero, May Stevens. There was Suzanne Lacy and Leslie Labowitz working together as "Ariadne," Candace Hill-Montgomery, Adrian Piper, Mierle Ukeles ... It was a fairly big show at the ICA and had a nice catalogue. But it was all in the ICA, nothing out in the city.

Two last questions. We have both just been to the Venice Biennale, I was in Kassel yesterday, there is Münster, which opens tomorrow, and the Basel Art Fair. We started this interview with the 1950s and 1960s and the art world has expanded exponentially since then. And yet at the same time all the big feminist shows you wanted to realize in the 1970s or 1980s are being realized now. We also have shows that more and more look into different modernities as well as 1960s avant-gardes in Latin America and Asia; those in Eastern Europe are also getting more visibility. I was wondering how you feel about the current moment. It's a big question.

And not one I can really answer. I'm just voluntarily out of the loop. I live in a tiny village in New Mexico (population 265); I edit my monthly community newsletter, I'm involved in land use, community planning, watershed politics, which is very complicated here. I write about local artists for catalogues and stuff. Since 1980, I've been writing about Native American artists quite a bit; there are a lot of good ones working in the area. In fact that's why I was in Venice, with the National Museum of the American Indian. Edgar Heap of Birds had an outdoor installation about Native people in Europe—as captives, in Wild West shows, etc.

Venice was fascinating for me because I've never gone

to any of these big blockbuster shows. As a freelancer I
wouldn't have to have been asked to cover them so my ex-
penses wouldn't have been paid, and I hate writing about
big group shows. I've never been to Documenta, I hadn't
been to the Venice Biennale for literally 50 years. It was just
overwhelming, but it was also fascinating; I loved the fact
that it was all over the city and on the different islands and
so forth. We walked a lot, just as tourists, and we randomly
ran into the Daniel Buren show at a gallery and the Estonian
representation …

Where can I find your newsletter?

You can't! It's called *El Puente de Galisteo* and it's only for
people in the village. We used to just stuff it in people's
mailboxes until the Post Office made us get locked boxes
and now it's mailed out. In fact I should get off the phone
soon; I've got to get it into the printer.

*It is fascinating that at the very beginning of your practice you
anticipated the globalization of the art world very early by taking into
account, or making visible, non-Western art. In some ways your
current activity seems to have to do with the local. Is this some form
of resistance?*

Probably, but in a very covert manner. Context has always
meant a great deal to me. I'm interested in how things happen
in specific situations and today I'm living a semi-rural life
on the edge of a village that was originally mostly Hispano,
where Spanish is the older people's first language; that's
all very interesting to me. In 1958 when I got out of college,
before I went into the art world, I volunteered with the
American Friends Service Committee, which was the prede-
cessor of the Peace Corps, in a Mexican village in the state
of Puebla. That was my first experience of the Third World. I
love languages, though I don't speak any of them well any-
more. Mexico was a very influential moment for me, though I
don't quite know what it has to do with curating. Now I find
myself at the age of 70 back in a somewhat similar place. I'm
writing a book about the history of this area. I'm becoming
a real historian, surrounded by thousands of little documents
and so forth. It's great fun.

So that's another form of mapping. In the interview we have come to the idea of mapping a couple of times.

Yes. And now I'm actually mapping a very specific area, dealing with land grants and forgotten place names, rather than all over the place. There will be no show about this. I recently wrote something for a British book called *Focus on Farmers*. I like thinking about rural things and land use and so on, but there is always art somewhere in the back of my mind. Art has trained me to do whatever I want to do. The ideas that I got from artists have formed the ways I look at the world.

The Archeology of Things to Come
Daniel Birnbaum

This is a book about Hans Ulrich
Obrist's precursors, his grand-
parents. But the professional parents,
Suzanne Pagé and Kasper König,
his most influential teachers in the
world of exhibition making, are not
present, and would probably require
an additional volume. So let me
begin by citing from a conversation
I had with Pagé about curating.
The interview, published in *Artforum*,
is the result of an encounter that
Hans Ulrich facilitated in 1998,
during a period in which he was vis-
iting me regularly in Stockholm
while preparing *Nuit Blanche*, a large
Scandinavian exhibition.

DB *It seems to me that although
you're the director of a powerful
institution, you've never tended to
take center stage yourself. You
present a rather low-key version
of the curator's role.*

SP Yes and no. I don't like to put
myself into the spotlight, but I
like to illuminate the backstage.

What I suggest is actually very demanding. It takes an effort not to emphasize your own subjectivity, and to let the art itself be at the center. The real power, the only one worth fighting for, is the power of art itself. Artists should be given maximum freedom to make their visions clear to others, and to exceed the limits. That is my role, my real power. The curator helps to make that happen. And the best way for me to do so is to be open and lucid enough to accept the new worlds that artists reveal in their most radical dimension.

But you choose who is going to show in the first place. You can't deny that this involves great power.

The curator should be like a dervish who circles around the artworks. There has to be complete certainty on the part of the dancer for it all to begin, but once the dance has started it has nothing to do with power or control. To a certain degree it is a question of learning to be vulnerable, of remaining open to the vision of the artist. I also like the idea of the curator or critic as a supplicant. It's about forgetting everything you think that you know, and even allowing yourself to get lost.

This reminds me of what Walter Benjamin writes in Childhood in Berlin, *where he says that it takes a lot of exercise if you want to learn how to really get lost in a city.*

Yes, what I'm after is a form of concentration that suddenly turns into its opposite, being available for a true alternative adventure.

About a decade later, Hans Ulrich sent me an interview with Kasper König, his perhaps most important mentor, where similar thoughts about the fundamental invisibility of the curator are expressed: "Yes, keeping things simple is always my motto: here on the one hand there are the works of art, quite traditionally, not the artists but the products of artists, and on the other the public, and we're in-between. And if we do our work well, we disappear behind it."

It was in 1967 that John Barth published his controversial

essay "The Literature of Exhaustion," in which he proposed that the conventional modes of literary representation associated with the novel had been "used up," and that the novel was worn out as a literary format. After the death of the novel one can either be naïve and continue as if nothing has happened (as thousands of writers do), or one can make the very end of the genre productive: from Jorge Luis Borges to Italo Calvino one finds fantastic versions of a such "literature after literature" in which the end game is turned into a new kind of writing. A case in point: Calvino's brilliant 1979 meta-novel *If On a Winter's Night a Traveler*, which accommodates so many incompatible books. Perhaps it is in the same way that painting is dead and yet kept alive by Gerhard Richter, who paints in all styles, giving priority to none. At least this is the position that critic Benjamin Buchloh wanted the artist to accept in a legendary interview.[1] In a grandiose way Richter would thus demonstrate the end of his discipline.

In a comparable way, it would seem that the biennale has reached its unavoidable end. But reaching this end is perhaps necessary if one is looking for a new start. Hans Ulrich Obrist knows this and therefore, in collaboration with Stéphanie Moisdon, he staged the Lyon Biennale, which opened in Sepmber 2007, as a kind of meta-literary game. In the spirit of Oulipo (an experimental group of poets and mathematicians), the whole event was reduced to a list of manuals, the curator was nothing but an algorithm. Perhaps another version of an end was marked by Francesco Bonami's 50th installment of the Bienale di Venizia in 2003—at least that is how Obrist and I thought about it when preparing our sections. The show contained a multiplicity of shows: the most extreme, dense, and impressive Asian biennial (curated by Hou Hanru), sections organized by artists (Gabriel Orozco and Rirkrit Tiravanija), a kind of laboratory in the garden (*Utopia Station*, an Obrist, Tiravanija, Molly Nesbit collaboration), and numerous other incompatible exhibitions displaying their own logic. It was a heterogeneous event, and in a way the biennale to put an end to the biennale as an experimental form. It tried to exhaust all possibilities at once, and pushed the plurality as far as possible. Many people didn't like it much, but I have a sense that almost everything coming after this endeavor will look conservative.

The end of the biennale does not mean that no more biennials will be staged (just as the "death of the novel" never meant the disappearance of actual books from the stores). On the contrary, there are more biennials than ever. But as a form for experimentation and innovations it seems that it has reached a stage where it must reinvent itself. The idea that forms of artistic expression can exhaust themselves is nothing new. For instance, in the mid 1920s the very young Edwin Panofsky made a similar claim: "When work on certain artistic problems has advanced so far that further work in the same direction, proceeding from the same premises, appears unlikely to bear fruit, the result is often a great recoil, or perhaps better, a reversal of direction." Such shifts, says Panofsky, are always associated with a transfer of artistic leadership to a new country or to a new discipline.

But the biennial is not an art form, so how does this comparison with painting and literature function, some of you may wonder. I am not so sure. With figures such as Pontus Hultén and Harald Szeemann, who both recently passed away, the role of the curator took on new qualities. Szeemann sought, he said, to create shows that were "poems in space." And in the wake of his move away from all traditional museological attempts to classify and order cultural material, the figure of the curator could no longer be seen as a blend of bureaucrat and cultural impresario. Instead, he emerged as a kind of artist himself or, as some would say—perhaps with some skepticism toward Szeemann's genuine belief that art exhibitions were spiritual undertakings with the power to conjure alternative ways of organizing society—a meta-artist, utopian thinker, or even shaman. A comparison with Pontus Hultén, the founding director of the Centre Pompidou, offers a way to think through a crucial distinction—one having to do with institutional models and the very conception of curating. It could perhaps be said that Szeemann and Hultén defined opposite ends of the spectrum, and in so doing vastly expanded the spectrum itself. Szeemann chose not to direct a museum and instead invented a new role: that of the independent *Ausstellungsmacher*, who carries his own museum of obsessions in his head. Hultén, on the other hand, and more than anyone else, tested the limits of the contemporary art museum from within and tried to turn the whole institution

into a radically multi-disciplinary laboratory and production site. Now Hultén and Szeemann have both left us, and we have to sort out a global environment that they were instrumental in shaping. The successful museum has become a corporation, the biennale is in crisis. What is waiting around the corner? Of course art fairs that pretend that they are exhibitions, and a brand new park in Abu Dhabi where perhaps, in a few years, there will be a supersized biennial on steroids. In recent times we have witnessed a marginalization of all functions in the art world, which suggests the possibility of something significant taking place outside of the market. The critic was marginalized by the curator who in turn was pushed aside by the advisor, the manager and—most importantly—the collector and the dealer. There can no longer be any doubt: for many the biennale has been eclipsed by the art fair.

But no doubt there will be a new start. Somewhere in the near future, it will happen, because things don't just end like this. When new cultural formations appear they tend to use fragments from already obsolete forms. Panofsky pointed this out: the future is constructed out of elements from the past—nothing appears ex nihilo. The future of exhibition making will deploy devices we once knew but had forgotten about. This book is a unique toolbox, and Hans Ulrich Obrist is not simply an archeologist, he is also a guide into artistic landscapes that are yet to emerge.

[1] Benjamin Buchloh, "Interview with Gerhard Richter" in *Gerhard Richter: Forty Years of Painting*, exh. cat., MoMA New York 2002.

Imprint

Edited by Lionel Bovier,
with the assistance of Birte Theiler

COPY EDITING
Clare Manchester

DESIGN CONCEPT
Gavillet & Rust, Geneva

DESIGN
Nicola Todeschini

TYPEFACE
Genath

PRINT
EBS, Verona

ACKNOWLEDGEMENTS
The author would like to express his gratitude to the
following people and institutions for their kind support
of this project: Richard Armstrong, agnès b., Véronique
Bacchetta, Carlos Basualdo, Daniel Birnbaum, Stefano
Boeri, Christian Boltanski, Saskia Bos, Lionel Bovier,
Jacqueline Burckhardt, Daniel Buren, Christophe Cherix,
Bice Curiger, Chris Dercon, Michael Diers, Tom Eccles,
Zdenek Felix, Peter Fischli, Robert Fleck, Teresa Gleadowe,
Jens Hoffmann, Koo Jeong-A, Jean-Baptise Joly, Kasper
König, Jannis Kounellis, Bertrand Lavier, Ingeborg Lüscher,
Jean-Hubert Martin, Ivo Mesquito, Pia Meyer, Molly Nesbit,
David Neuman, F. and E. Obrist, Paul O'Neill, Suzanne
Pagé, Adriano Pedrosa, Mario Pieroni, Julia Peyton-Jones,
Beatrix Ruf, Nicholas Serota, Dora Stiefelmeier, Sally Tallant,
Birte Theiler, Lorraine Two, Gavin Wade, David Weiss.

PUBLISHED BY
JRP | Ringier
Letzigraben 134
CH–8047 Zurich
T +41 43 311 27 50
F +41 43 311 27 51
E info@jrp-ringier.com
www.jrp-ringier.com

IN CO-EDITION WITH
Les presses du réel
35, rue Colson
F–21000 Dijon
T +33 3 80 30 75 23
F +33 3 80 30 59 74
E info@lespressesdureel.com
www.lespressesdureel.com

ISBN 978-3-905829-55-6 (JRP | Ringier)
ISBN 978-2-84066-287-7 (Les Presses du réel)

Distribution

GERMANY AND AUSTRIA
Vice Versa Vertrieb, Immanuelkirchstrasse 12, D-10405 Berlin,
info@vice-versa-vertrieb.de, www.vice-versa-vertrieb.de

FRANCE
Les presses du réel, 35 rue Colson, F-21000 Dijon,
info@lespressesdureel.com, www.lespressesdureel.com

SWITZERLAND
Buch 2000, AVA Verlagsauslieferung AG, Centralweg 16,
CH-8910 Affoltern a.A., buch2000@ava.ch, www.ava.ch

UK AND OTHER EUROPEAN COUNTRIES
Cornerhouse Publications, 70 Oxford Street, UK-Manchester
M1 5NH, publications@cornerhouse.org,
www.cornerhouse.org/books

USA, CANADA, ASIA, AND AUSTRALIA
D.A.P./Distributed Art Publishers, l55 Sixth Avenue,
2nd Floor, USA-New York, NY 10013, dap@dapinc.com,
www.artbook.com

Documents Series 3:
Hans Ulrich Obrist

This book is the third volume
in the "Documents" series,
dedicated to critics' writings.

The series is directed by
Lionel Bovier and Xavier Douroux.

Also available

DOCUMENTS SERIES

Saul Anton, *Warhol's Dream*
JRP|Ringier: 978-3-905770-35-3

Bob Nickas, *Theft Is Vision*
JRP|Ringier: 978-3-905770-36-0

Dorothea von Hantelmann, *How to Do Things with Art*
JRP|Ringier: 978-3-03764-104-0

Christian Höller, *Time Action Vision*
JRP|Ringier: 978-3-03764-124-8